Dedicated to the friends and families of these
talented photographers around the world.

Pictures of the Year
Photojournalism 19

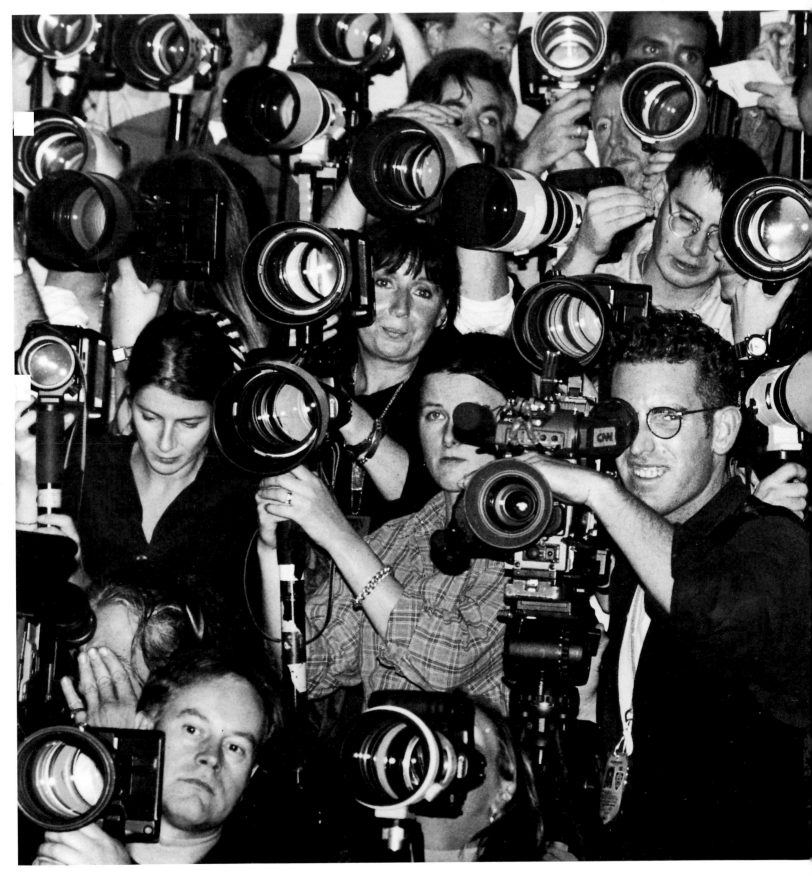

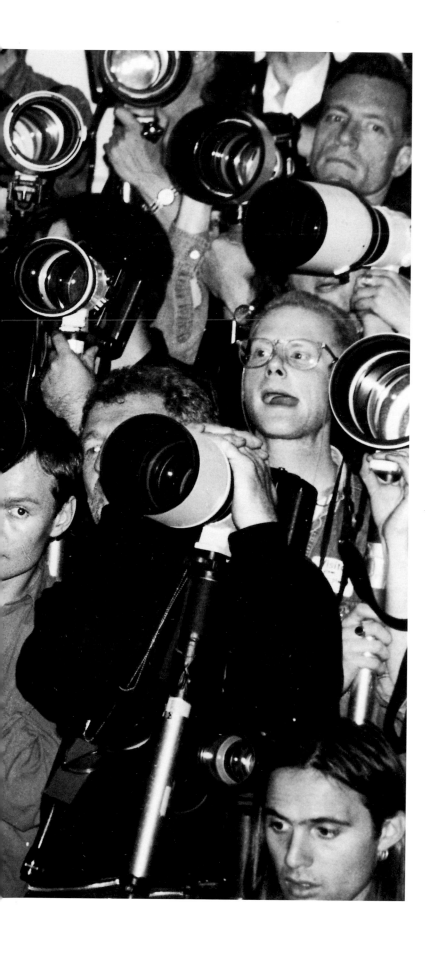

AN ANNUAL BASED ON THE **51ST PICTURES OF THE YEAR** COMPETITION SPONSORED BY THE NATIONAL PRESS PHOTOGRAPHERS ASSOCIATION AND THE UNIVERSITY OF MISSOURI SCHOOL OF JOURNALISM, SUPPORTED BY GRANTS TO THE UNIVERSITY FROM CANON U.S.A., INC., AND EASTMAN KODAK CO.

From the NPPA President

This volume of photographs represents the best of what photojournalists had to offer during the year 1993. Over 1500 photojournalists and editors entered over 23,000 slides and 1,000 tear sheets in the annual Pictures of the Year competition, sponsored by the National Press Photographers Association, the University of Missouri School of Journalism, and the corporate sponsors, Canon U.S.A., Inc., and Eastman Kodak Co.

Great photographs come from the commitment of the visual journalist who spends long hours of research, long hours of quest, yet only moments of fleeting vision – but vision that is informed and sophisticated, vision that appeals to the eye as well as the heart. The photographs in this volume show a sense of place, a sense of moment, and they grip one's imagination.

Photography is a potent tool in the hands of an accomplished photojournalist. Excellent visual documentation can move a country as words seldom can.

Kevin Carter's photograph of a vulture waiting for a starving Sudanese child to die is chilling even to the most cynical among us. And Americans were horrified by Paul Watson's image of an angry crowd dragging the corpse of a U.S. serviceman through the streets of Mogadishu.

Michael Williamson spent over 15 years documenting the lives of the homeless across the United States, hoping to make a difference in the plight of America's forgotten faces. His commitment was rewarded when he won the Kodak Crystal Eagle Award for impact in photojournalism.

Anthony Suau, Magazine Photographer of the Year,

chronicled the events unfolding in eastern Europe and the former Soviet Union, and his images may become icons for this decade. Canon Photo Essay winner Larry Towell's powerful work on El Salvador will stand as a testament to the need for peace, no matter how distant from our shores. The daily commitment of Newspaper Photographer of the Year, Lucian Perkins, brings solid photojournalism to the readers of *The Washington Post* on a consistent basis.

Not all of the photos in this volume are of chaos or suffering. Many of them reflect life in America's backyard, celebrating the spirit, joy and caring of the human family. They reflect our best qualities.

The documentary photographer is on the front line of daily history. A reporter does not have to witness, although the best ones do. A photographer must witness, and the best ones bring more to the moment than a literal look at a situation. They bring visual poetry that transcends mindless documentation of a scene or event. The best ones are reflected in this volume. As you look over the photographs, remember the commitment of the documentary photographer: those hours away from friends and families; those moments of uncertainty; those moments when one may feel all of humanity is lost; those moments of beauty and grace when one feels that all the world belongs to them.

Always remember their commitment. They reflect your world. They challenge you to see beyond yourself. They encourage you to soar and inspire. They challenge you to act.

Bill Luster
President, National Press Photographers Association

Front cover photo by Kevin Carter, Sygma
Back cover photo by Stephen Jaffe, freelance for Reuters
Cover design by Diana Shantic, Los Angeles Times

Printed and bound in the United States of America by Jostens Printing and Publishing Division, Topeka, KS 66609.
Canadian representatives: General Publishing Co., Ltd., 30 Lesmill Road, Don Mills, Ontario M3B 2T6.

This book may be ordered by mail. Please include $2.50 for postage and handling. But try your bookstore first!
Running Press Book Publishers, 125 South 22nd Street, Philadelphia, PA 19103-4399.
ISBN (paperback): 1-56138-412-7

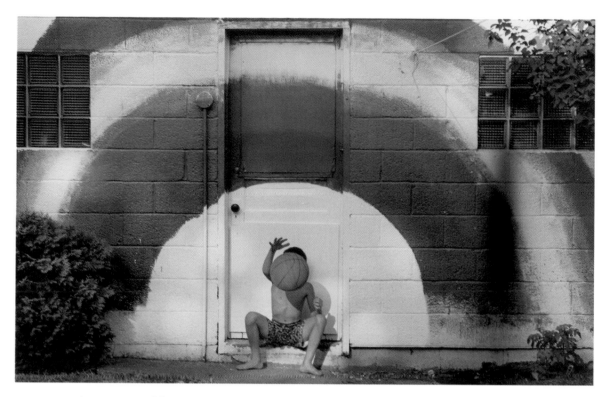

AWARD OF EXCELLENCE, NEWSPAPER FEATURE PICTURE STORY
Allan Detrich, The Toledo Blade
Ilja Miller dribbles a ball in front of a rainbow painted on the garage by his father, Dennis Miller, who died of AIDS-related illness. Dennis painted the rainbow so that Ilja would have a memento.

TABLE OF CONTENTS

Staff

EDITOR
JOE COLEMAN

TEXT EDITOR
PATRICIA BIGGS HENLEY

ASSOCIATE EDITOR, DESIGNER
DIANA SHANTIC

ASSOCIATE EDITOR, DESIGNER
PETE WATTERS

ASSOCIATE EDITOR, DESIGNER
DAVE SEIBERT

ASSOCIATE EDITOR, DESIGNER
CHARLES LEIGHT

ASSOCIATE EDITOR, PHOTO COORDINATOR
MICHAEL SPECTOR

ASSISTANT EDITOR
LAURIE HAGAR

IMAGING
MICHAEL DORNBIER

ADVISING EDITOR
HOWARD I. FINBERG

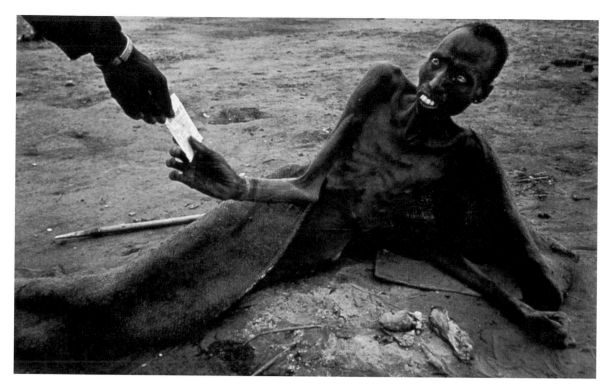

2ND PLACE, MAGAZINE PHOTOGRAPHER OF THE YEAR
James Nachtwey, Magnum
A starving man in southern Sudan receives a packet of rehydration salt from an aid worker.

Introduction

Letting go is hard to do.

For readers of this book, an unpleasant image is easy to dismiss — a quick turn of the page, just avert the eyes and move on to the next photograph.

I've often wondered how photographers deal with those same images, when they are real and in front of them. How do they exorcise the demons that must haunt them late at night?

You hear the explanation, "The camera lens allows me to distance myself from the event (or subject)."

Does it really? Should it?

Capturing the emotion, the gritty nature of the real world, is what gives photography its power. Strip that emotion away and what's left?

It is such lack of emotion that has reduced much of journalism to a series of "he said/she said" quotes. Wanting journalism with passion and emotion is not the same as expecting bias and lies. Rather, it recalls an earlier era when journalistic institutions could express "feelings" – of joy, anger, disbelief, happiness, wonderment, excitement.

These institutions expressed the feelings of their readers. And the readers responded.

Fortunately, photography still has some

– continued

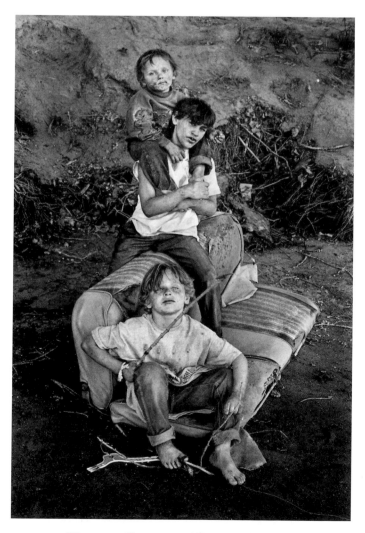

KODAK CRYSTAL EAGLE AWARD
Michael S. Williamson, The Washington Post
Three brothers sit on a junked car seat near the Sacramento River. Their family is homeless.

of that power.

Look at the photo by Kevin Carter showing a vulture stalking a starving Sudanese child. Force yourself to study the image, look at the details. Don't turn the page, don't let go.

Carter, who won a Pulitzer Prize for that image, committed suicide in 1994. He once told an interviewer that after he took that photograph, he sat under a tree for a long time, "smoking cigarettes and crying."

I don't know whether Kevin Carter couldn't let go of the horror he witnessed that day in the Sudan. Perhaps there were other reasons for his action. With suicide, there are no answers, only more questions.

Unfortunately, too many newspapers and magazines don't want to publish such powerful images. They don't want to shock their readers or remind them of the world of hurt outside.

Taking and publishing powerful photographs, however, could provide an important way of connecting people to the real events outside their immediate circle, of connecting them to the larger world. This is a difficult challenge for editors who can be torn between the bottom line of business and the higher needs of journalism.

The reader has a different mission: Look at the images, don't just glance and turn away; try to make the connection to the world around you.

Caring is the first step toward making things better.

— • —

Letting go is hard in other ways.

This will be the last book produced by this very talented team of editors and designers. When we took on this project in 1988, it was with the goal of raising the quality of *The Best of*

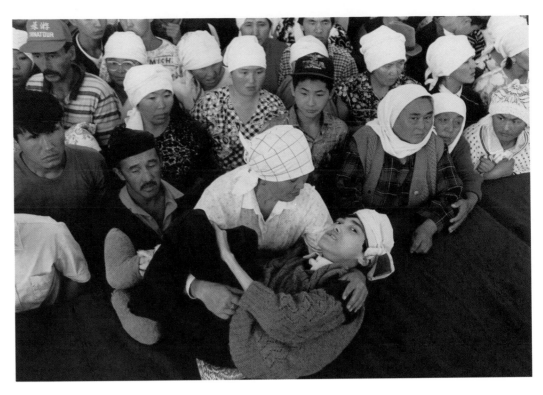

NEWSPAPER PHOTOGRAPHER OF THE YEAR
Lucian Perkins, The Washington Post
A woman lifts her son onto a stage in hopes a faith healer can cure his deformities. They live near the former nuclear test site in Semipalatinsk, Kazakstan.

Photojournalism to a higher level. All the people who worked on this project over the past six years had one thing in common: They cared about photography and wanted to build a better showcase for the best photographic images in the world.

Slowly, this book has evolved from a collection of different images to the definitive record of one of the world's most important photojournalism competitions.

However, like even the most successful Broadway shows, sometimes you need to know when to get off the stage and let someone else take over. It is time for someone else to bring a new level of excitement and energy to this important project.

To those who have been with me from the start — Joe Coleman, Patricia Biggs Henley, Pete Watters, Michael Spector — I can't find the words to express my admiration and appreciation.

When we started, I promised this staff of volunteers a learning experience. I think we all have learned a great deal.

Howard I. Finberg
Advising Editor

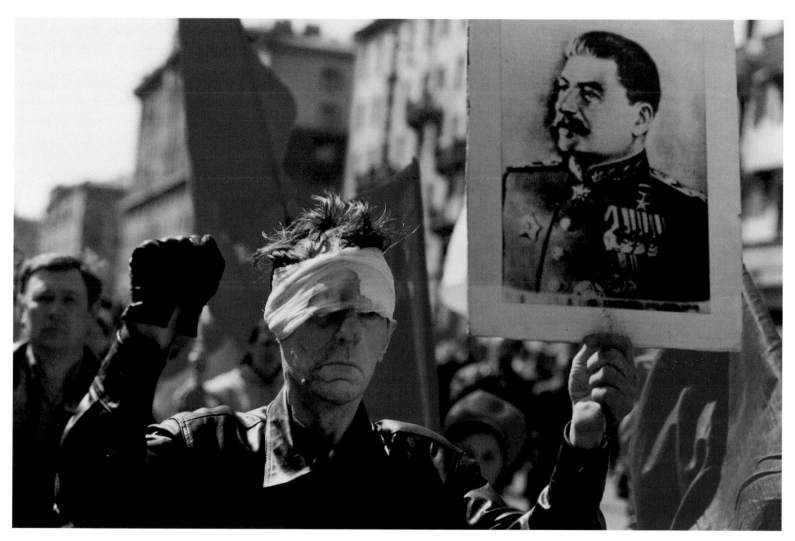

Bloodied during a confrontation with Moscow police on May Day in which scores of people were wounded, an angry Nationalist defiantly marches home.

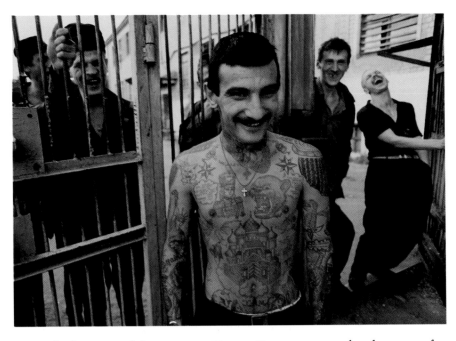

At a high-security labor camp at Kovrov, Russia, inmates laugh as one of the repeat offenders proudly shows off his tattoos.

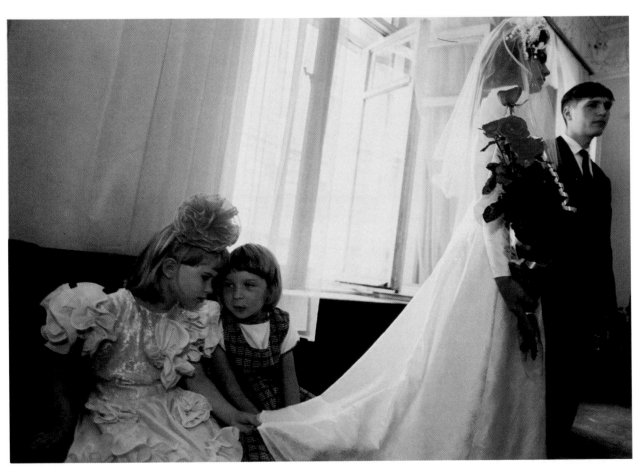

At the Moscow Bridal House two girls gossip as a couple wait their turn to be married.

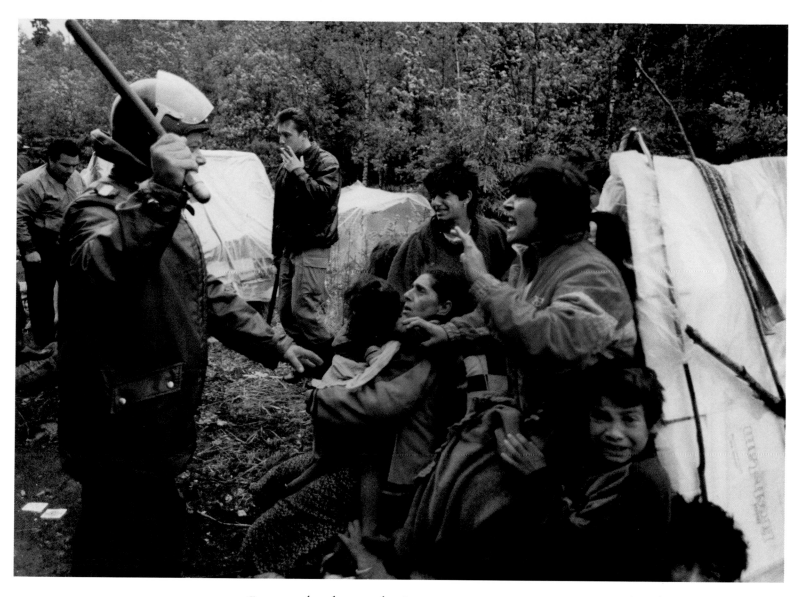

Swinging their batons, the Omon enter a gypsy camp.

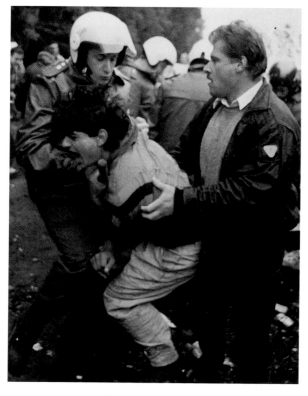

A gypsy is beaten as the police separate
the men and women.

RAID ON A GYPSY CAMP

As part of a continuing crackdown on ethnic minorities
living illegally in Russia, the country's elite police
force, the Omon, raided a gypsy camp hidden in the forest
about 25 miles outside Moscow. The gypsies were rounded
up, many of them beaten, and their camp was destroyed.
Later that day, they were put on a train back to their
homeland in the Ukraine.

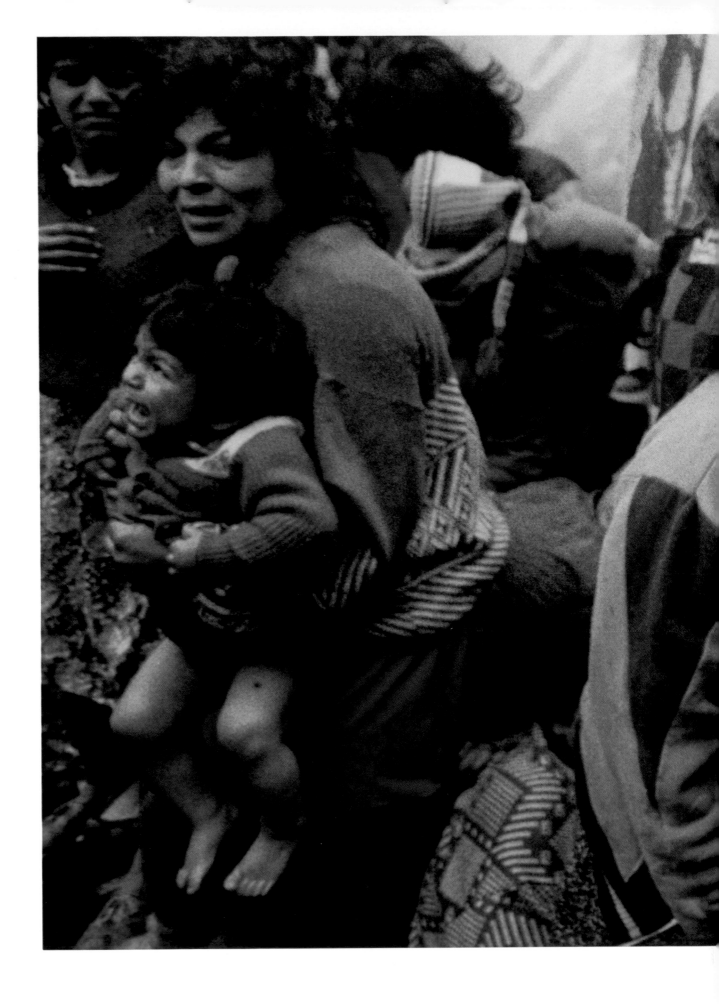

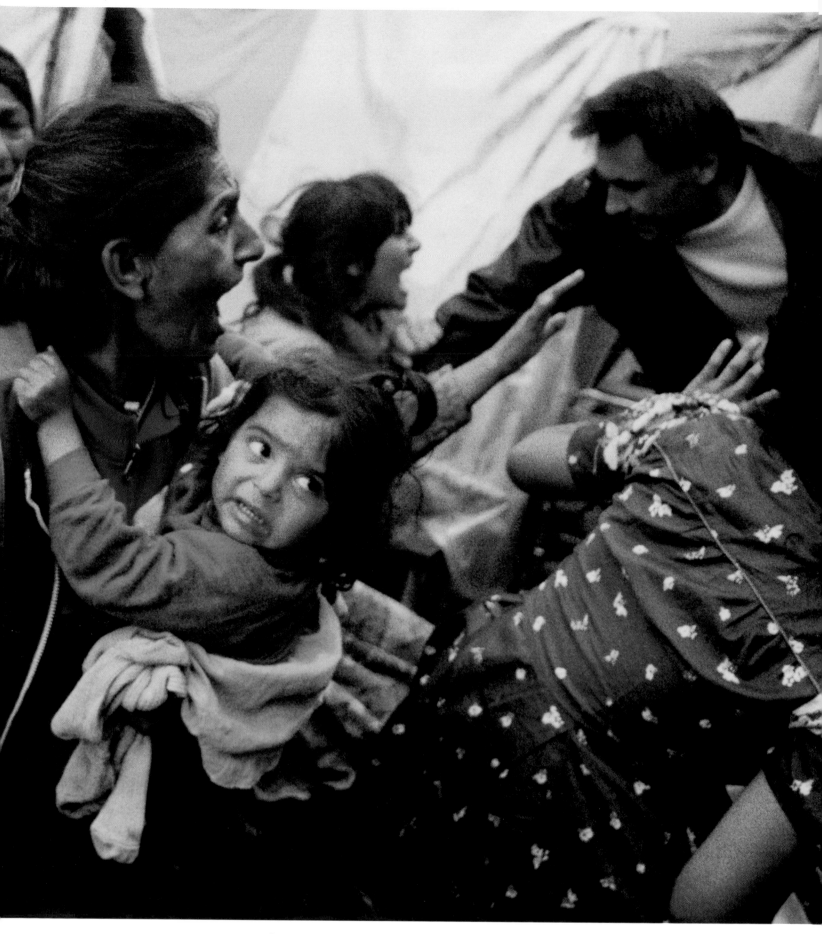

Gypsies run for cover in vain as they are trapped by the encircling officers.

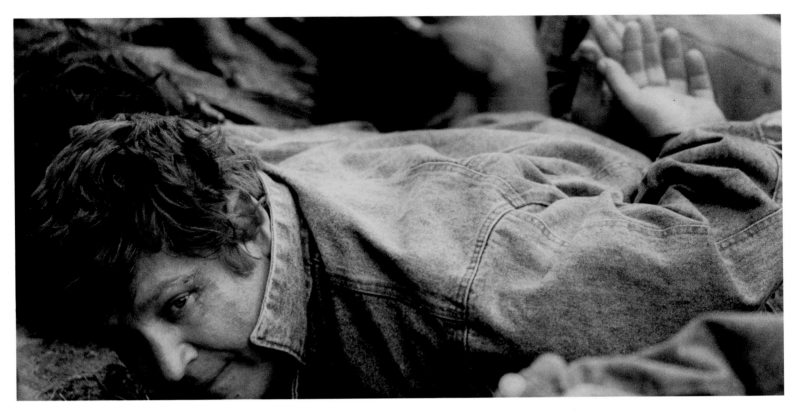

A gypsy man, tied by the Omon, struggles to see what is happening in his camp.

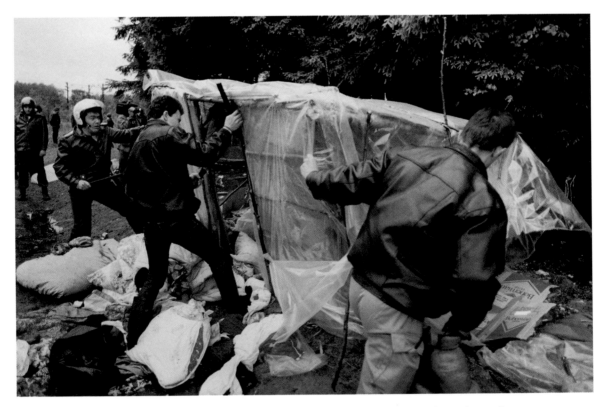

After rounding up the gypsies, the officers tear the camp apart searching for stolen items.

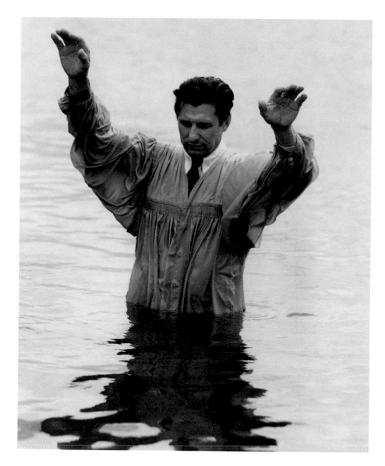

A Russian Baptist minister finishes a ceremony during which
190 people were baptized in the Moscow River. Since the fall
of communism, Russians have been able to practice religion
freely, and many are exploring their religious roots.

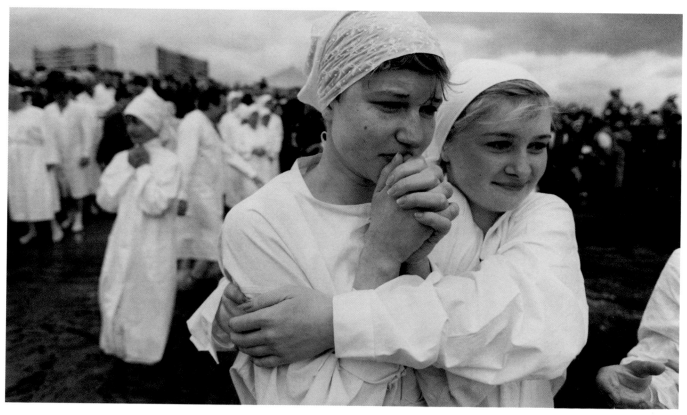

Two Russian girls brave the cold weather and water as they await their turn to be baptized.

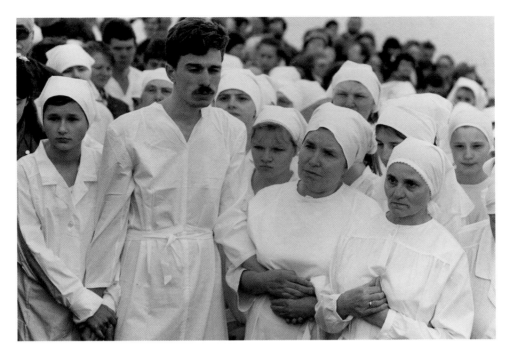

Believers wait by the riverside for their turn at baptism.

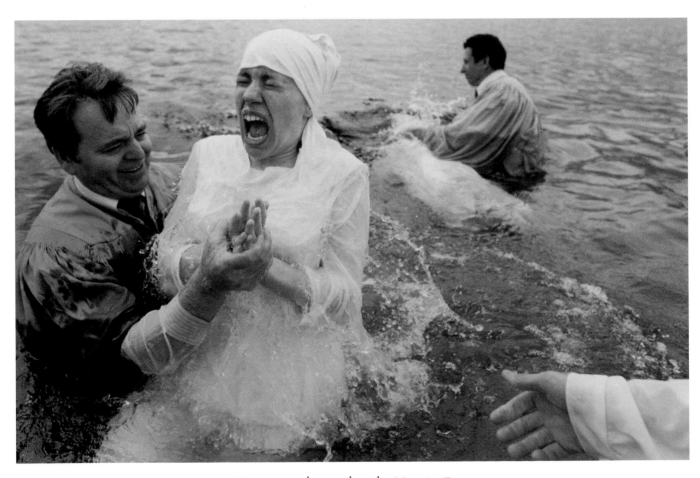

A woman is baptized in the Moscow River.

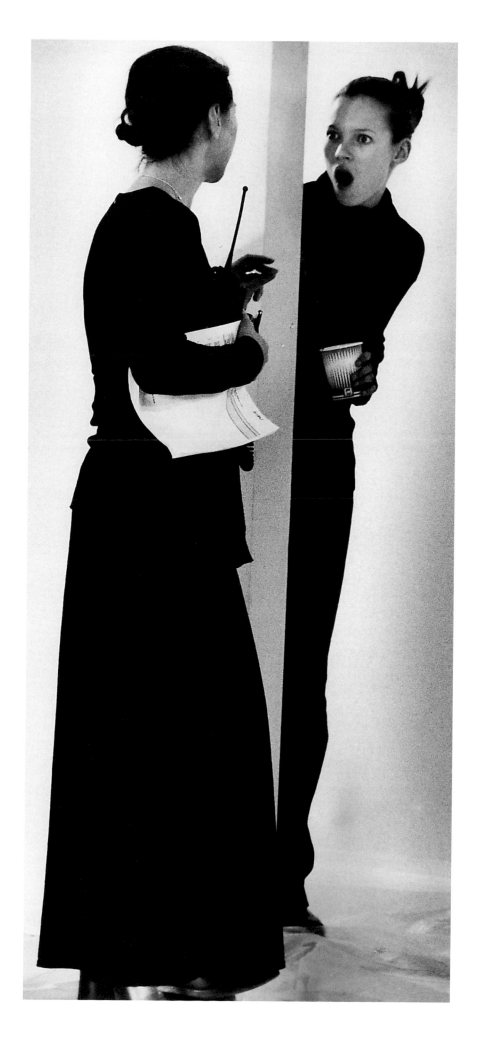

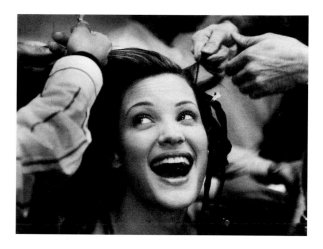

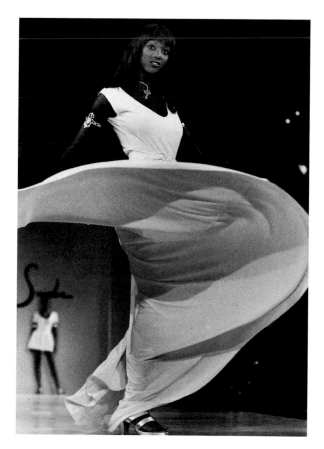

FASHION FEVER

Each Fall and Spring, madness descends upon New York when America's top designers unveil their latest collections on the runways. Model Kate Moss (left photo) learns her cues before the Calvin Klein show. Tereza Makova (top) has her hair done in preparation for the Nicole Miller show, and model Naomi Campbell swirls down the runway.

Eve plays nonchalant as she models in the Nicole Miller show.

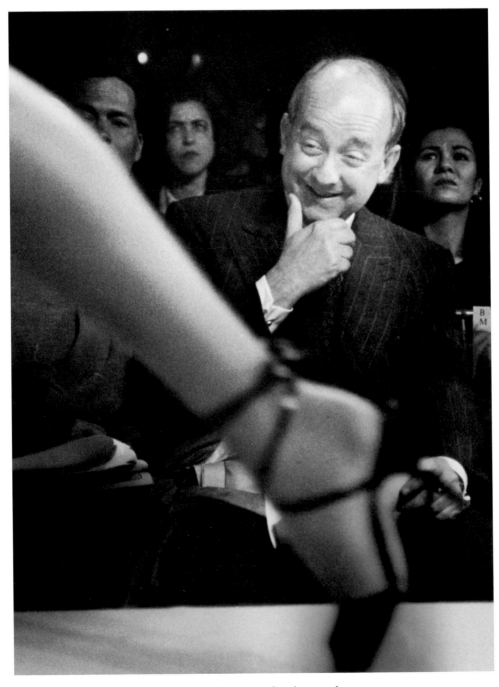

A fashion buyer — hard at work.

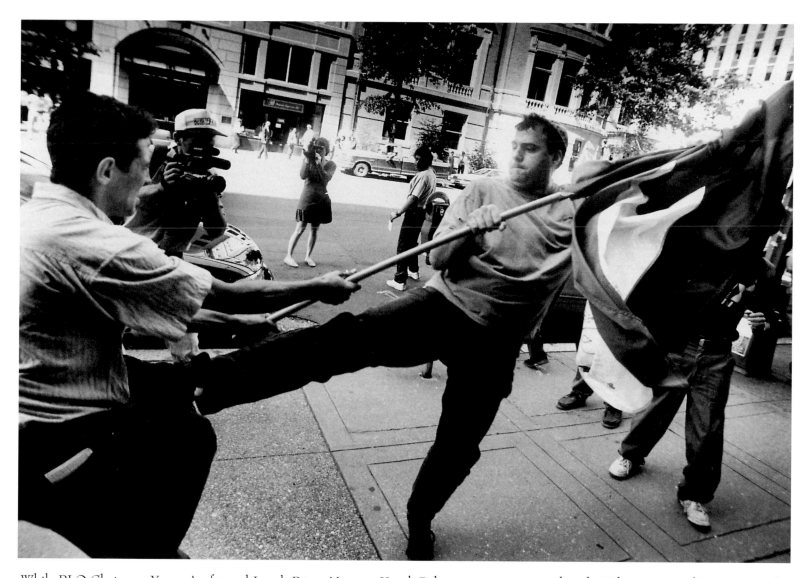

While PLO Chairman Yasser Arafat and Israeli Prime Minister Yitzak Rabin sign a peace accord at the White House, the scene outside is less peaceful. Kahane Chai member Yosef Bennetten tries to take a Palestinian flag from Khali Mahmoud, setting off fighting on the streets of Washington, D.C.

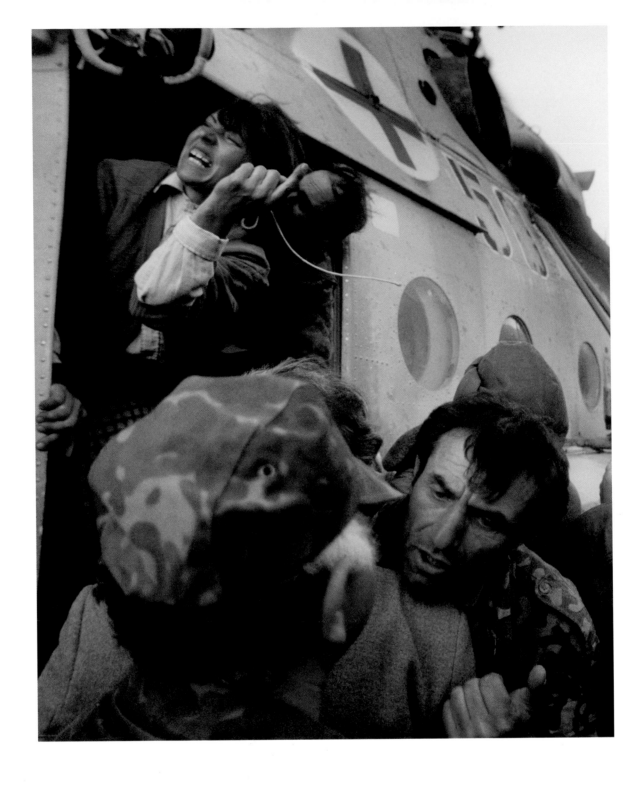

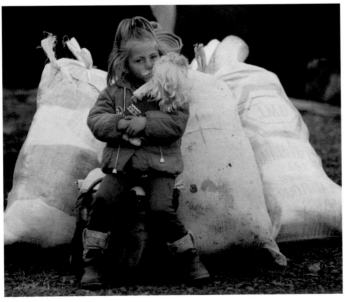

When fighting broke out in Abkhazia, Georgian refugees fled to the village of Chuberi where they could board helicopters for safe passage back to Georgia. A woman (above) on the day's last flight out pleads with her family to board with her, but the craft already is overcrowded. A girl (left), one of a group of refugees left behind for the night, sadly guards her family's possessions.

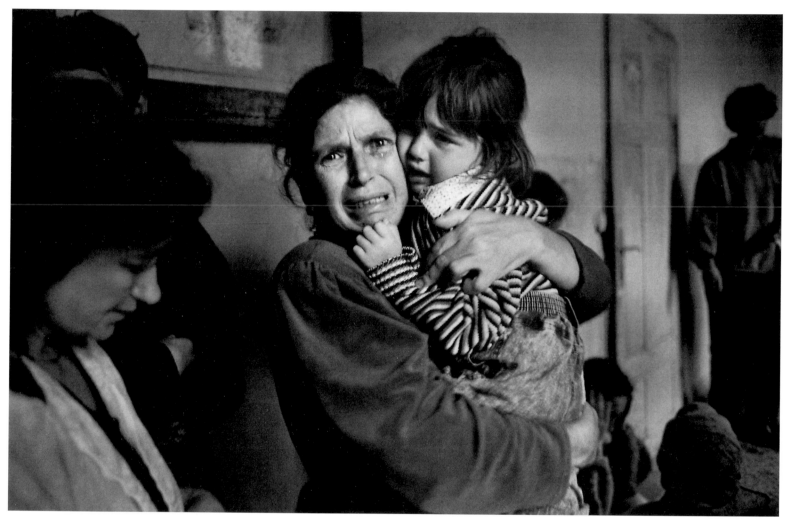

A Muslim mother and her child embrace in terror as Serbian artillery shells hit the building housing them and other refugees in Travnik, Bosnia-Herzegovina. The attack came only 30 minutes after the woman had been released by Serbs to the United Nations.

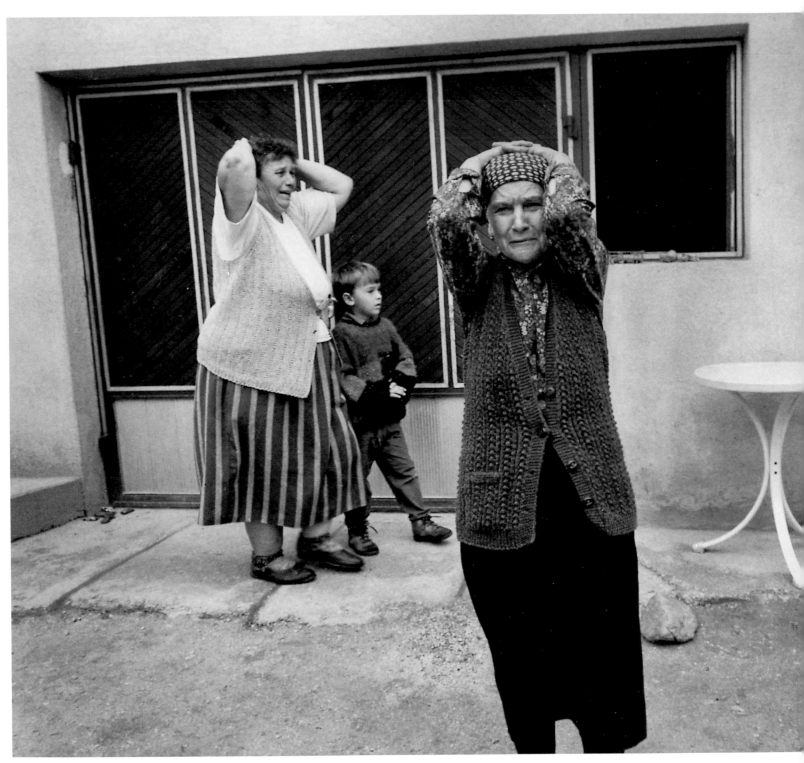

Croatian women in Vitez, Bosnia-Herzegovina, cry out in fear and anger as the thundering sound of war echoes in the distance.

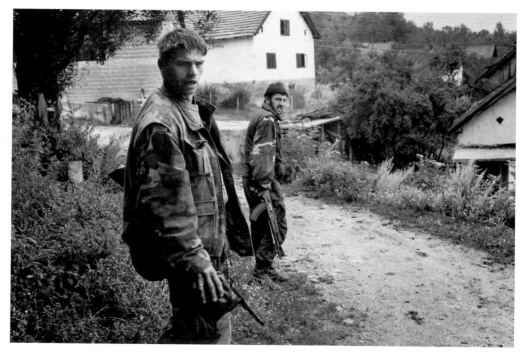

Bosnian soldiers in Vitez prepare to launch a counter attack against Muslim forces.

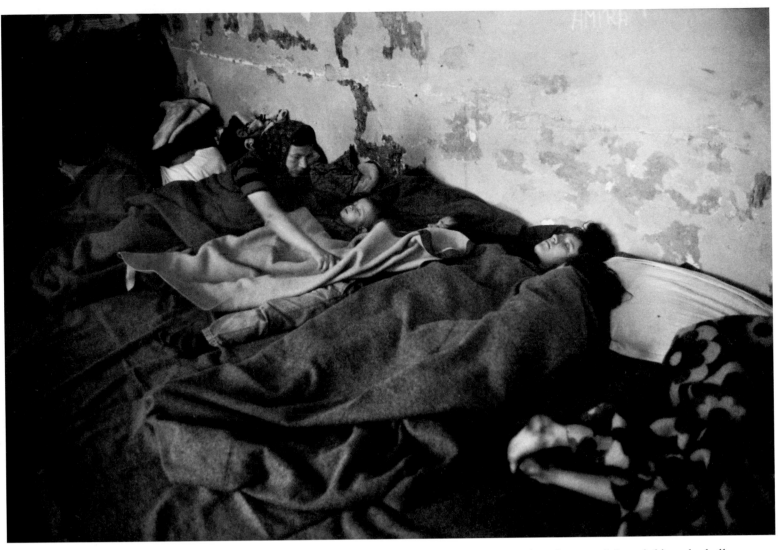

Finding no room at a camp for Muslim refugees in Travnik, Bosnia-Herzegovina, a mother sleeps with her child in the hallway of an old schoolhouse.

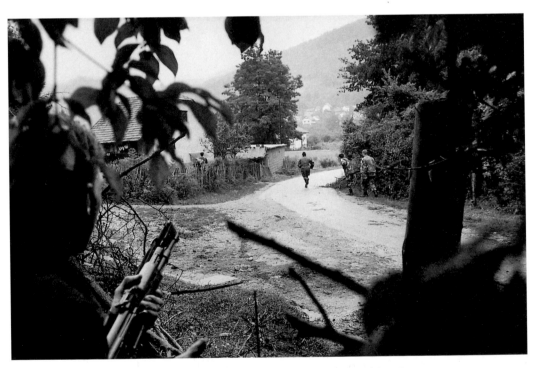

Croatian forces move under intense sniper fire to fortify their front-line positions against advancing Muslims in Vitez, Bosnia-Herzegovina.

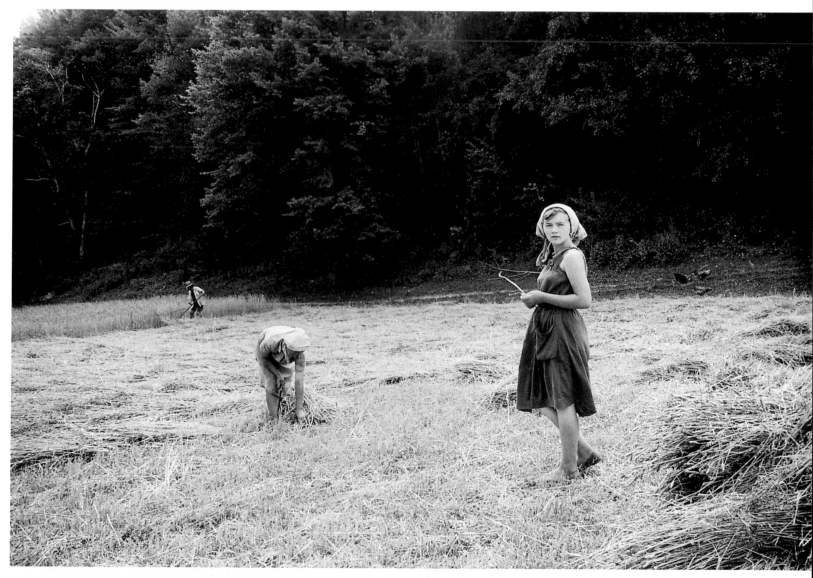

In Lupac, Banat, workers harvest grain for the winter.

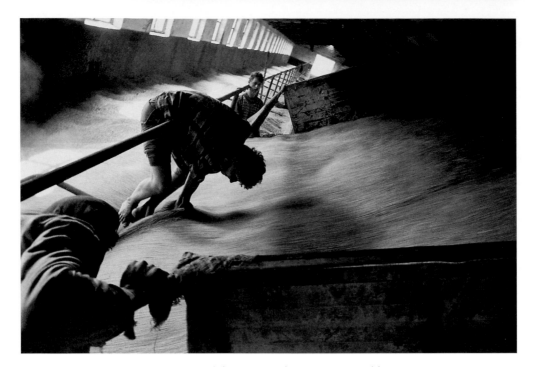

Grain is poured from a truck in Motic, Moldavia.

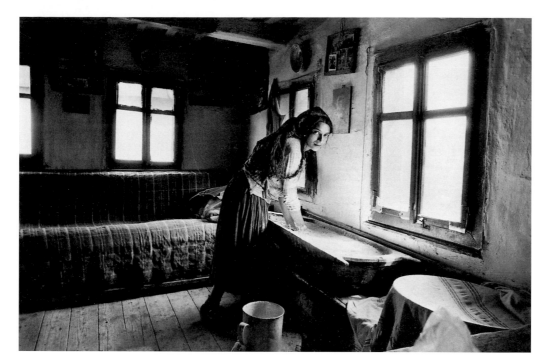

In Ucea, Transylvania, a woman prepares bread for an Easter feast.

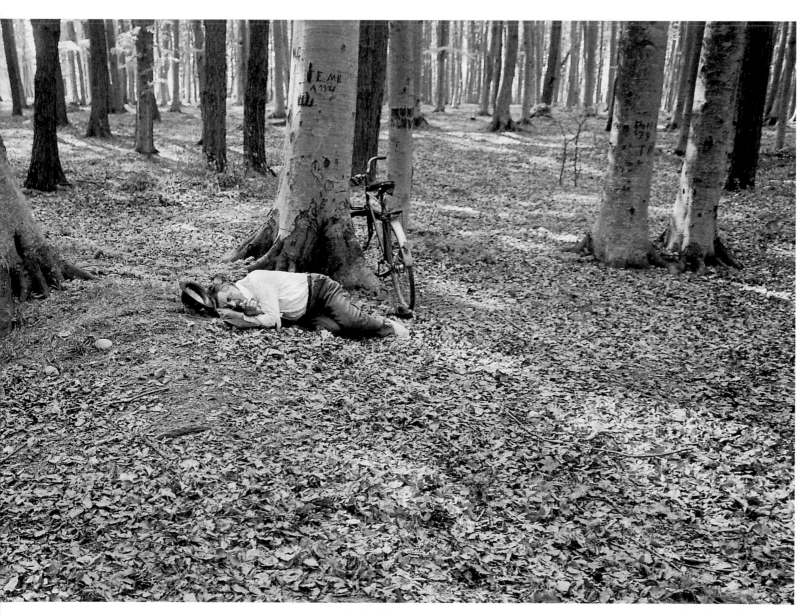

A man rests on a bed of leaves in Simbata, Transylvania.

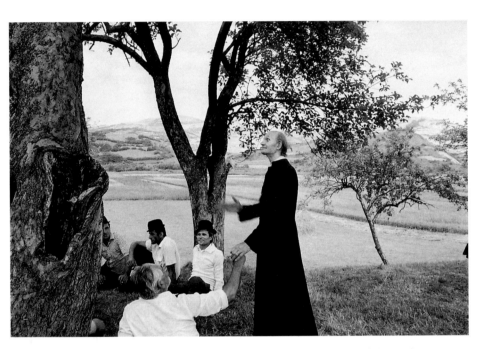

A priest relates a story to a group of men at an annual festival in Sieu, Maramuras.

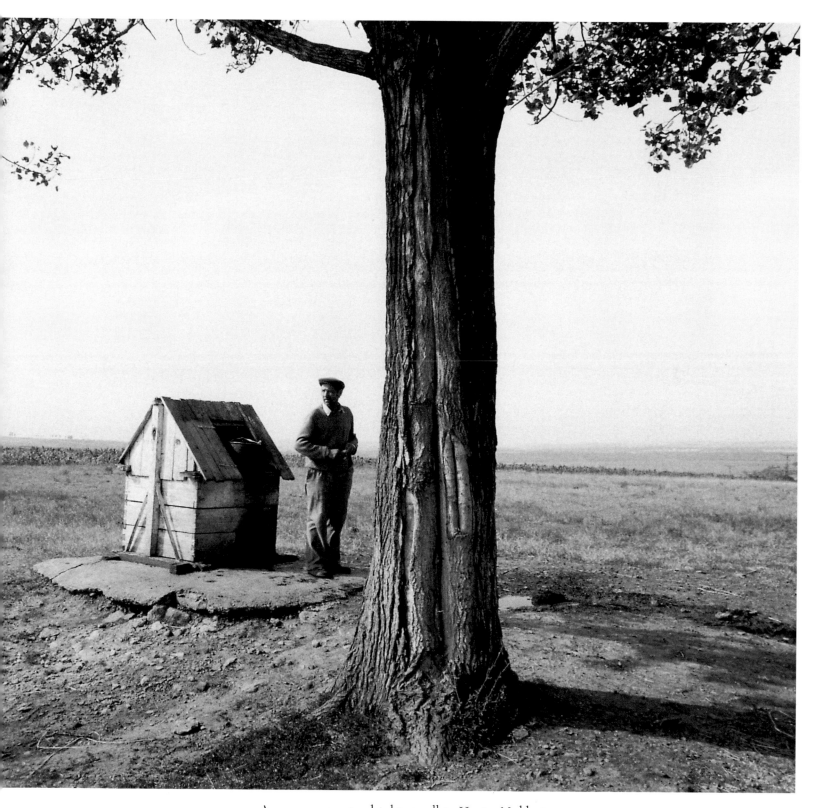

A man pauses at a drinking well in Horia, Moldavia.

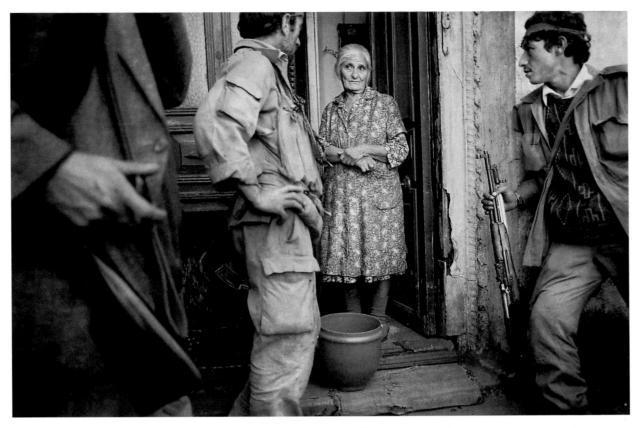

As Abkhazian rebels move through the destroyed city of Sukhumi to launch an attack on the Parliament building, local residents offer them water.

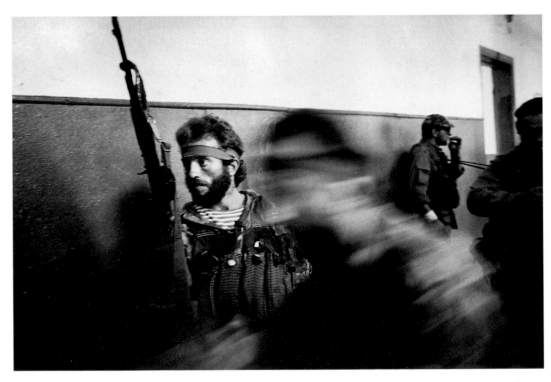

In a schoolhouse behind the Parliament building in Sukhumi, Abkhazian rebels prepare for a second ground assault after the first was repulsed by Georgian forces.

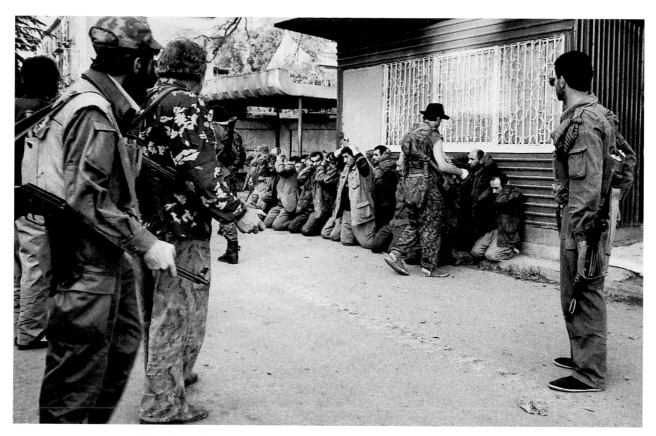

Georgian prisoners taken from the assault on the Sukhumi Parliament building are forced to their knees and beaten. The fate of these prisoners is unknown, but they probably were executed.

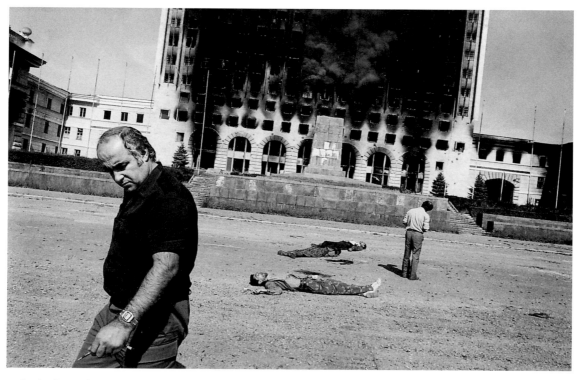

The bodies of Georgian soldiers lie in front of the burning Parliament building the day after it was captured by Abkhazian forces in Sukhumi.

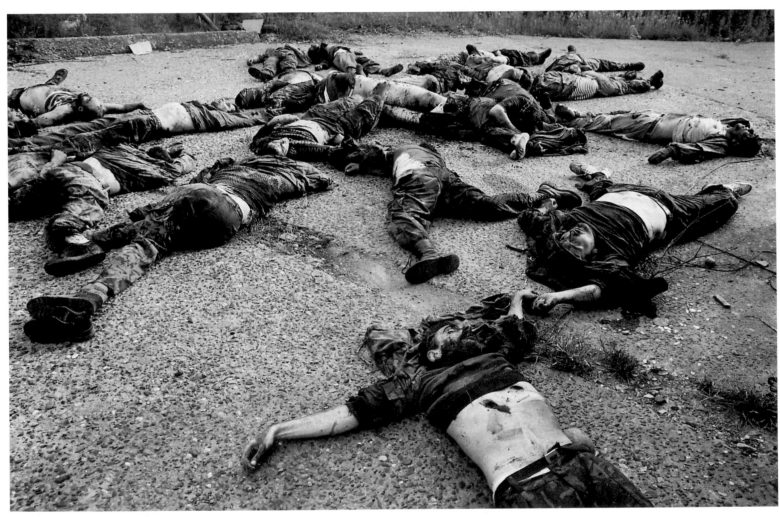

The bodies of executed Georgian soldiers are strewn on the outskirts of Sukhumi the day after Abkhazian forces captured the Parliament building.

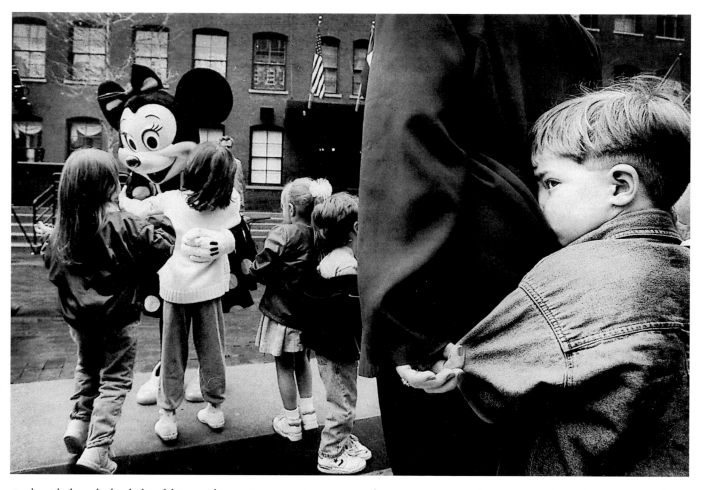

Ricky Shelton hides behind his mother as Minnie Mouse greets braver youngsters during a parade in downtown Dallas.

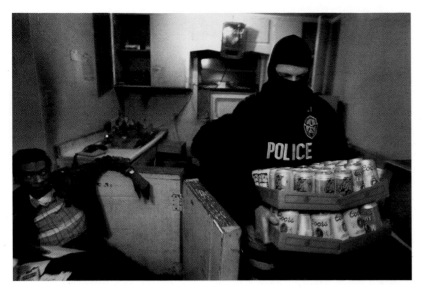

A Dallas vice officer confiscates beer from a bootleg house run by Emmitt Greene (left). Police say such establishments, which operate without license, are breeding grounds for violence and drug problems.

A driver performs a roadside sobriety test near Interstate 17 in Dallas.

THE LEGAL DRUG

Alcohol provides a social lubricant in American society, a prop often used from the teen years until old age. But it is a pleasure that exacts a price in traffic deaths (17,699 in 1992), dependency problems (18.5 million Americans), violence (90 percent of reported rapes on college campuses involve alcohol), and health costs (1990 estimate for alcohol-related health care for the elderly is $1 billion).

Rafael Castillo enjoys a beer with friends at a drive-in restaurant and bar in Dallas. The men began drinking there to avoid fighting that occurs at local bars.

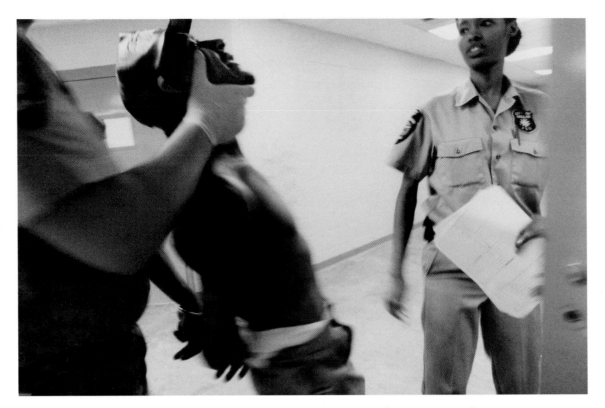

A detention officer forces Carlos Gonzales to a cell at the Dallas County Inebriate Detention Center after Gonzales became violent.

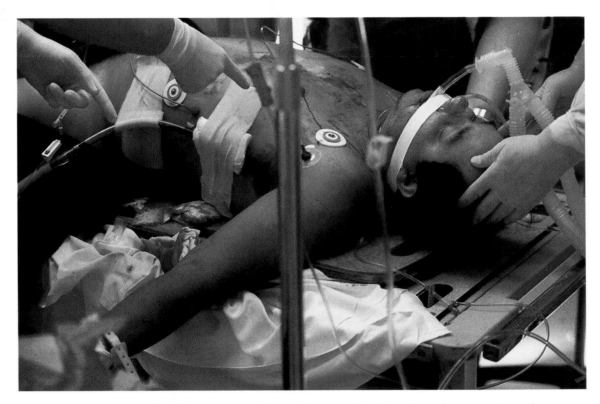

Doctors rush to save the life of a man suffering from a self-inflicted gunshot wound. He became despondent after drinking and attempted suicide.

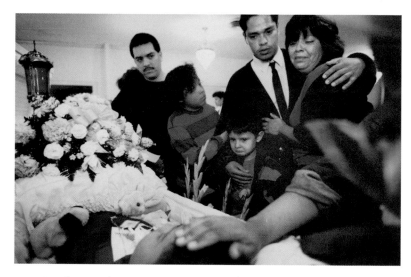

Family members grieve at a rosary service for the late Gracie Godina and her two sons, who were killed in an accident with a drunken driver. The drunk, who escaped injury, had five previous DUI convictions.

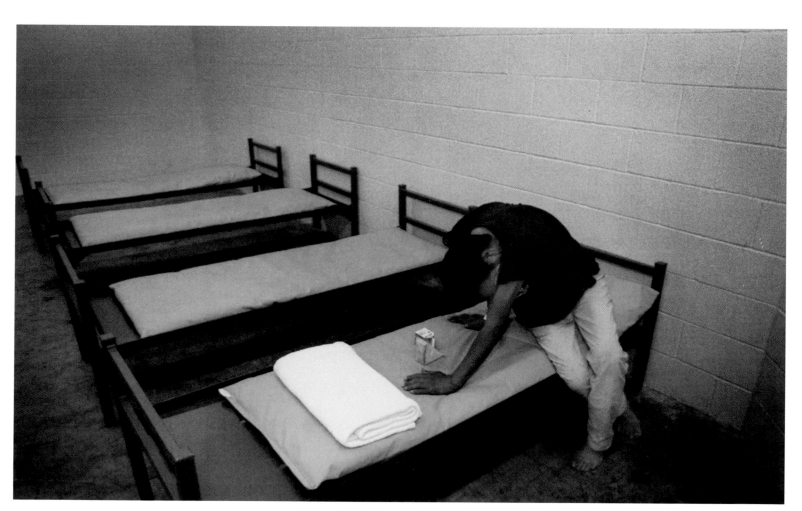

Gabriel Skyhorse, an alcoholic, begins to go through withdrawal after being locked up for public intoxication.

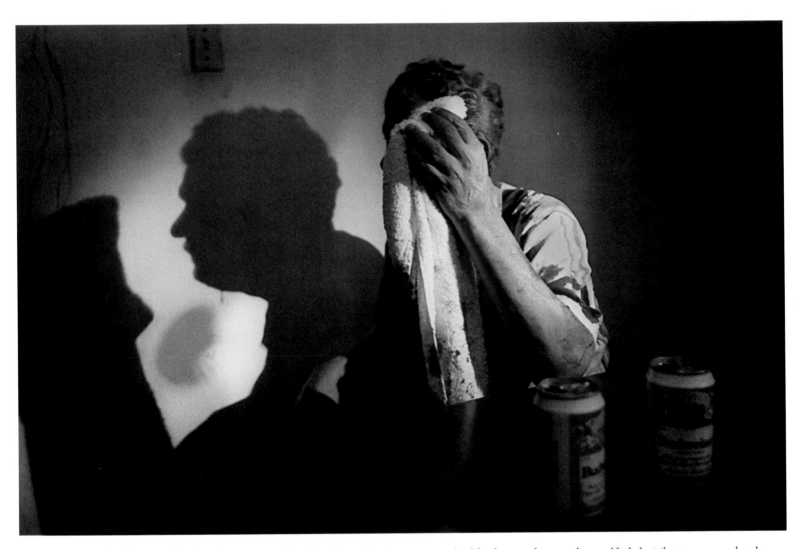

Bobby Lasano holds a towel to his face to stop the bleeding after he was attacked by his nephew with a golf club. The two were drinking when the incident occurred.

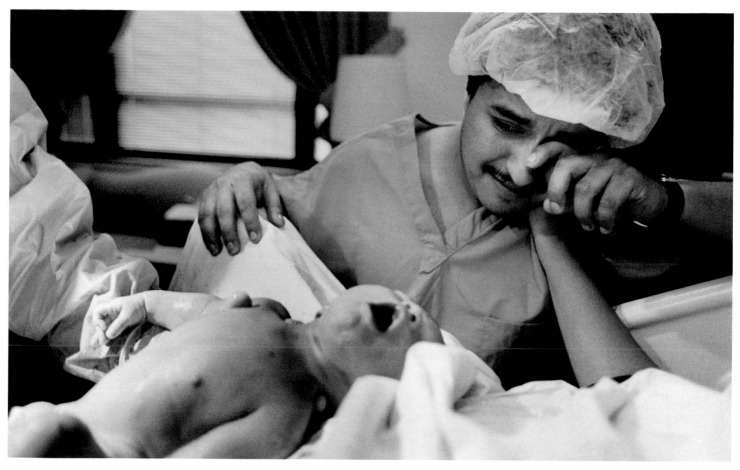

Juan Valdez was not present when his first child was born, so he was determined to witness the birth of his second child, Juan Jr.

OF FATHERS AND FAMILY

A child is born ... and a man becomes a father. For each new dad, a unique experience lies ahead, from the moment the child's heartbeat can be heard inside the mother's womb, through countless stories and games and scraped knees, until finally the child is no longer a child, but a young adult going out to take a place in the world.

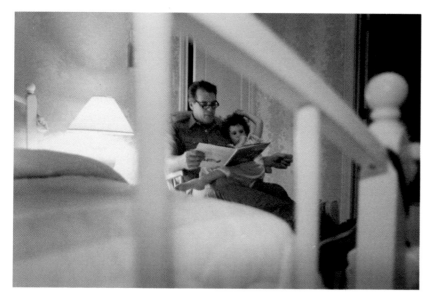

After divorce and remarriage, Dennis McGroarty, 51, is enjoying a second family. He is attempting to be the perfect father this time, reading to Mallory, 3, nightly.

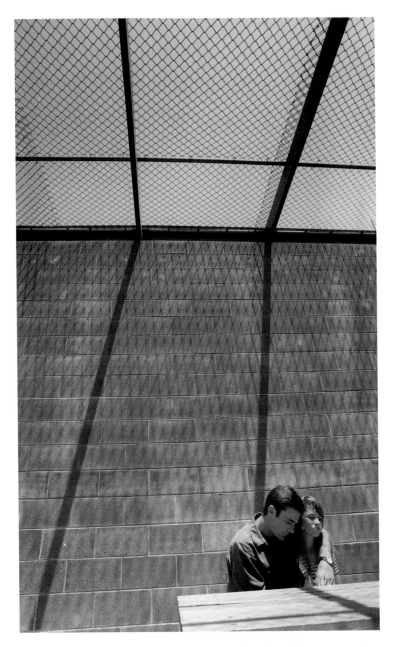

Stanley Swain's daughter, Crystal, was barely walking when he began serving time for robbery, kidnapping and assault. Twelve years later, with parole imminent, he is trying to forge a relationship with her.

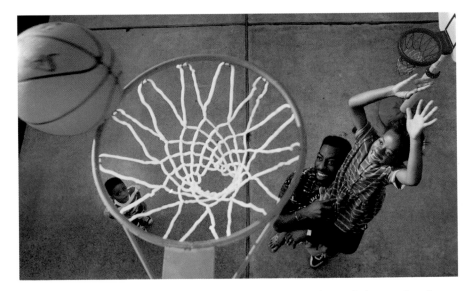

Joe Norman was never close to his father. Feeling that it left a void in his life, he spends plenty of time with his daughter, Jourdan, 6, and son, Alexander, 2.

Jose Marin's formal education stopped in Mexico with the fourth grade. Now his youngest daughter is graduating from high school and planning to attend Harvard University.

Chuck Candler has seen the paternal role reversed: At least once a week, he visits his 64-year-old father, Bob, who suffers from Alzheimer's disease.

An assemblage of detail photos from six of Dallas' arts
leaders for a story on "The new face of the arts."

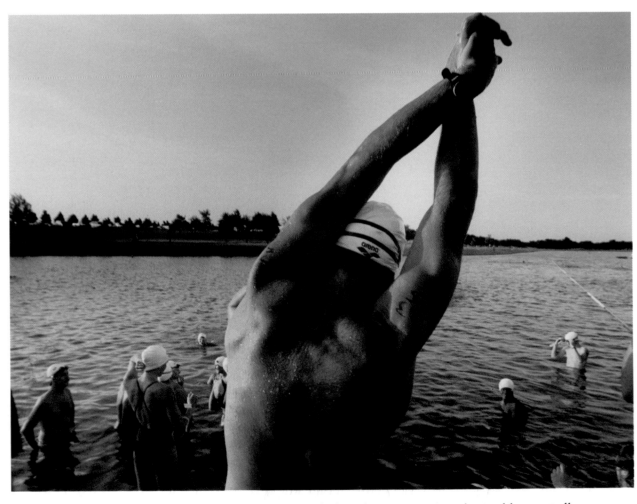

Swimmers warm up in the early morning sun before the Farmers Branch Triathlon in Dallas.

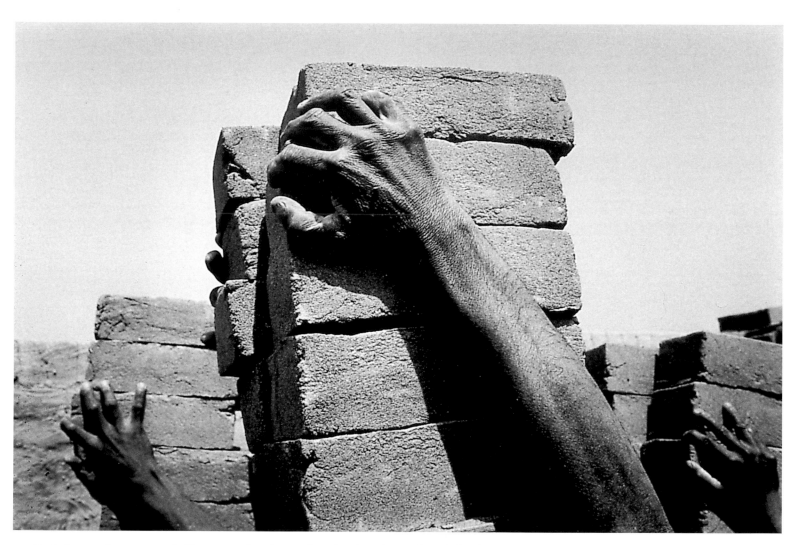

In Bihar, India, "untouchables" carry bricks on their heads. The work is difficult, and falls to the lowest class in the caste system.

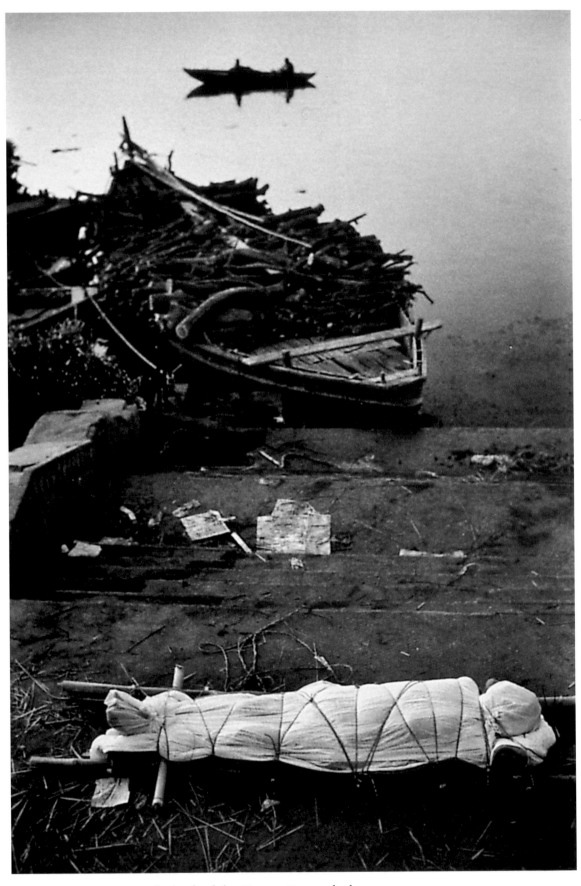

On the bank of the Ganges River, a body awaits cremation.

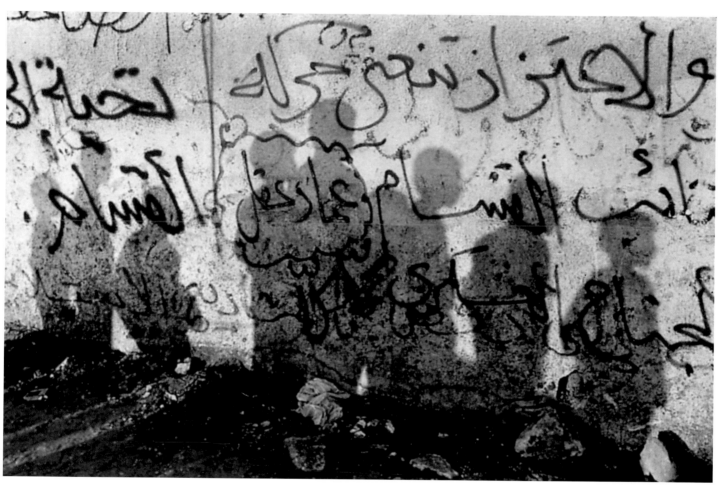

The shadows of Palestinian boys are cast against a graffiti-covered wall in Gaza.

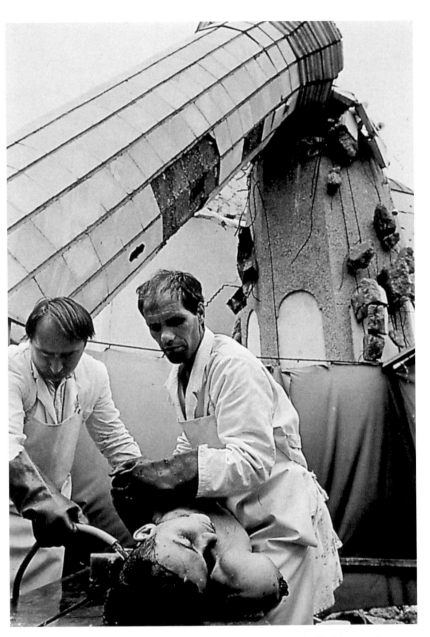

Near a mosque in Bosnia-Herzegovina that was shelled by Serbs, a makeshift morgue is used for cleaning bodies of dead soldiers.

Bosnian Moslem soldiers return from battle on a truck with a bullet hole in the windshield.

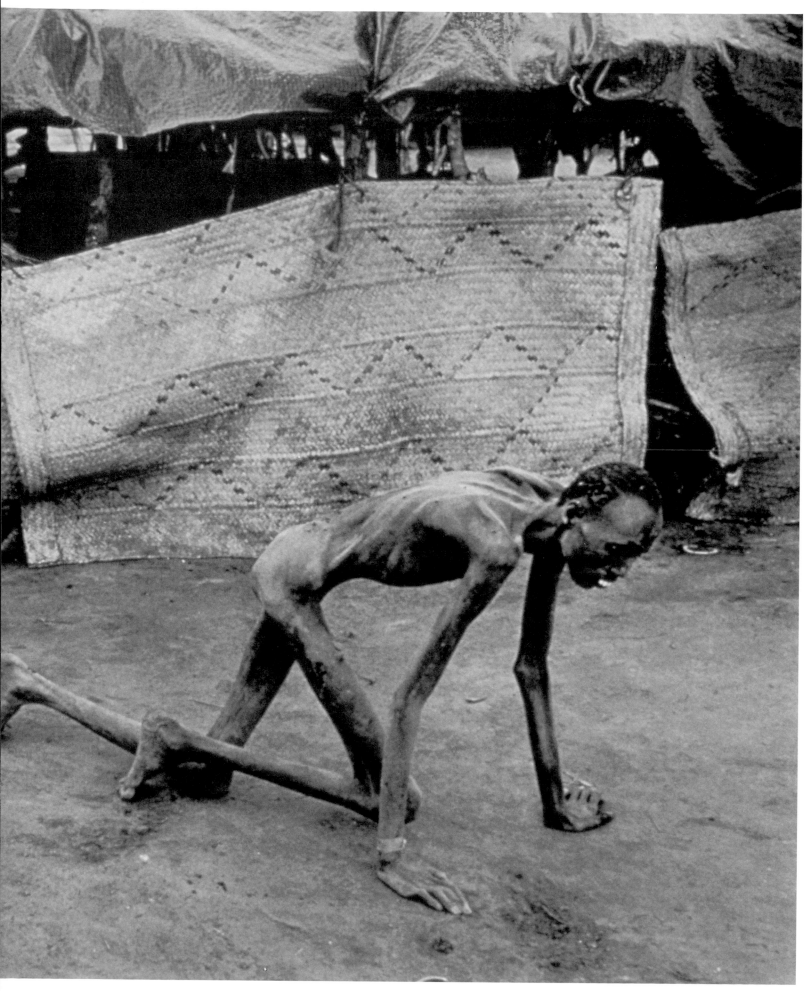

A starving man in southern Sudan, too weak to walk, crawls at the feeding center.

A Haitian voodoo priest exhorts a crowd at a rally against ousted President Jean-Bertrand Aristide.

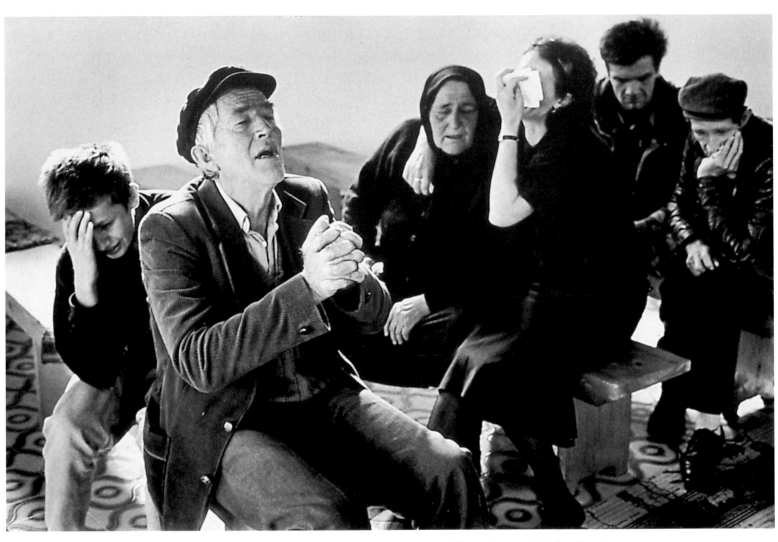

At a village church, a family mourns a Croatian soldier who was killed in battle.

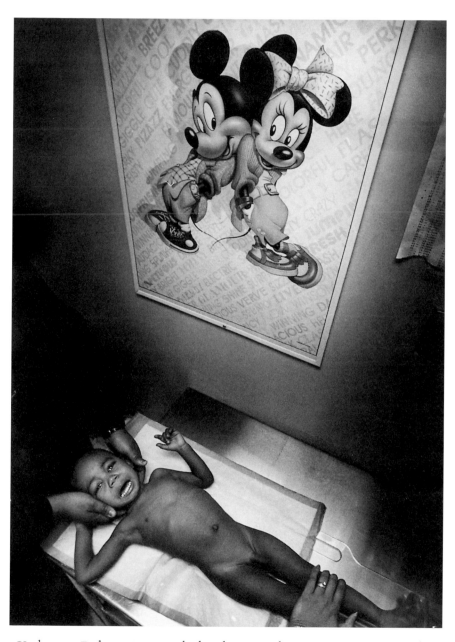

Kashmiere Perkins, 2, is weighed and measured at Boston City Hospital's Failure to Thrive Clinic. At 20 pounds, his weight is equivalent to that of a healthy 9-month-old.

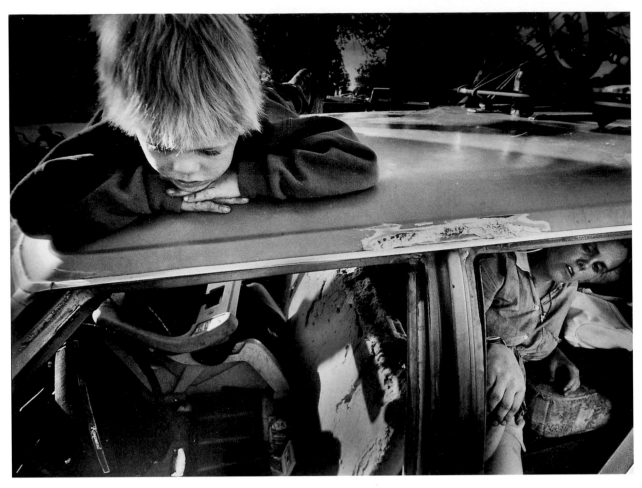

"Most of America is ninety days from where I am," says Brian Brunner, who lost his $66,000 job as a computer operator. He now lives with his wife, Debra; son, Thomas, 6; and five other children in a 1971 station wagon.

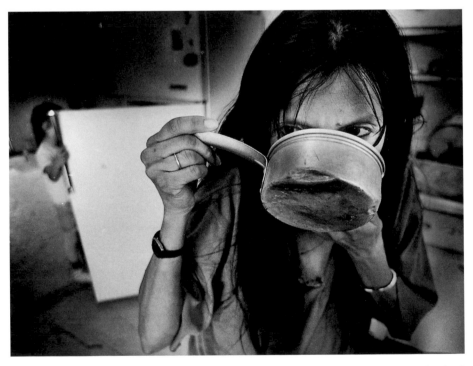

Ella Mae Sale, on the Torreon Reservation in New Mexico, drinks water fetched from over two miles away. Her family of seven does not get food stamps because the father, living in the Northwest, makes $450 a week.

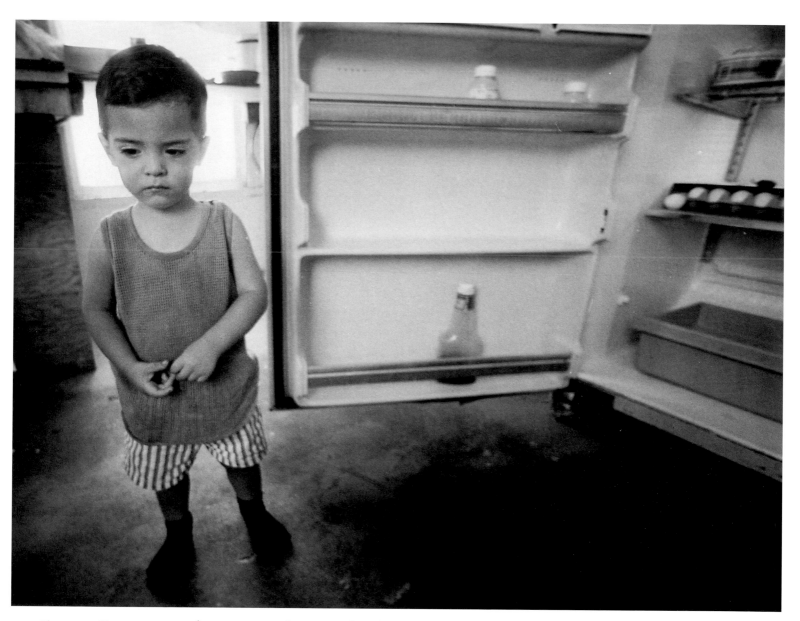

Francisco Bautista, 2, stands next to a nearly empty refrigerator. His mother says that pride keeps her from accepting welfare.

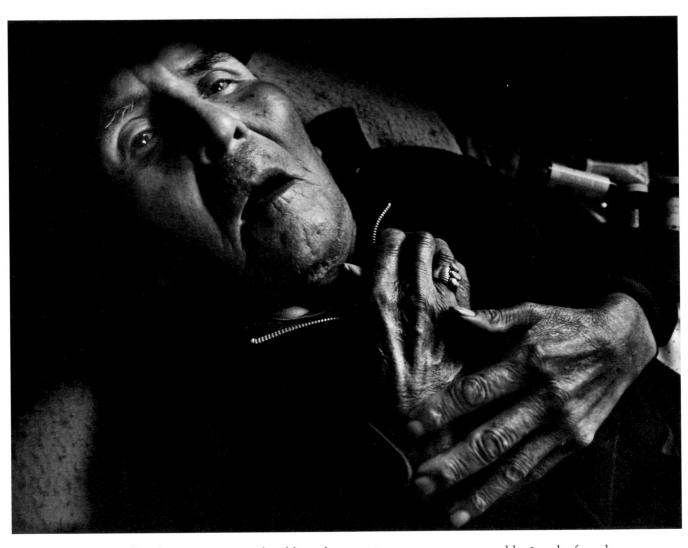

Phillip Lee, 72, suffers from a uranium-related lung disease. Navajo uranium miners like Lee die from lung cancer at five times the national rate.

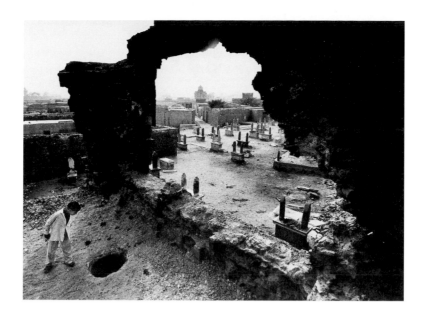

Cairo's City of the Dead: Tombs of the remembered dead are used as homes for the forgotten living. The area in foreground – not just the hole – is used as a toilet.

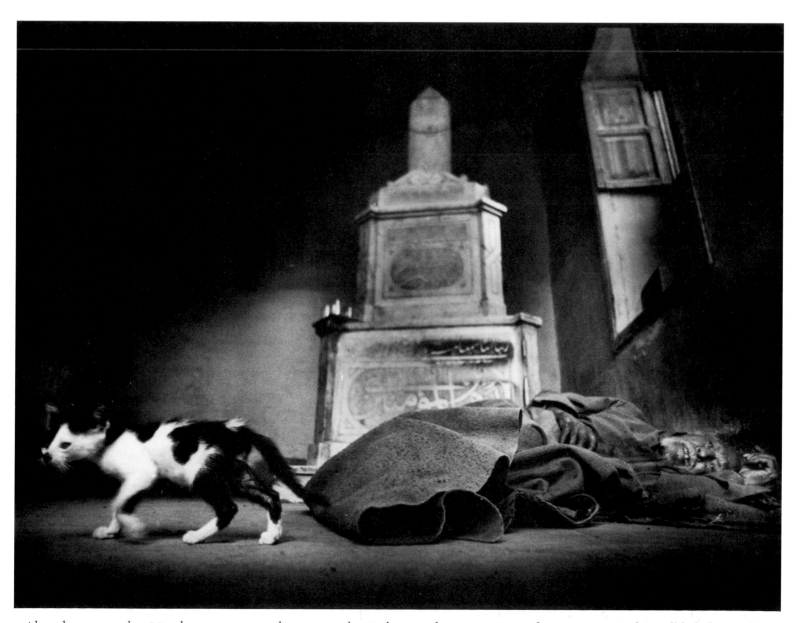

Ahmad, a man in his 80s who cannot move, lies in a tomb. He dreams of going to France for an operation that will help him walk, but living with the remains of Dr. Labib el Sa-Id may be the closest he ever gets to a doctor.

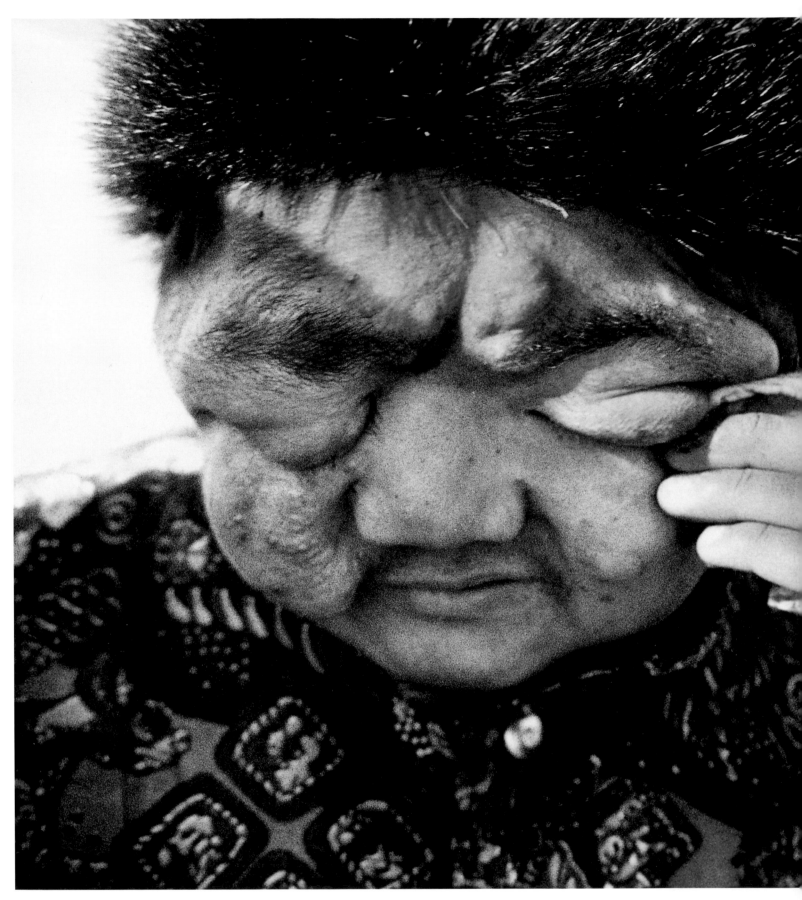

Berik Syzdykov, 14, lives downwind of the Semipalatinsk test site in Kazakhstan. He has large flaps where his eyes should be, is blind, and has the mental capacity of a 6-year-old. The region's people suffer from high cancer rates and weakened immune systems.

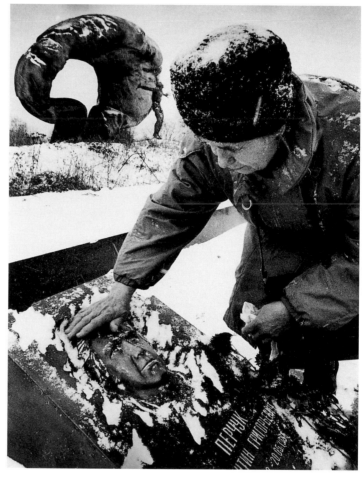

Nadezhda Perchuk wipes snow off a memorial to her son and other victims of the Chernobyl nuclear accident. The bodies are buried in lead-lined coffins near Moscow.

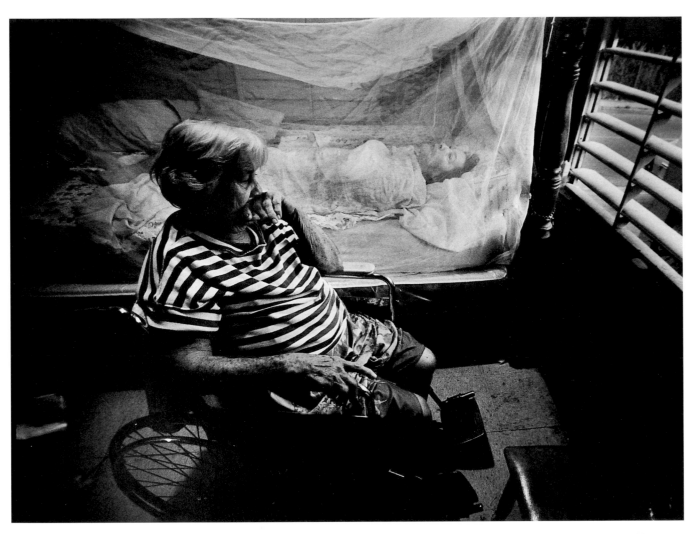

Francesca Casillas, 74, almost blind and barely able to lift her arms, sits at the bedside of her 52-year-old daughter. In a two-block area of their neighborhood in Catano, Puerto Rico, six people have birth deformities. Industrial pollution is the suspected cause.

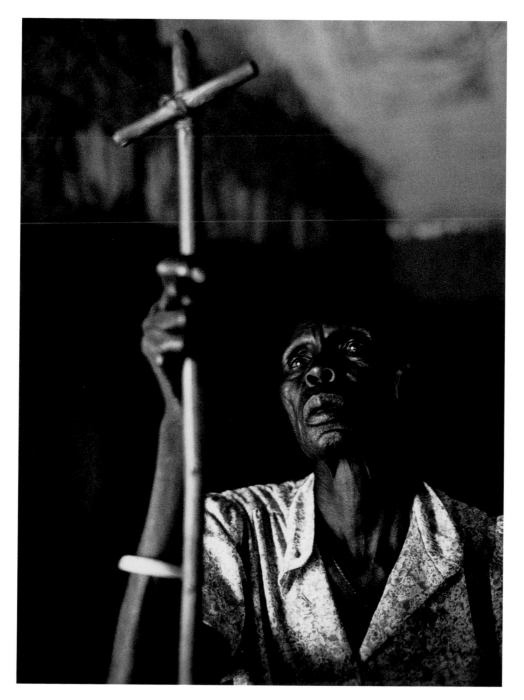

1ST PLACE
John R. Stanmeyer, Tampa (Fla.) Tribune

An elderly Dinka woman clutches her cane while telling of her journey to the Atepi relief camp in southern Sudan. She is one of more than 1.7 million Sudanese who have fled their homes during the country's 10-year civil war.

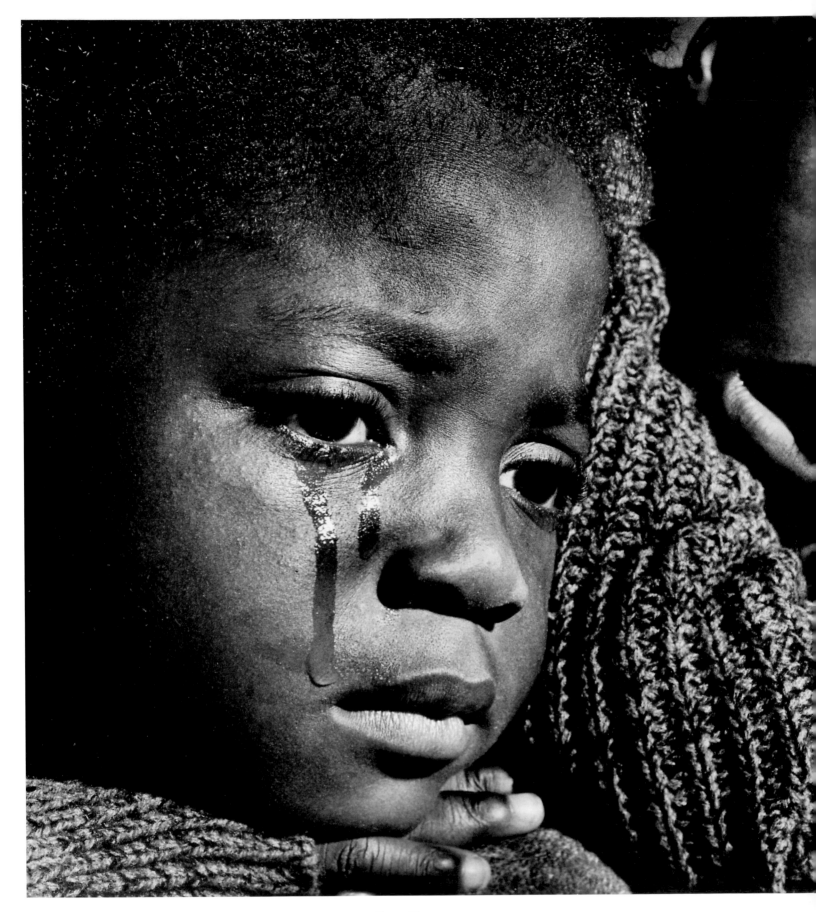

3RD PLACE
Candace B. Barbot, Miami Herald

Five-year-old twins Jasmine and Jose Simmons were abandoned by their father, a crack addict who lives on the streets of Miami. They now live with their grandmother.

AWARD OF EXCELLENCE
**Christopher A. Record,
The Charlotte Observer**
A beggar huddles against a wall in
Alajuela, Costa Rica.

2ND PLACE
Joey McLeister, Minneapolis Star Tribune
Maria Rivera, mayor of Crystal City, Texas, takes a break from her
1500-mile drive to join her family for summer work in
the sugar-beet fields of northern Minnesota.

AWARD OF EXCELLENCE
Fred Zwicky, The Peoria (Ill.) Journal Star
"Did you know that a fly can breed a million young?" asks John Mueller, 91, whose company
is the nation's largest manufacturer of fly swatters.

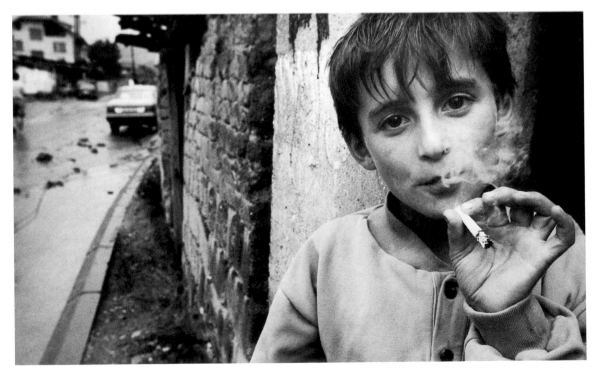

AWARD OF EXCELLENCE
Michele McDonald, The Boston Globe
An Albanian child smokes a cigarette in Kosovo, a province of the
former Yugoslavia now under Serbian military control. Unemployment for Albanians in Kosovo has
reached 85 percent, and the schools have been closed by the Serbs.

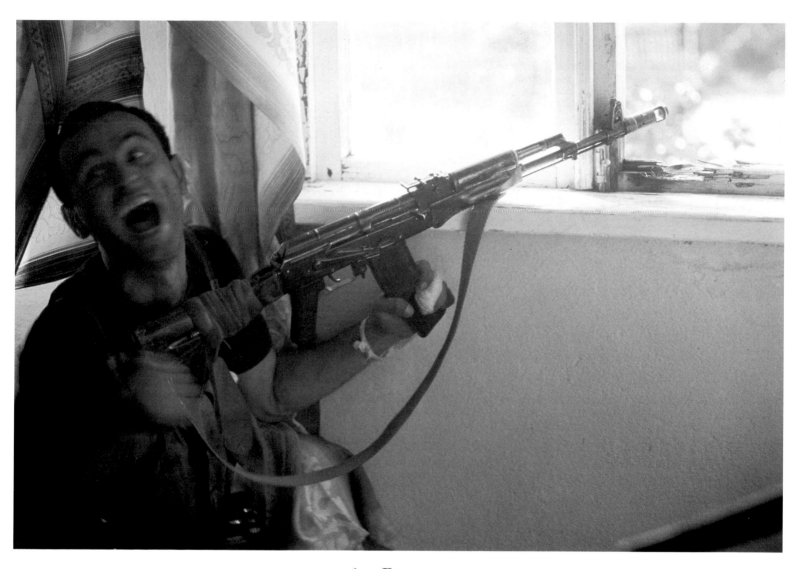

1ST PLACE
Malcolm Linton, Black Star
A Georgian loyalist exults after shooting a rebel sniper in the Abkhazia region. Bloody fighting has
erupted since the Abkhazians declared independence from Georgia in 1992.

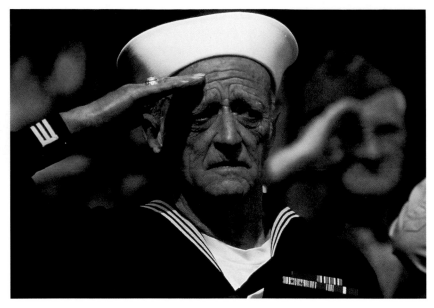

Award of Excellence
**Christopher Fitzgerald, freelance
for American Legion Magazine**

World War II navy veteran Russell Richardson of North Grafton,
Mass., salutes during a Memorial Day observance.

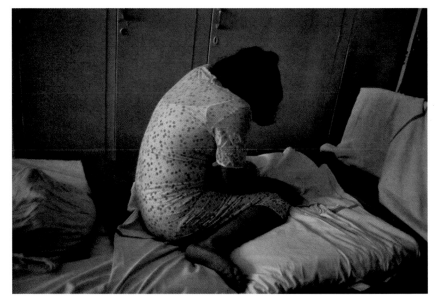

Award of Excellence
Nina Berman, SIPA Press

An 18-year-old Muslim woman hides her head in shame at a
hospital in Tuzla, Bosnia-Herzegovina, after having an abortion. She
became pregnant after being raped repeatedly by Bosnian Serbs.

*The 2nd place winner in this category is shown on page 207
as part of the 1st place Magazine Picture Story.*

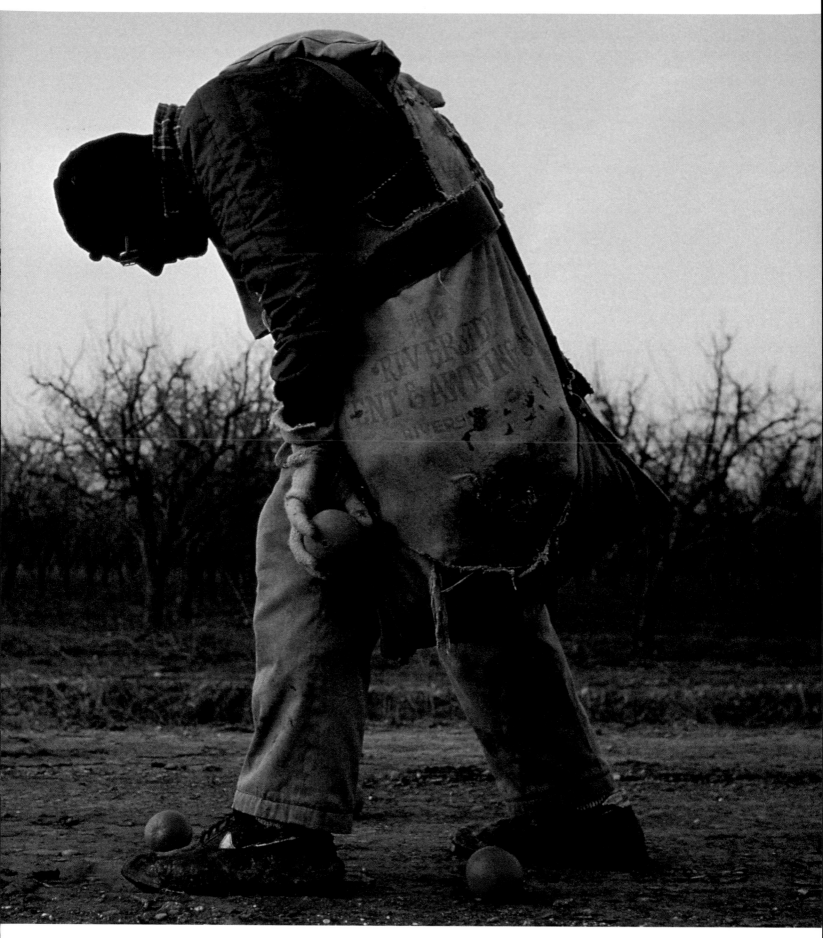

3RD PLACE
Joel Sartore, National Geographic Magazine

Hartley Bowmar, 77, carries a sack of oranges to a collection bin in an orange grove near Orland, Calif. An orange picker for decades, Bowmar says he plans to continue "as long as I can still scurry up a ladder."

AWARD OF EXCELLENCE
Chris Rainier, JB Pictures Ltd.

A young boy performs initiation rites in Irian Jaya, New Guinea.

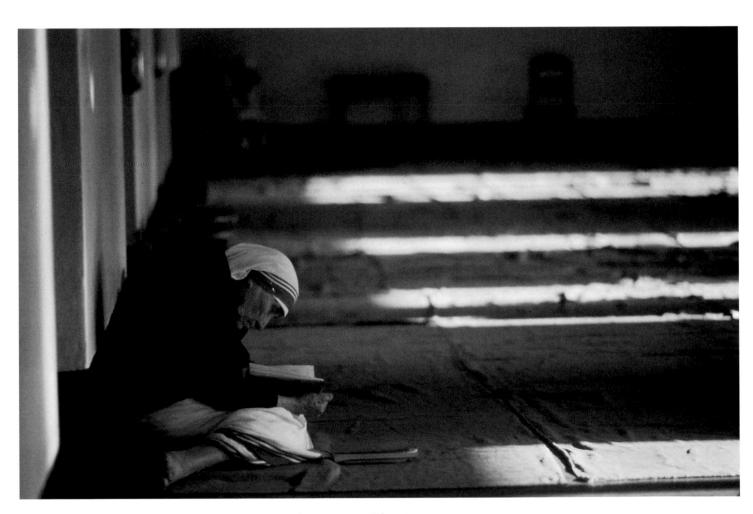

AWARD OF EXCELLENCE
Al Schaben, JD&A Agency

In a rare moment of solitude, Mother Teresa, 83, reads the Bible in the early-morning light
of her Calcutta, India, home chapel.

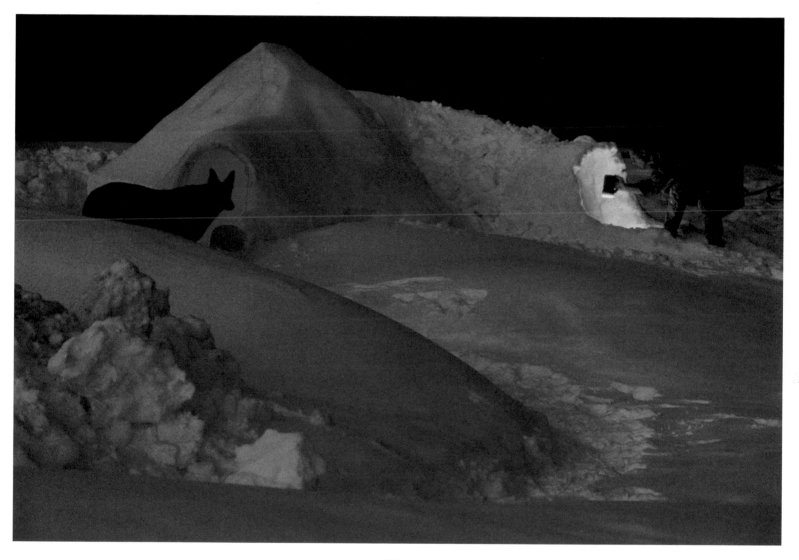

1st Place
Carl D. Walsh, Biddeford (Maine) Journal Tribune
Frank Russo enters one end of an igloo he built in his yard in Kennebunk, Maine, as his dog peers into the other end.

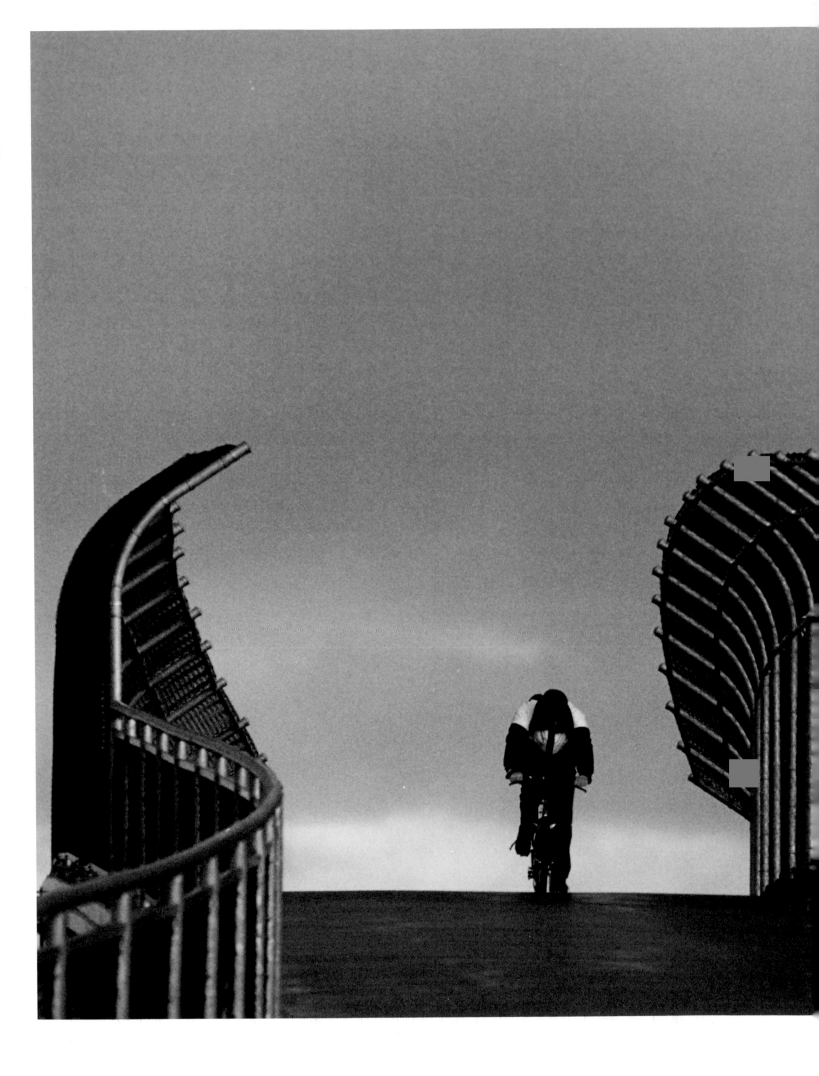

AWARD OF EXCELLENCE
Christopher Anderson, Spokane Spokesman-Review
A cyclist is treated to a rainbow as he rides to work in Spokane.

AWARD OF EXCELLENCE
Christopher T. Assaf, Newport Beach-Costa Mesa Daily Pilot
Late at night, workers change the movie marquee at Edwards Harbor Twin Cinemas in Costa Mesa, Calif.

AWARD OF EXCELLENCE
Sherman Zent, The Palm Beach Post
Ellen Rosenberg of Royal Palm Beach, Fla., is known as "the bird lady."
She cares for injured birds until they can be released to the wild.

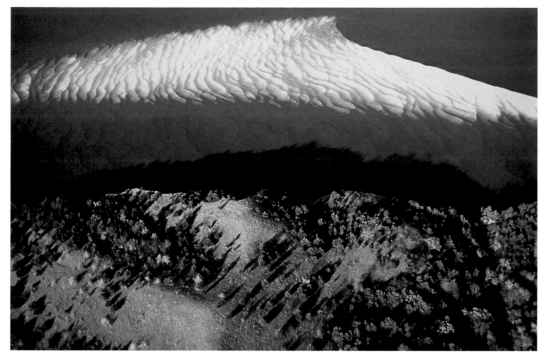

AWARD OF EXCELLENCE
Larry Mayer, The Billings (Mont.) Gazette
A sandbar on the Missouri River appears as a majestic mountain in this aerial view.

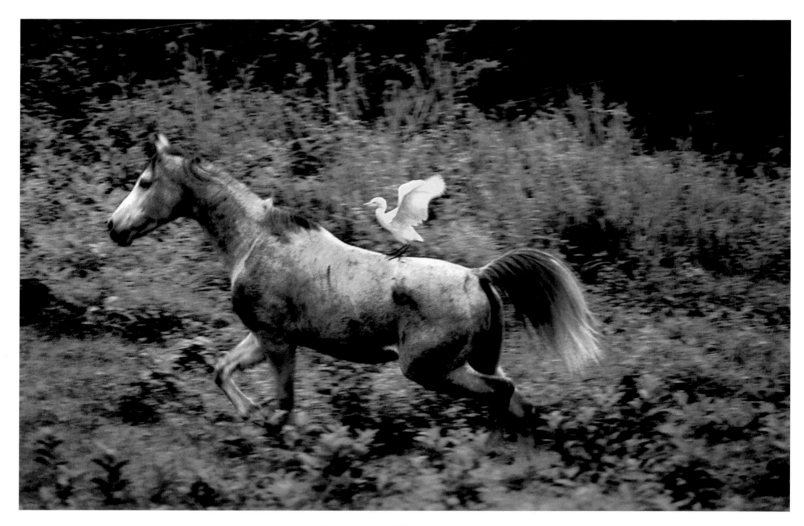

AWARD OF EXCELLENCE
Richard D. Schmidt, The Sacramento Bee
Flapping its wings for balance, a cattle egret rides bareback across a meadow on the island of Kauai, Hawaii.

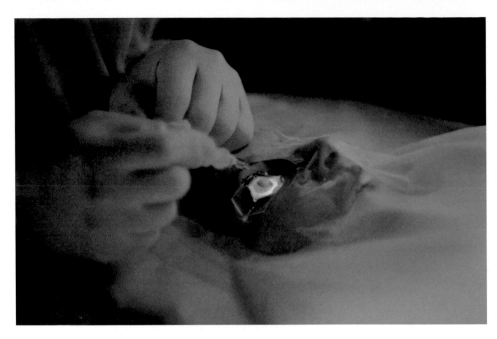

2ND PLACE
Matthew Craig, Augusta (Ga.) Chronicle
A surgeon applies fluorescent drops to a patient's eye to check incisions
made during radial keratotomy.

3RD PLACE
Larry Mayer, The Billings (Mont.) Gazette
A lone tree is surrounded by irrigation ditches in a farm field near Crawford, Neb.

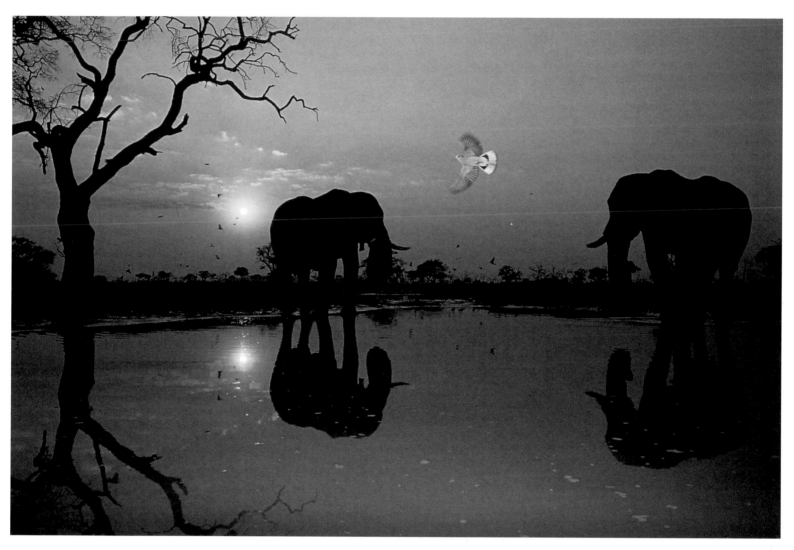

1ST PLACE
Frans Lanting, Life
The African night gives way to another dawn.

ᴀᴡᴀʀᴅ ᴏꜰ ᴇxᴄᴇʟʟᴇɴᴄᴇ
Norma Jean Gargasz, freelance
A lone motorcyclist rides through the twilight on Mount Tamalpais in Marin County, Calif.

76 Magazine Pictorial

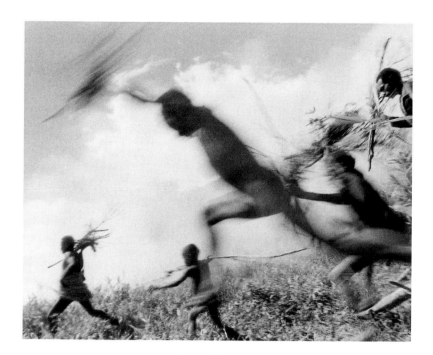

The following page:

3RD PLACE
**Steve McCurry,
National Geographic Magazine**
Amid the rubble of 14 years of civil war,
Afghan refugees return to rebuild Herat.

2ND PLACE
Chris Rainier, JB Pictures Ltd.
Men gather firewood during Pig Festival in Irian Jaya.

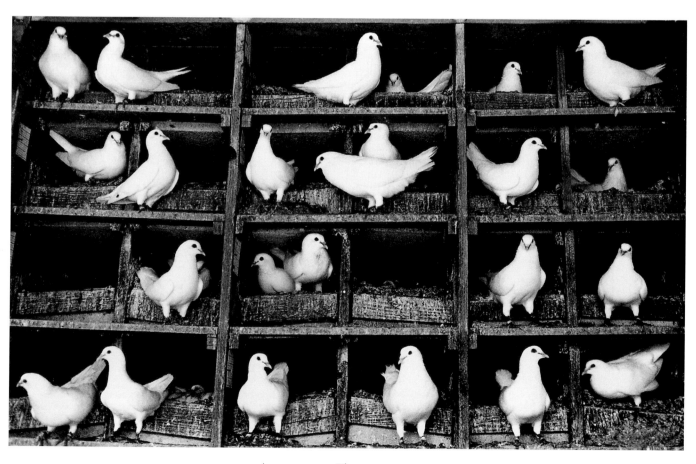

AWARD OF EXCELLENCE
Aaron Kamelhaar, freelance
White king pigeons roost at a breeding farm.

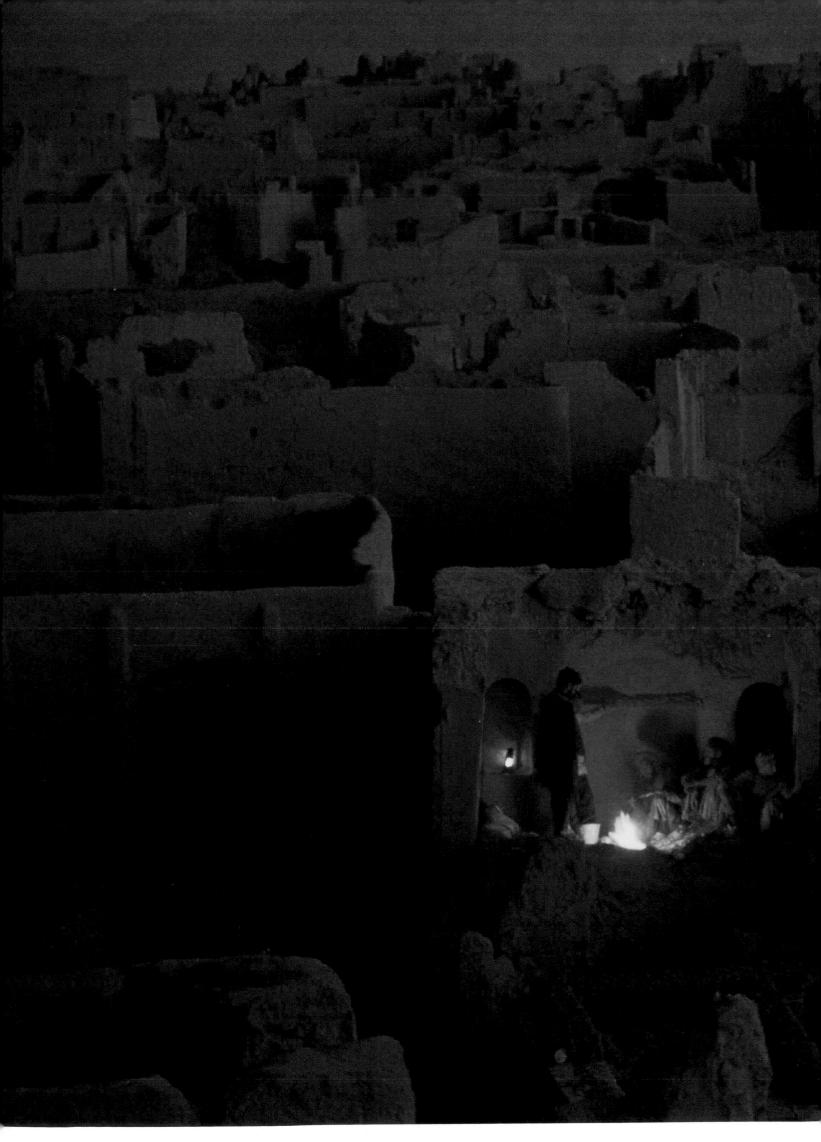

Award of Excellence
Jose Azel, Aurora & Quanta Productions
A carriage ride in New York City's Central Park takes on a surreal
quality after a snowstorm.

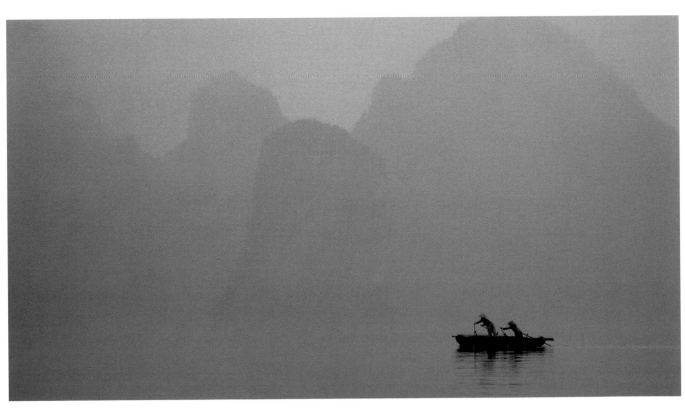

Award of Excellence
Lars Gelfan, freelance
A Vietnamese couple row a fishing boat in Halong Bay on the Gulf of Tonkin.

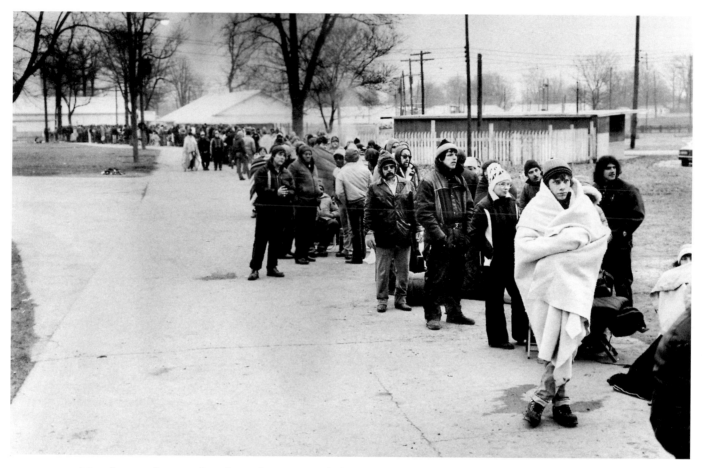

Two thousand unemployed people wait in sub-freezing weather to apply for one of 200 jobs at a washing-machine plant in Clyde, Ohio. 1983

HOMELESS IN AMERICA

Michael Williamson spent over 15 years documenting homelessness in America, its causes and the growing problem of intolerance toward the homeless. "I feel that we are our brothers' keeper," he says, "and that the problems of the homeless are our problems, too." Believing the war on homelessness, poverty and hunger has already been lost, Williamson nonetheless has tried, through photojournalism, to effect a change in America's awareness of the plight of the homeless and our attitude toward them. "I wish," he says, "that society would take the same pride that they do in winning conventional wars to win the war on homelessness in America."

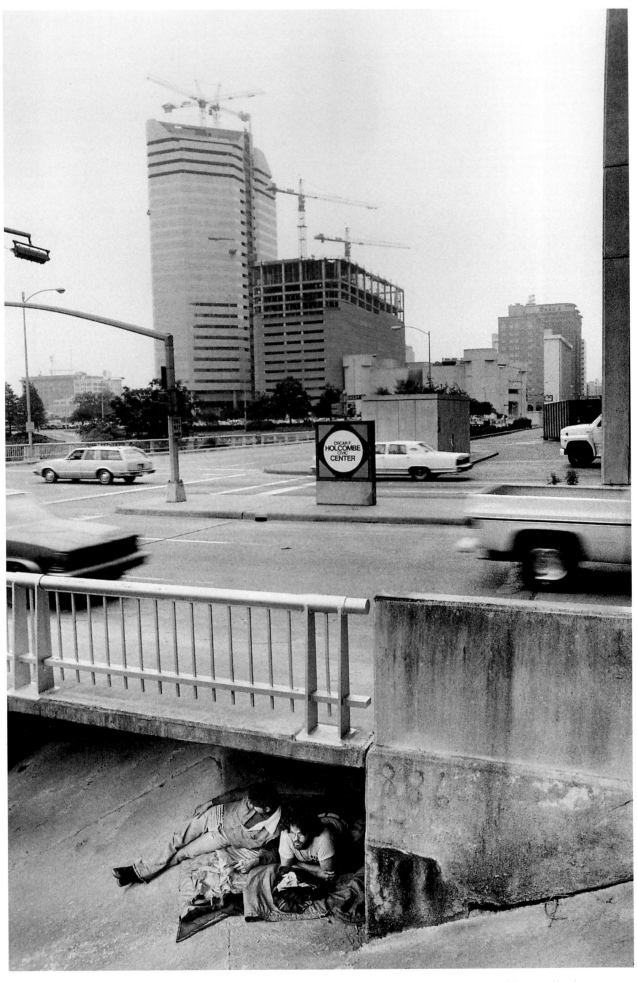

Workers from the north traveled to Houston for minimum-wage jobs, but many could not afford rent.
"New Jim" from Akron, Ohio, lives under a bridge with "Old Jim." 1983

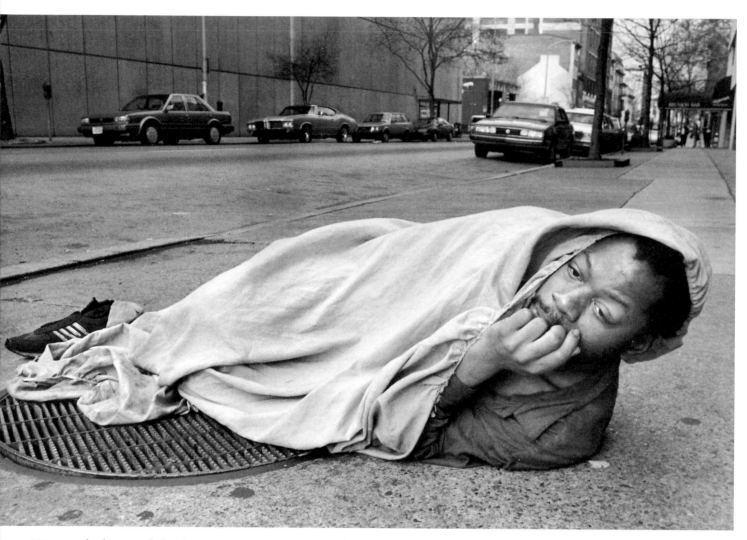

Winston finds warmth by sleeping on a steam grate in downtown Philadelphia. Homeless people are so common in the city that many passersby take no notice of them. 1992

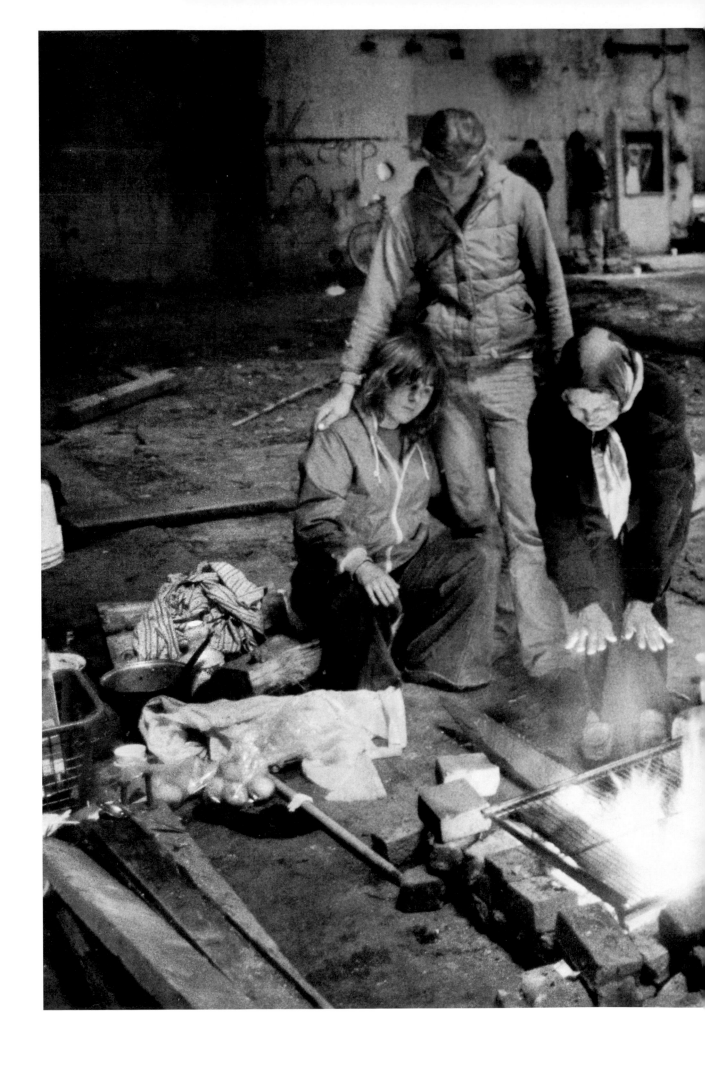

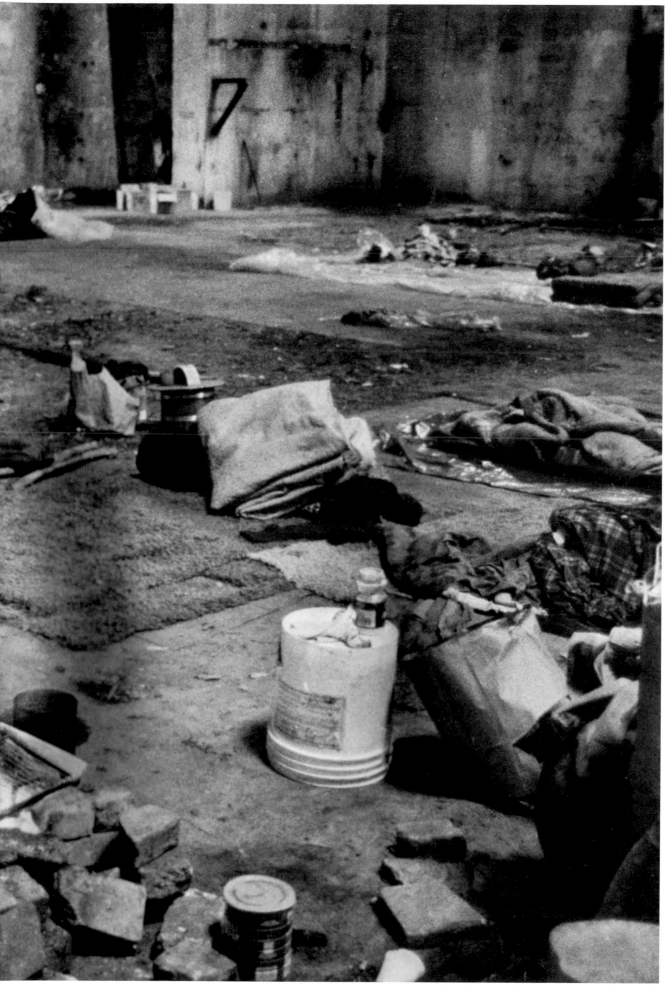

Squatters lived in this old power plant in Sacramento, Calif., for some time before police discovered and evicted them. 1982

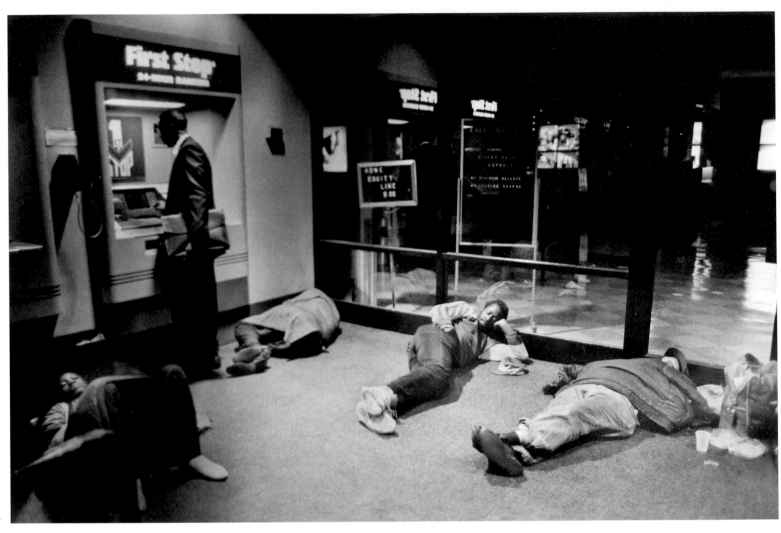

Homeless people find shelter in the 24-hour-teller lobby of a New York City bank. A customer stepping over them at 1 a.m. announces, "It's a New York party." 1990

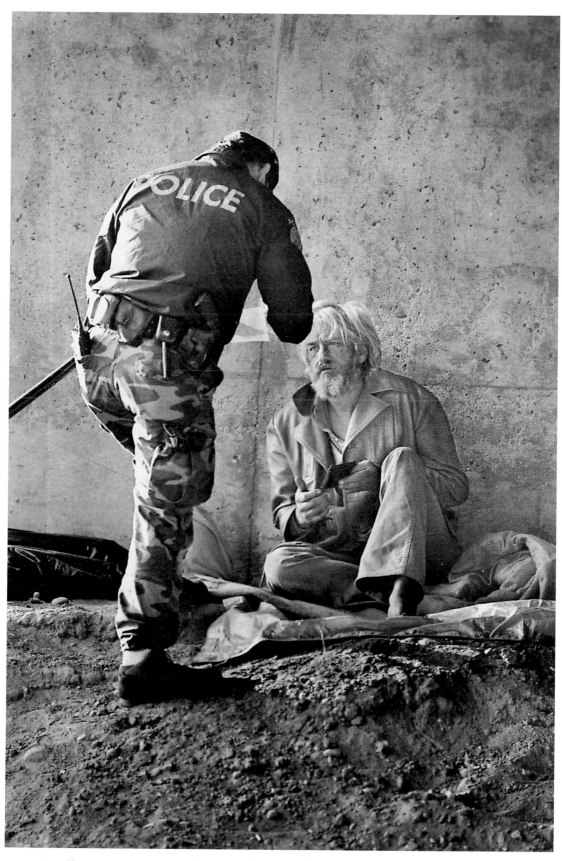

An officer writes a citation for a man living under an overpass along Interstate 5 near Sacramento, Calif. He is told to leave the area or face jail. 1989

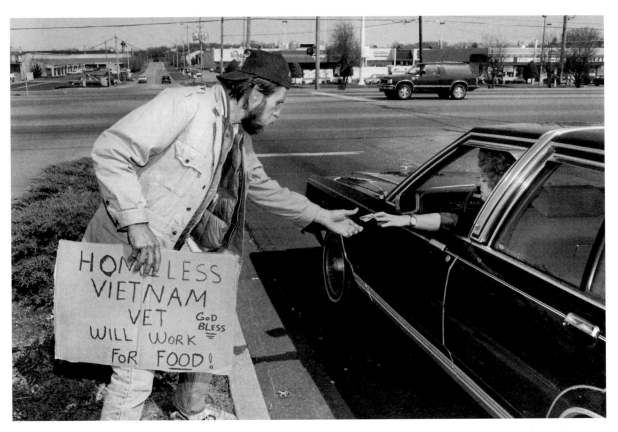

When funds get low, Robert, a disabled Vietnam War veteran, panhandles at a shopping mall
in Bowling Green, Ky. 1992

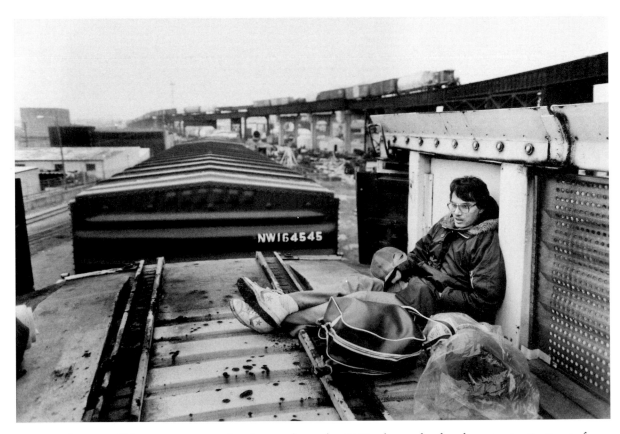

Don, whose small business went under during the early 1980s, hopped a freight train in St. Louis for
Denver, where he'd heard there were jobs. 1983

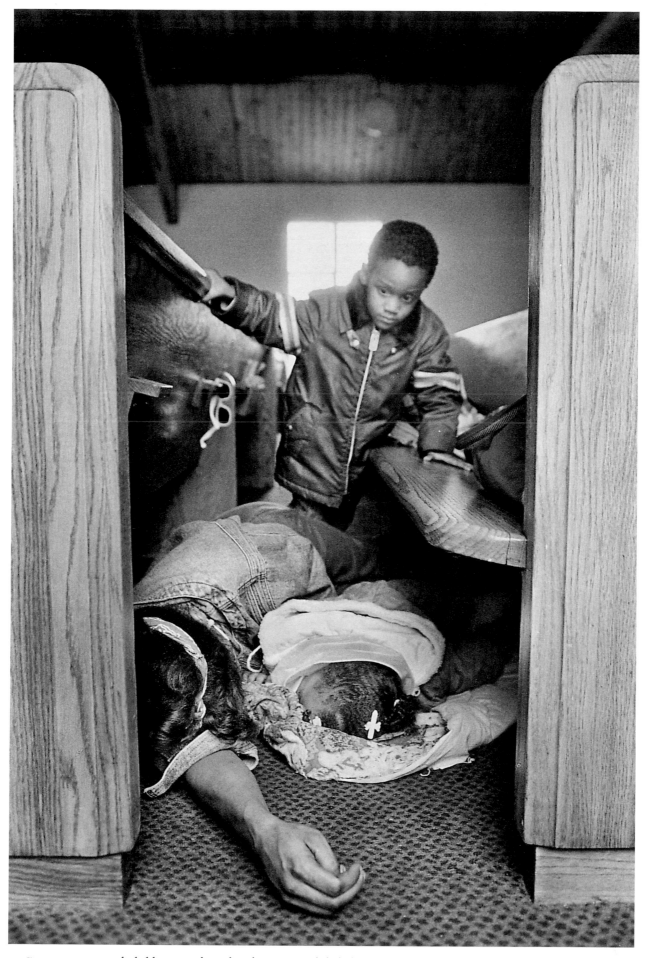

Some women and children are forced to live in squalid shelters, such as the Bible Tabernacle Church in Venice, Calif. It has been closed several times by county health inspectors. 1986

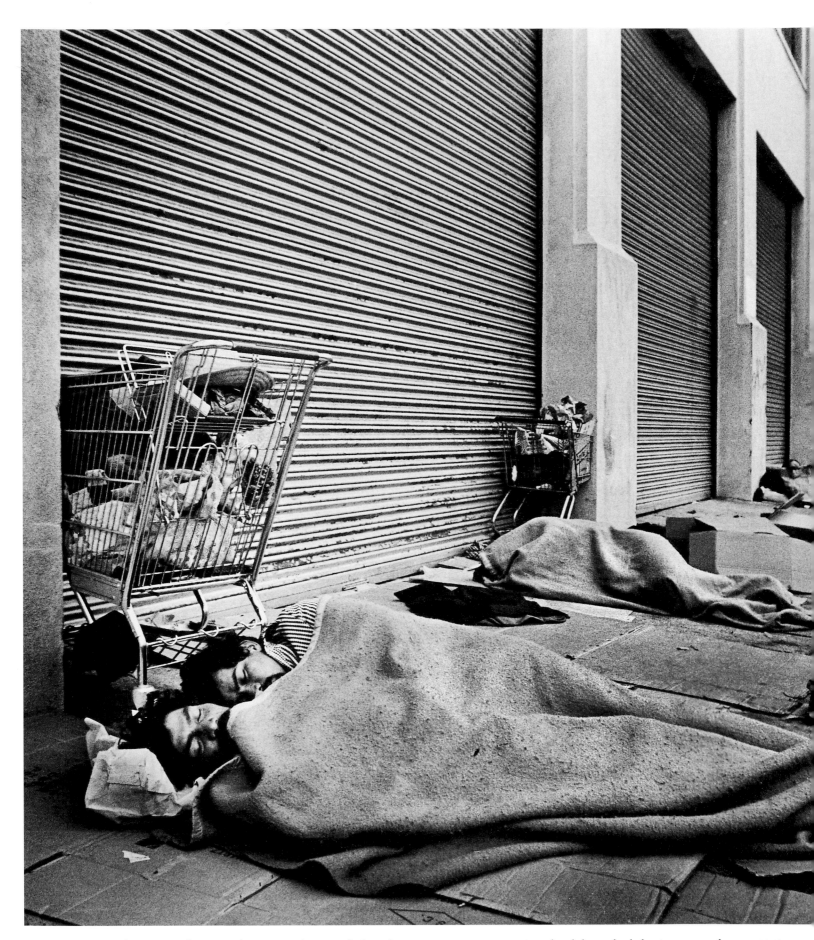

Mexican nationals come to the United States seeking work, but these immigrants in Los Angeles did not find the American dream. 1987

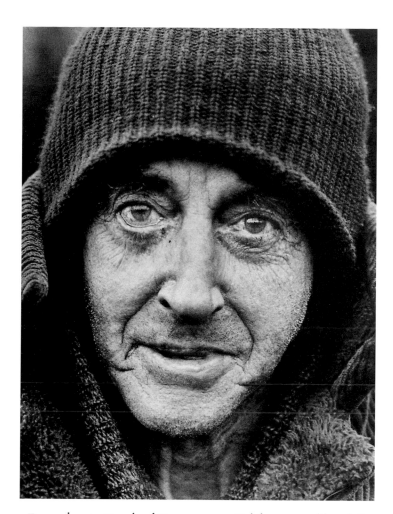

Pennsylvania Dutch of Sacramento, Calif., is too old and ill to get hired, but too young for Social Security. 1984

After police officers in West Sacramento, Calif., forced dozens of homeless people to vacate the banks of the Sacramento River, only remnants were left as evidence of their presence. 1989

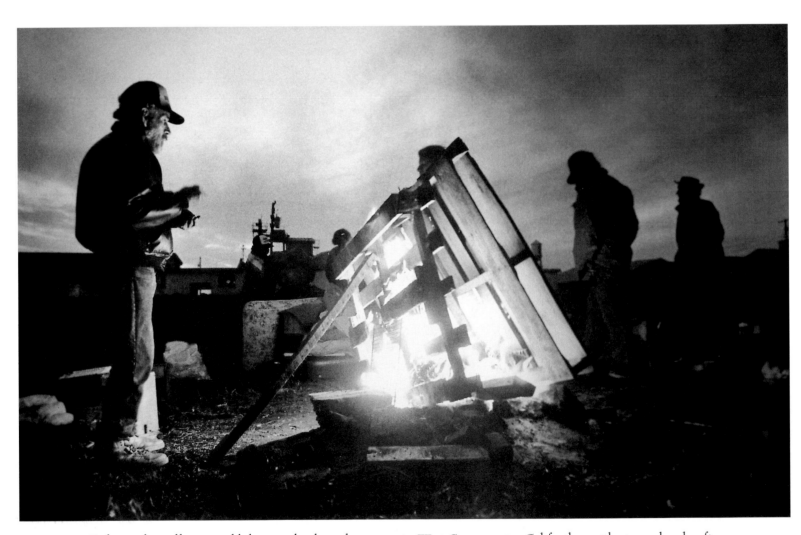

Before police officers could destroy this homeless camp in West Sacramento, Calif., the residents made a bonfire and burned all non-essentials. 1989

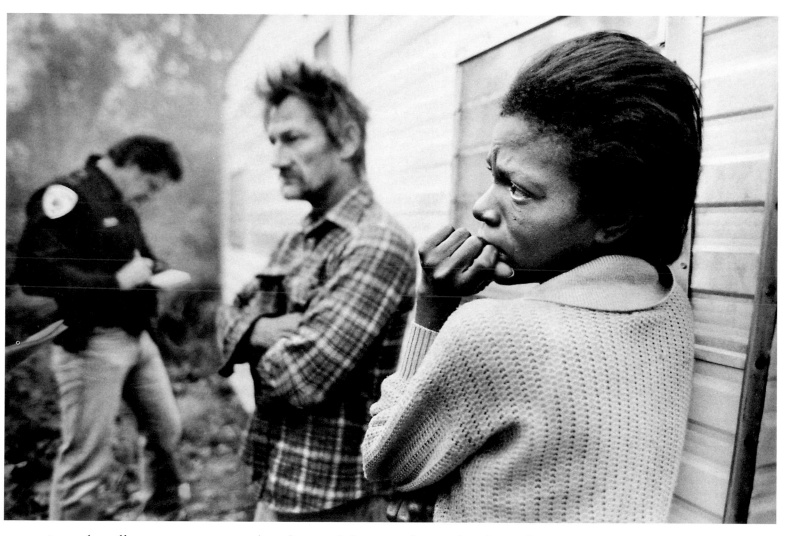

As a police officer writes a citation, a homeless couple living in a borrowed trailer on the river in West Sacramento, Calif.,
are told to leave or face arrest. 1989

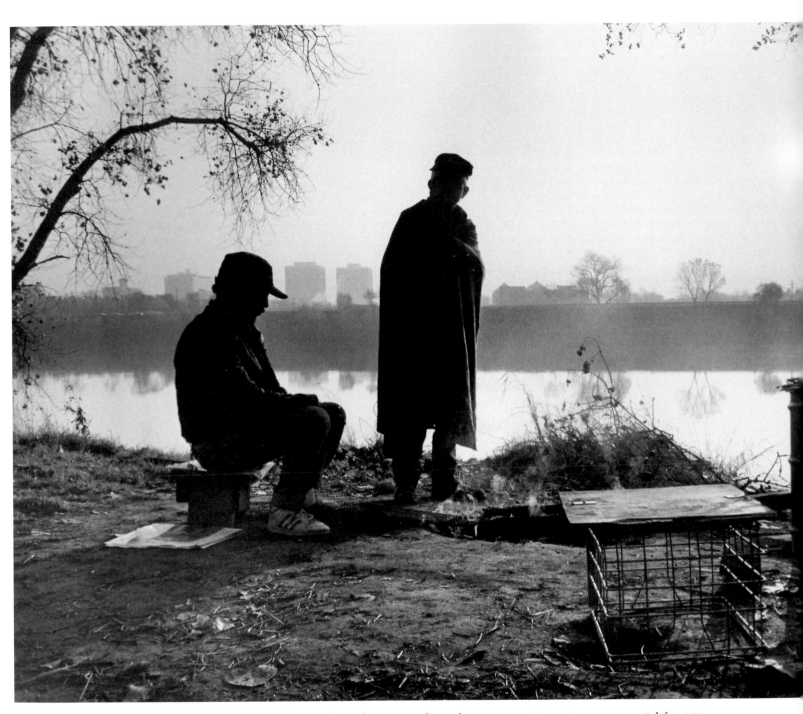

Mario and Richard huddle near a fire in a homeless camp along the river near West Sacramento, Calif. 1989

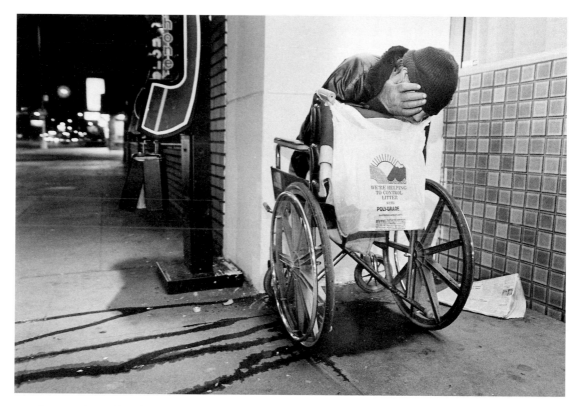

Each year, the railroads report that more than 600 rail riders are killed, and many are injured in accidents. Jack Barrett, who lost his legs while trying to jump aboard a train, lives on the streets of Sacramento, Calif. 1990

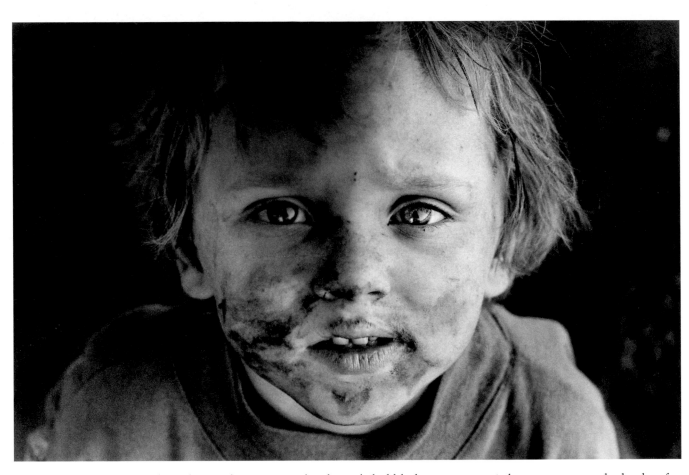

The faces of America's homeless no longer are only of grizzled old hoboes. Jeremy, 6, lives in a car on the banks of the Sacramento River near Sacramento, Calif. 1990

A guerrilla village in Perquin, El Salvador.

EL SALVADOR: BEFORE THE TRUCE

On Feb. 1, 1992, El Salvador's civil war ended with a formal cease-fire between the government and leftist guerrillas, known as the Farabundo Marti National Liberation Front. After 12 years of strife, about 75,000 people were dead, victims of a political conflict rooted partially in the country's great disparities of wealth among its people. For several years leading up to the cease-fire, photographer Larry Towell documented the lives of those trying to survive amidst chaos.

Commemorating Day of the Dead at General Cemetery in San Salvador.

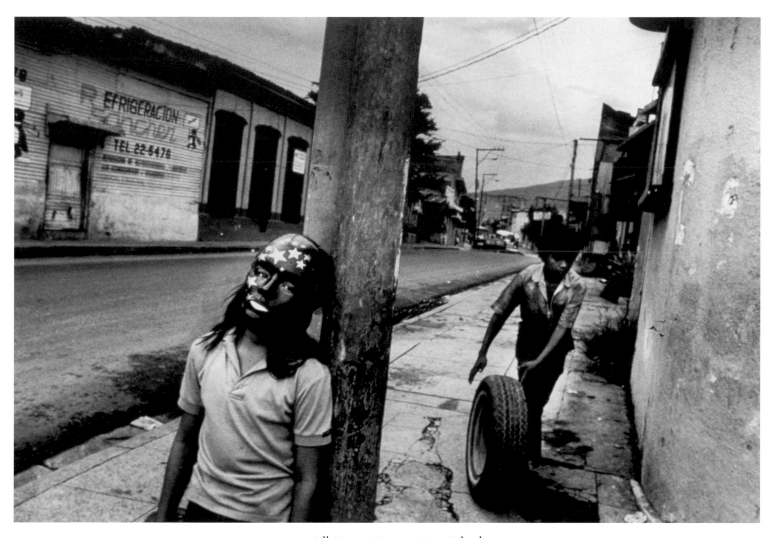

All Saints' Day in San Salvador.

A child in a hut in Guazapa.

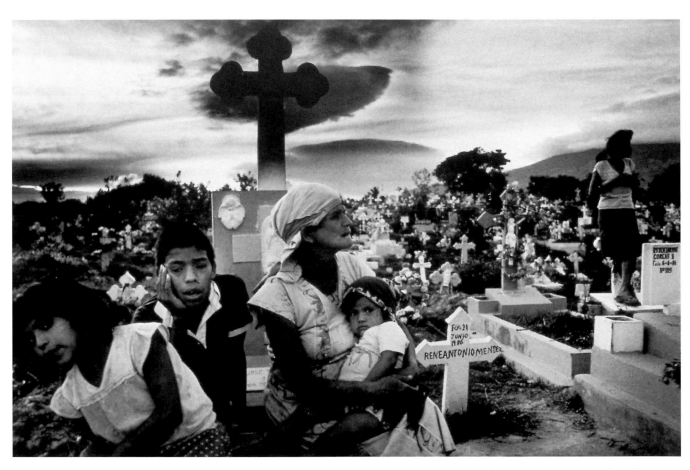

A homeless family lives in La Bermeja Cemetery in San Salvador. One of the demands of the rebels during peace talks was that social programs be established to ease the country's staggering poverty.

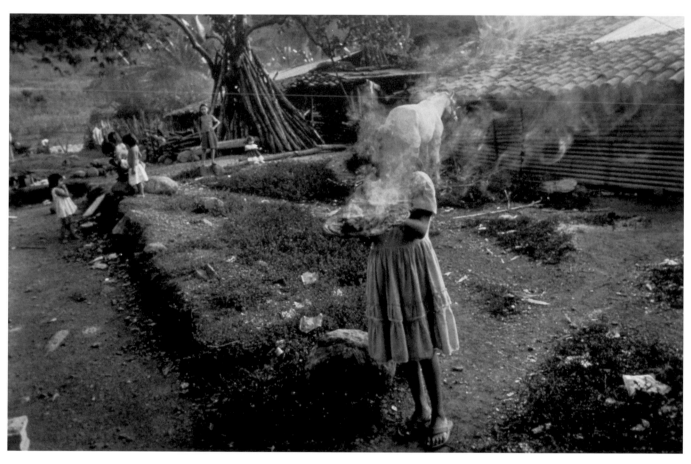

Daily life in a mountain village in Chalatenango Province.

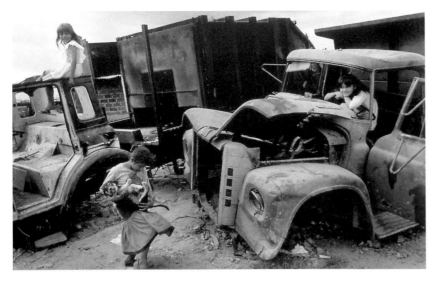

A child plays with a puppy in a San Salvador city dump.

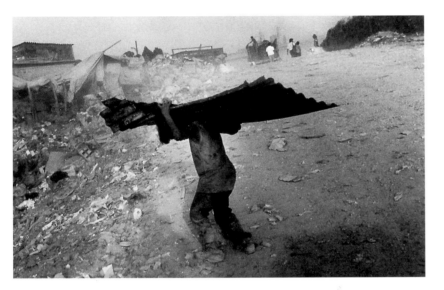

A child laborer in San Salvador's dump.

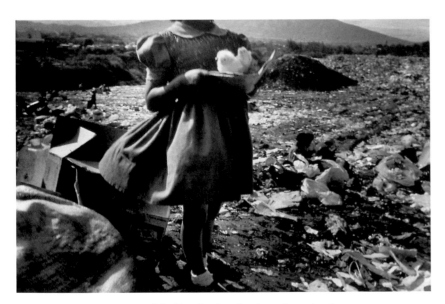

A girl holds chicks she found at the dump.

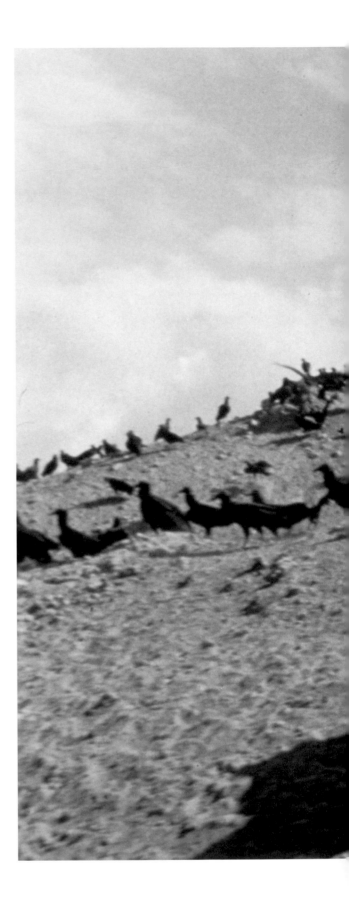

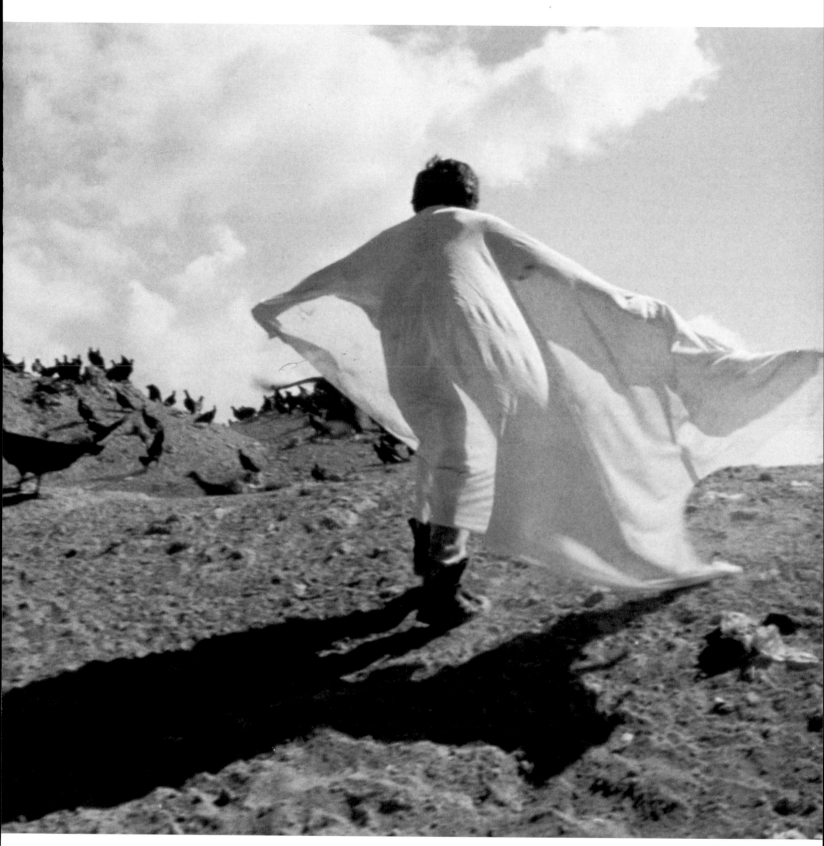

A child plays near vultures at the dump in San Salvador. In the late 1980s, a community of about 600 shanties existed on the edge of the dump. Families with no better resources scavenged the area and sold whatever usable items they found. The owner eventually had the shanties destroyed and dispersed the people.

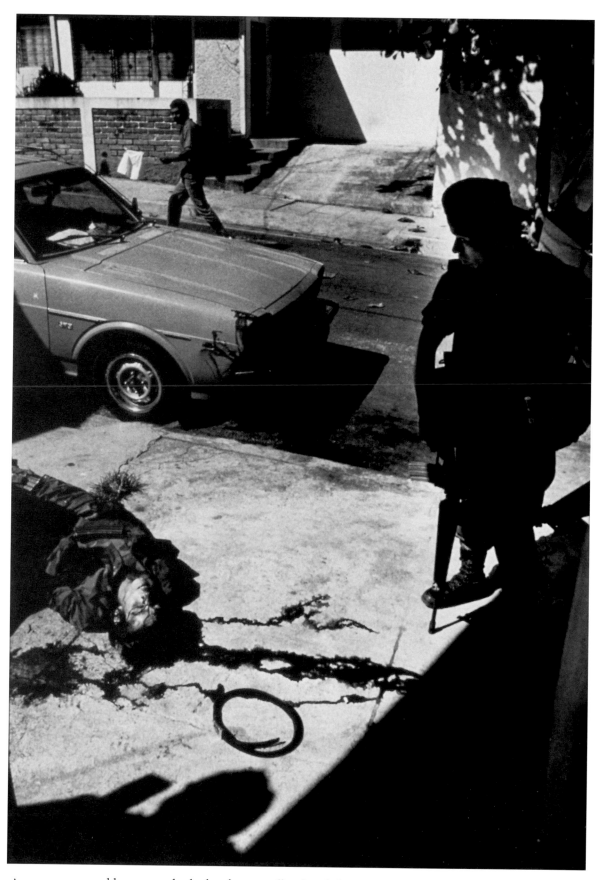

A government soldier views the body of a guerrilla after fighting in San Salvador in November 1989.

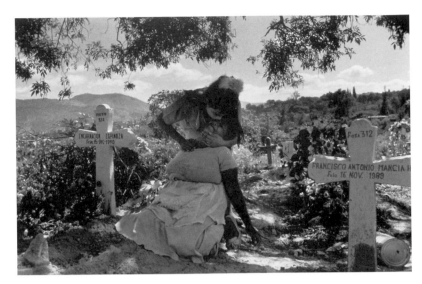

At La Bermeja Cemetery in San Salvador, a mother grieves for a son who was killed by a death squad.

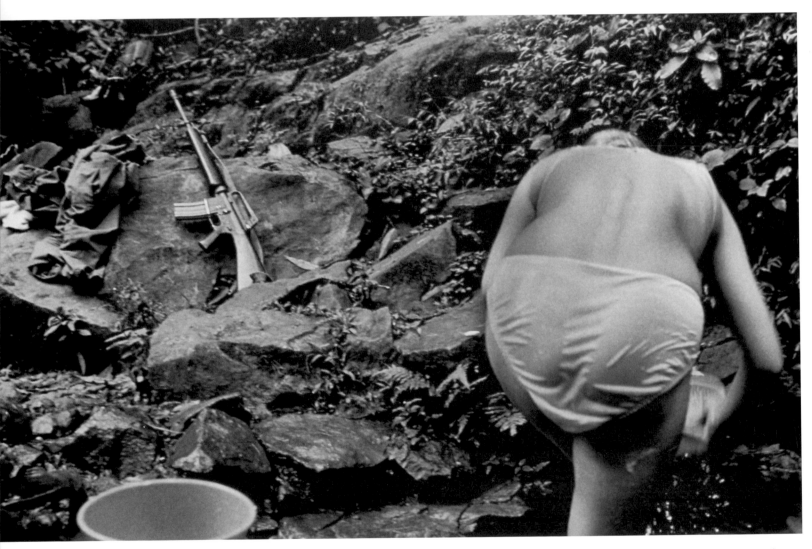

A guerrilla bathes in a stream in Morazon. After the peace accord took effect in February 1992, guerrillas could carry weapons only in their camps.

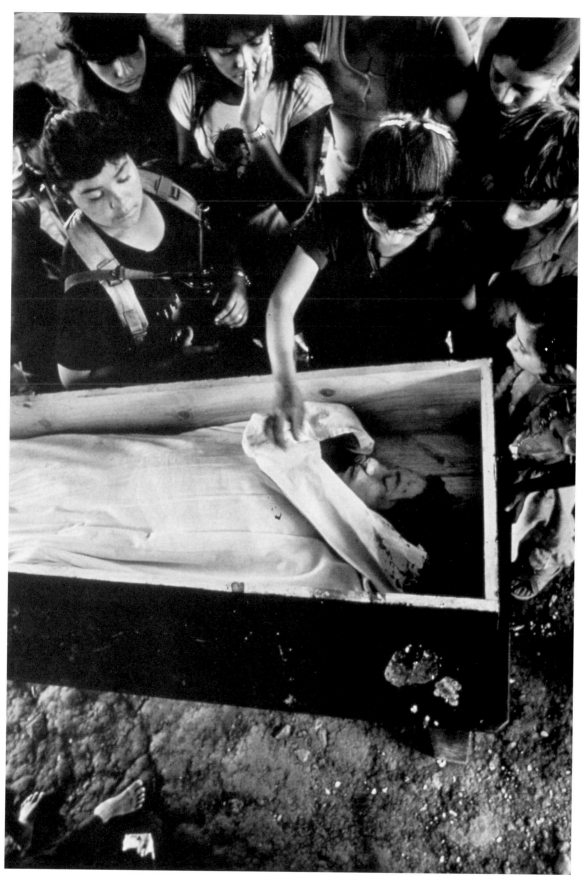

A funeral is held in Chalatenango Province for a guerrilla killed in combat.

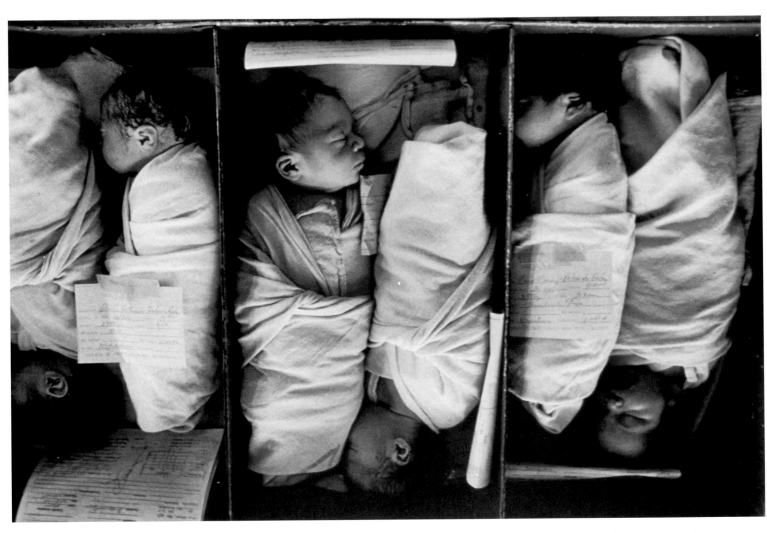

Unaware of the country's turmoil, babies sleep peacefully in boxes at a maternity hospital in San Salvador.

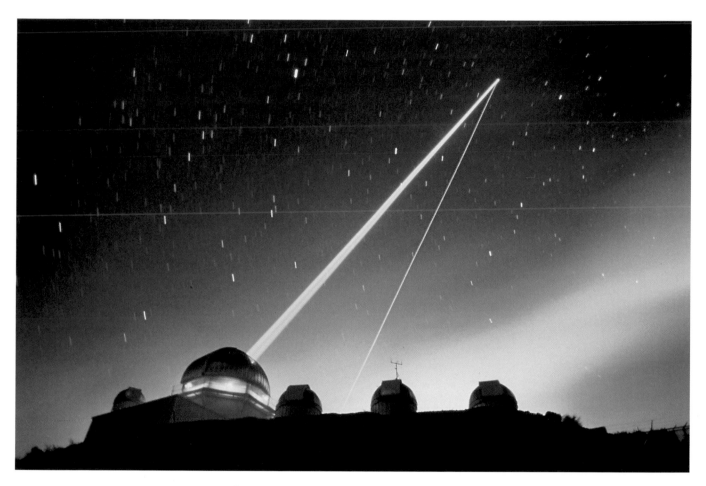

1ST PLACE
Roger H. Ressmeyer, National Geographic Magazine
Copper and sodium lasers are used to fix star twinkling and make telescopic images
more clear at the Starfire Optical Range in New Mexico.

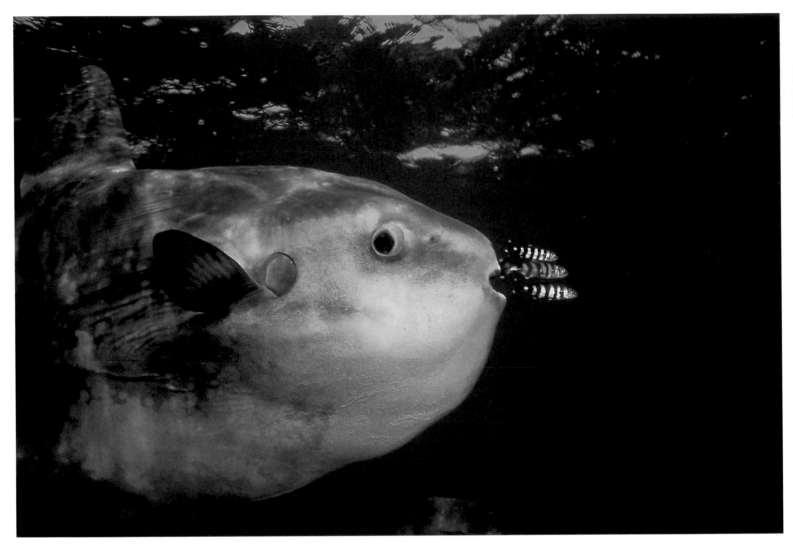

2ND PLACE
Richard Herrmann, International Wildlife Magazine

Awaiting scraps, three hungry pilot fish swim just ahead of a hundred-pound ocean sunfish in the Pacific Ocean. The sunfish dines mainly on jellyfish and zooplankton. The pilot fish get the leftovers.

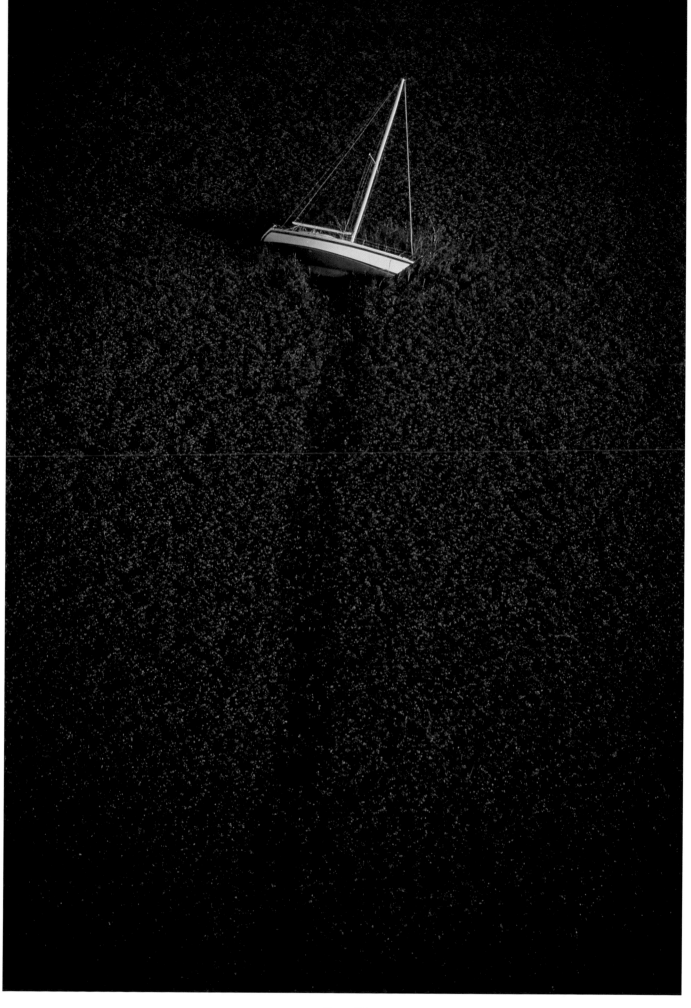

3RD PLACE
Cameron Davidson, National Geographic Magazine
A sailboat rests in a stand of mangrove trees after being pushed ashore by Hurricane Andrew at Key Biscayne, Fla.

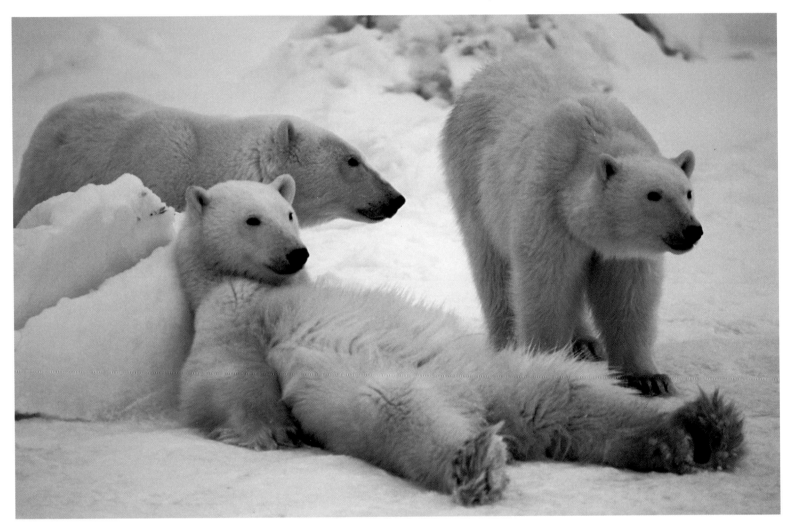

AWARD OF EXCELLENCE
Michio Hoshino, National Wildlife Magazine
Polar bears enjoy the good life along Canada's Hudson Bay.

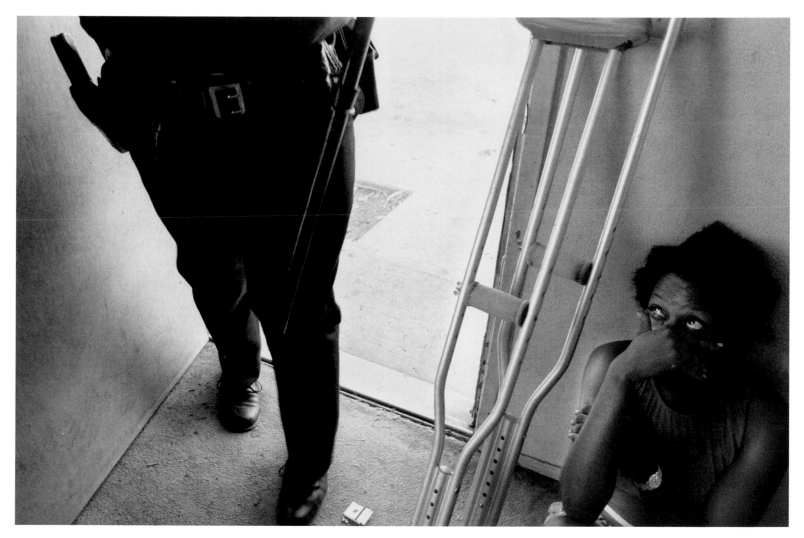

1ST PLACE
Carolyn Cole, The Sacramento Bee

A woman waits to be taken into custody for cocaine possession. Sacramento police officers arrested her in an apartment that earlier was condemned and boarded up in an effort to clean up the neighborhood.

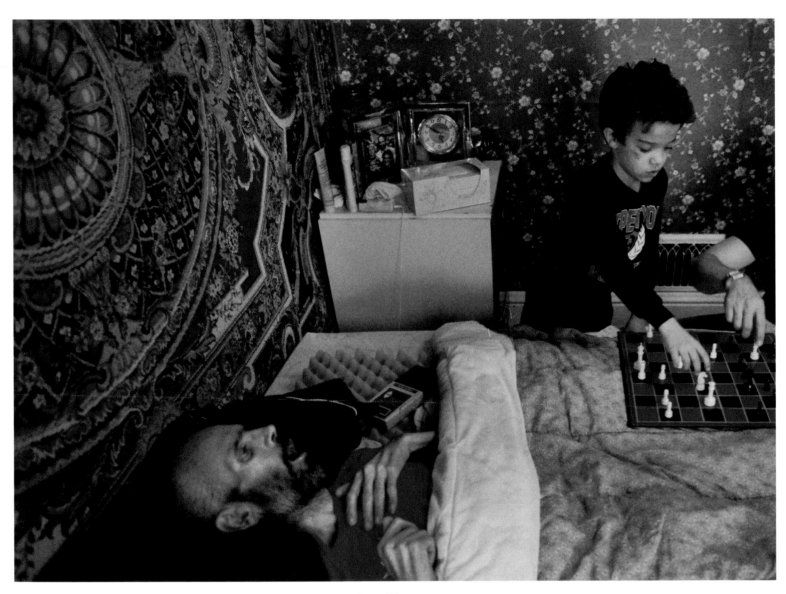

3RD PLACE
Allan Detrich, The Toledo Blade

Ilja Miller and his uncle, Don, play chess to help pass the time as Ilja's father, Dennis Miller, lies near death, a victim of AIDS.

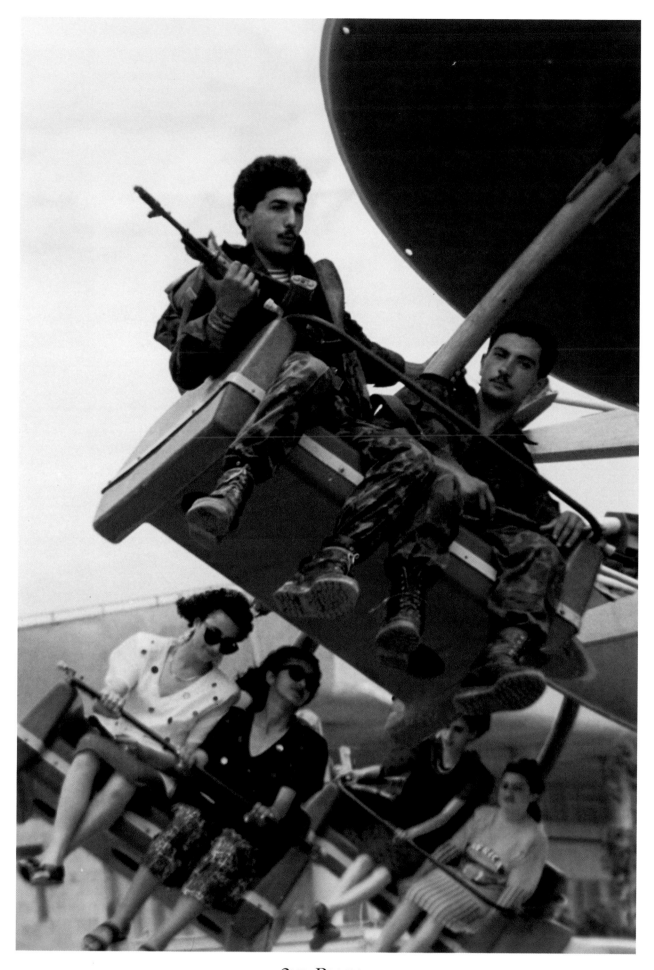

2ND PLACE
A. Zemlianichenko, The Associated Press
Two soldiers under Azerbaijani rebel commander Surat Huseynov relax on an amusement ride.

AWARD OF EXCELLENCE
Stephen Jaffe, freelance for Reuters

First daughter Chelsea Clinton (right) meets her classmates on the first day of school at Sidwell Friends private school in Washington, D.C.

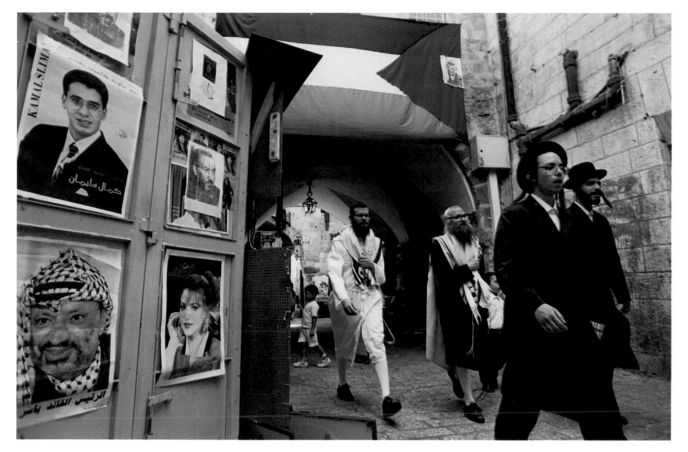

Jews in Jerusalem's Old City are confronted by a new reality following an accord between Israel and the Palestine Liberation Organization promising self-government for Palestinians.

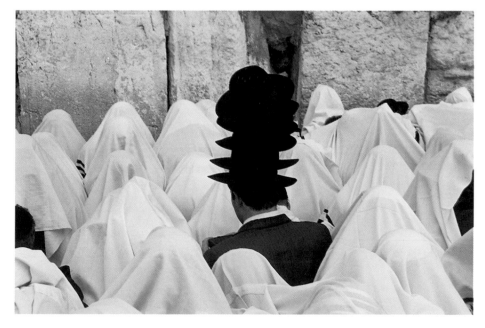

An Orthodox Jew carries the hats of his comrades who are covered with "taleth" during Passover prayer at Jerusalem's Wailing Wall.

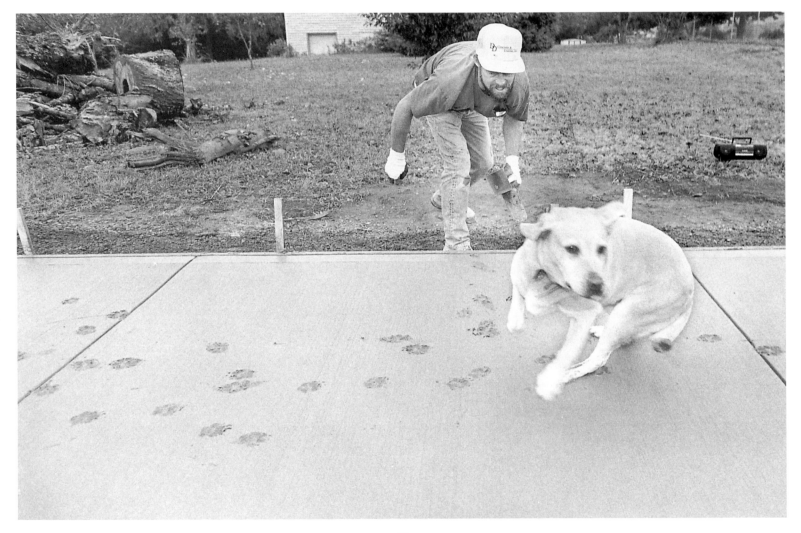

<div align="center">

AWARD OF EXCELLENCE
Craig Strong, freelance

Ray Baker, a foreman with D&D Concrete in Tualatin, Ore., chases a golden Labrador retriever off a new
sidewalk near Bridgeport Elementary School.

</div>

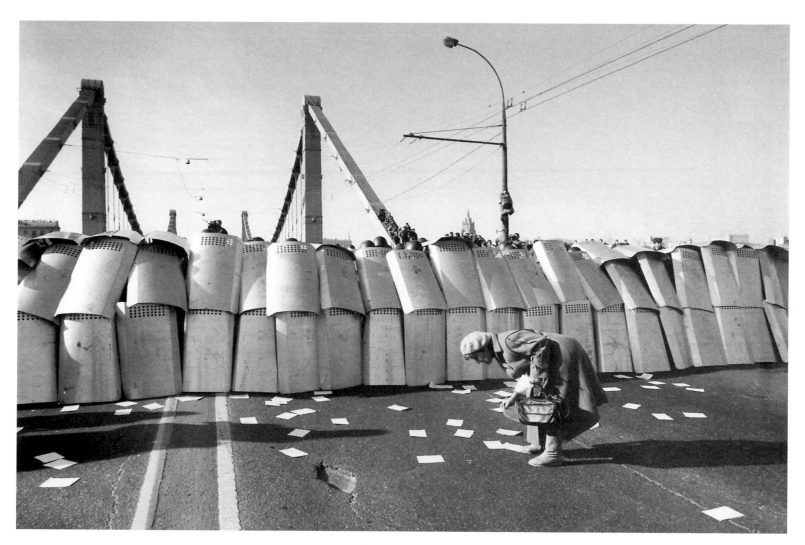

1ST PLACE
Anthony Suau, Black Star
The Russian police set up a blockade against a planned anti-Yeltsin demonstration headed for the Parliament building in Moscow.

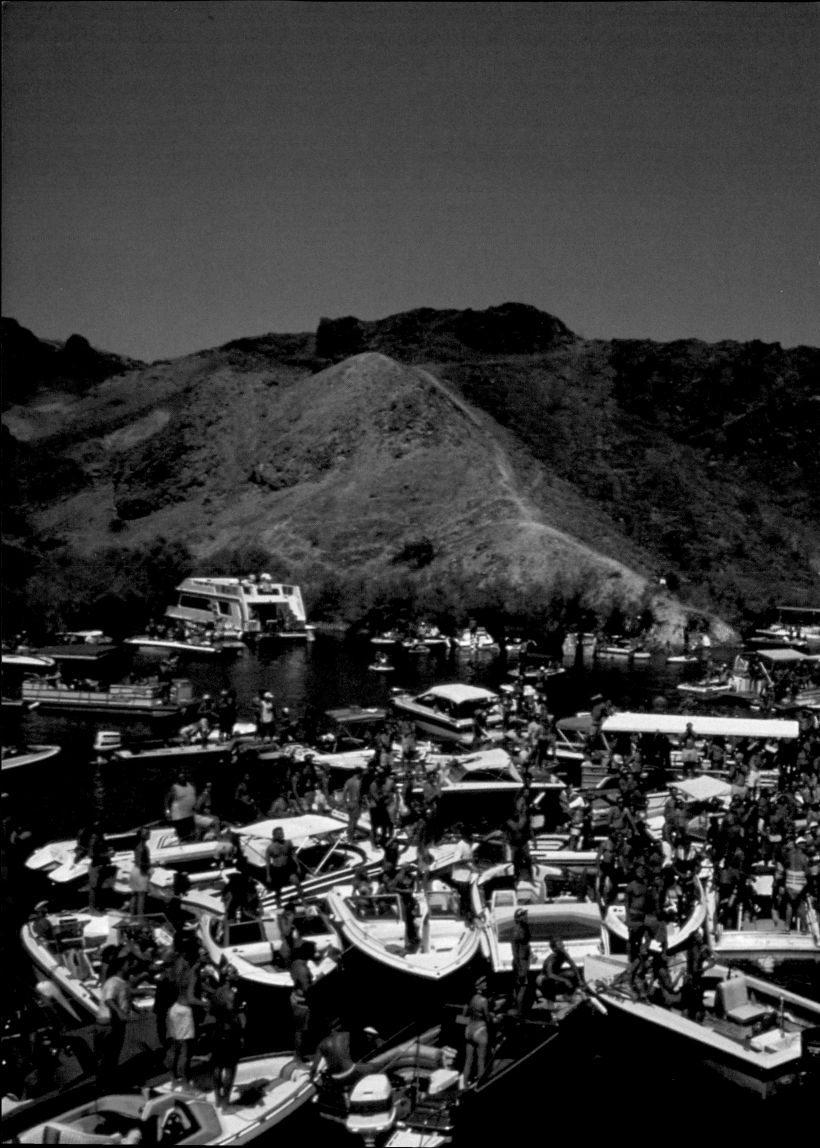

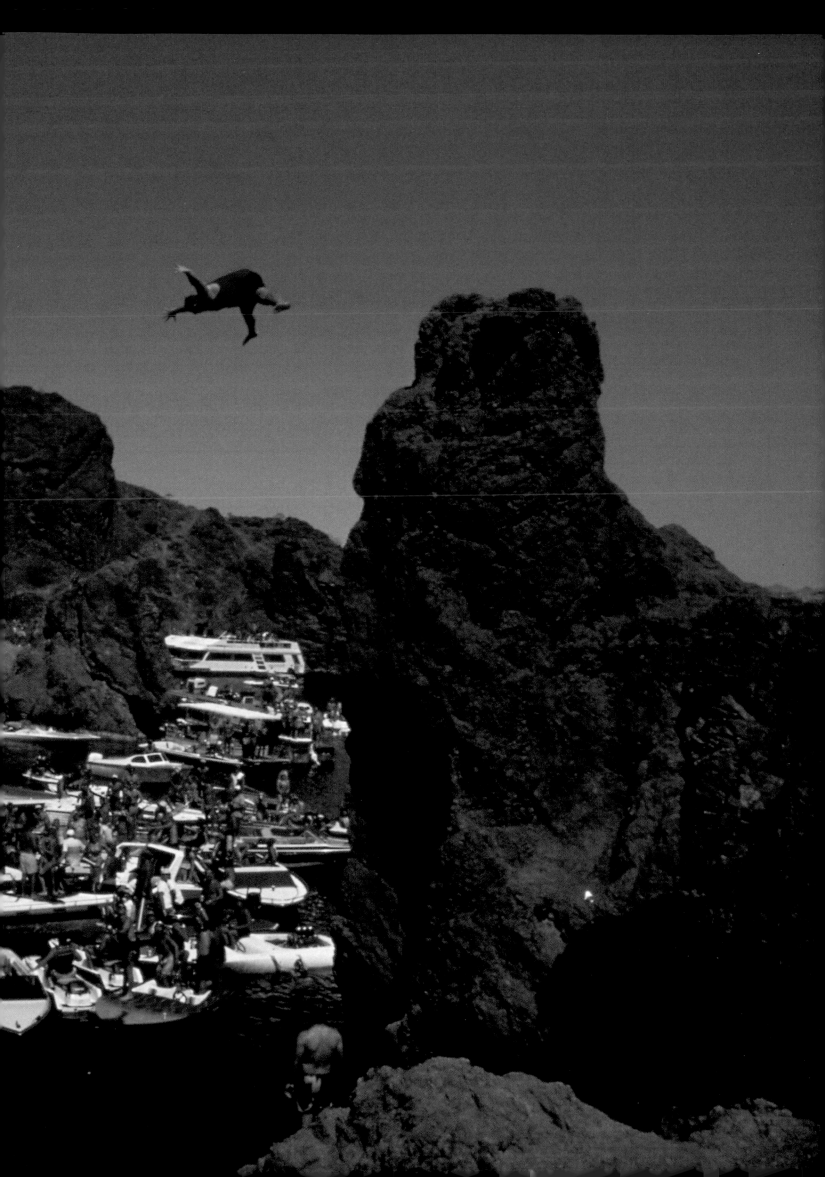

2ND PLACE
Jodi Cobb, National Geographic Magazine
A couple wait to be photographed during a mass wedding in Taiwan.

AWARD OF EXCELLENCE
Erica Lansner, Black Star
A woman and her belongings are carried through
Beijing by a bicycle taxi.

The preceding page:

3RD PLACE
Rick Rickman, National Geographic Magazine
An impromptu cliff-diving competition at Lake Havasu.

An unidentified man watches the city pass by along Sumter Street.

A WORLD APART

More than 8,000 people daily ride buses in Columbia, S.C. Some of the passengers come to know each other, chatting amiably as they travel to work, school or home, while others keep to themselves. "The buses beat walking," says one regular rider. "They take you where your own feet won't take you."

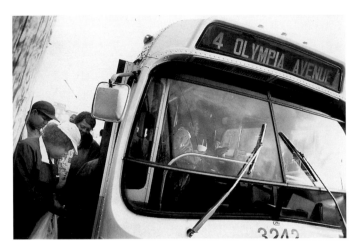

Riders board the 7:23 a.m. Olympia Avenue bus, one of the system's most crowded routes.

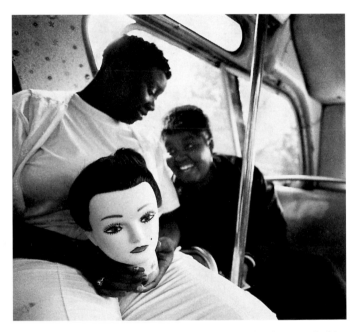

Jamie Glover and her mannequin head ride the Fairfield Road bus on the way home from a day at the Chris Logan Career College, where she is studying cosmetology. "Sometimes I feel like I been on this bus all day," Jamie says. "But if I didn't have it, there'd just be no hope at all for getting to and from."

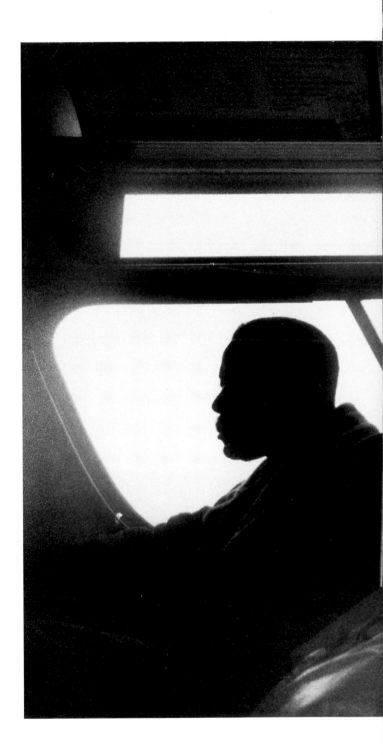

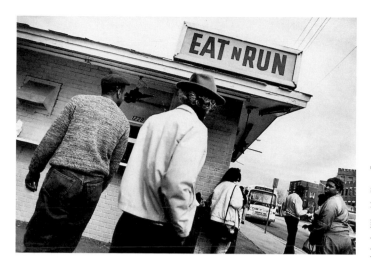

The Eat 'n Run snack shop, a fixture for over 30 years, gets most of its business from bus passengers.

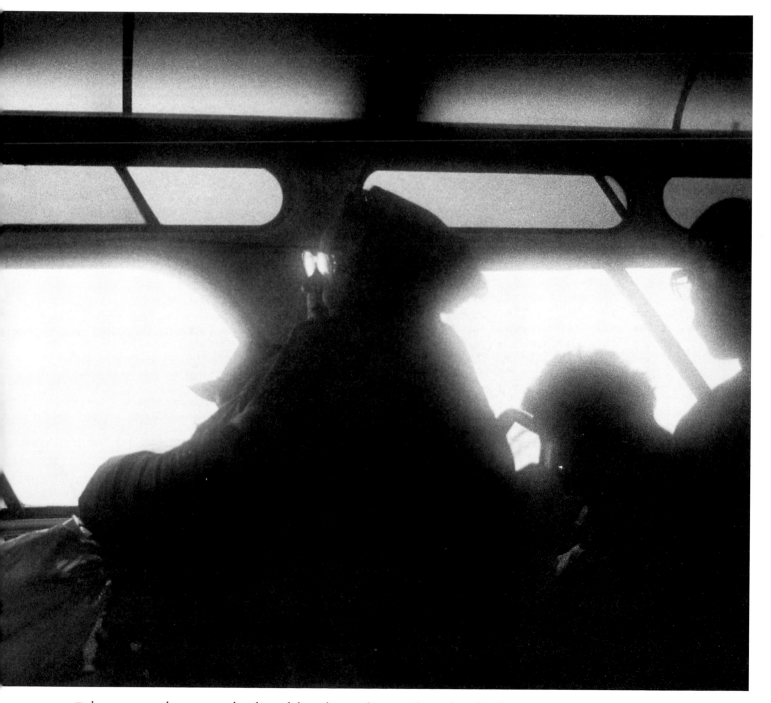

Riders on an early-morning bus bound for Olympia keep to themselves for the 15-minute trip from downtown.

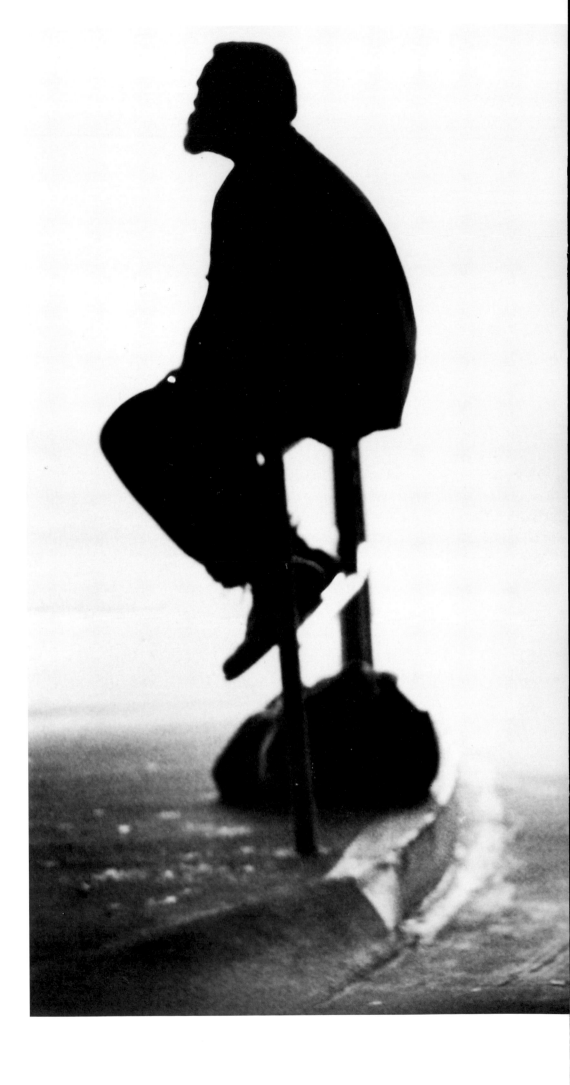

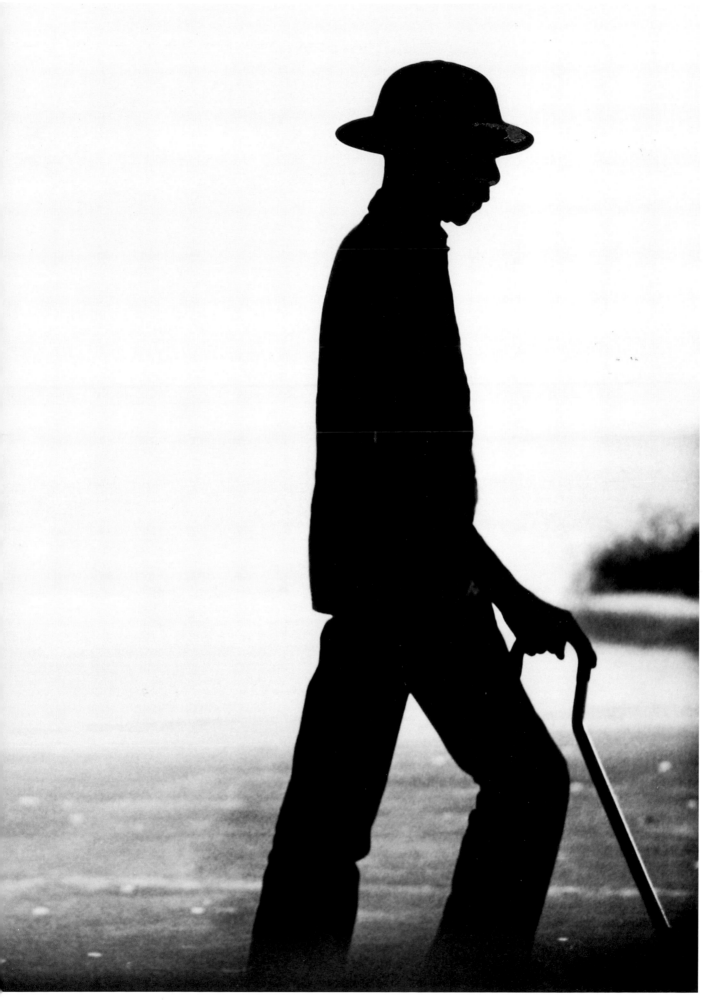

Robert Snow (left) waits on the next Denny Heights bus as Jesse Davenport walks under the parking garage at the stop. Davenport, with his trademark hat and cane, is a regular both on the bus and at most of the downtown stops.

Waiting for a bus, Sylvia Johnson (right)
says she's thankful for a reprieve from the rain.

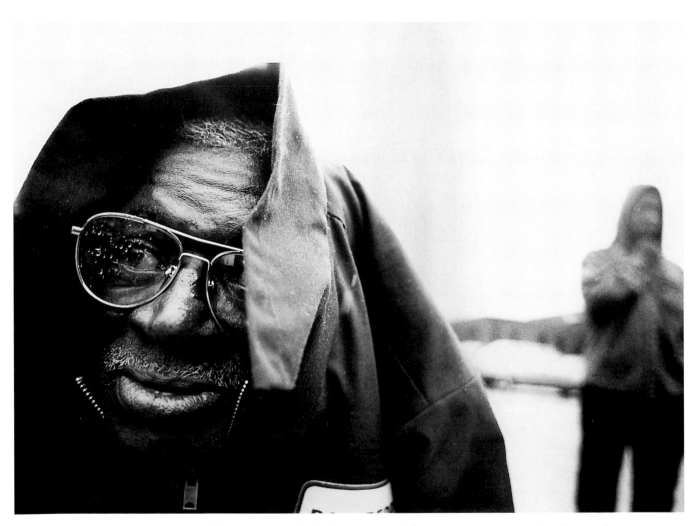

George Ladson, recently released from a hospital after being treated for pneumonia, waits for a bus in the rain. He
says his wife will "lower the boom" on him if she sees how wet he got.

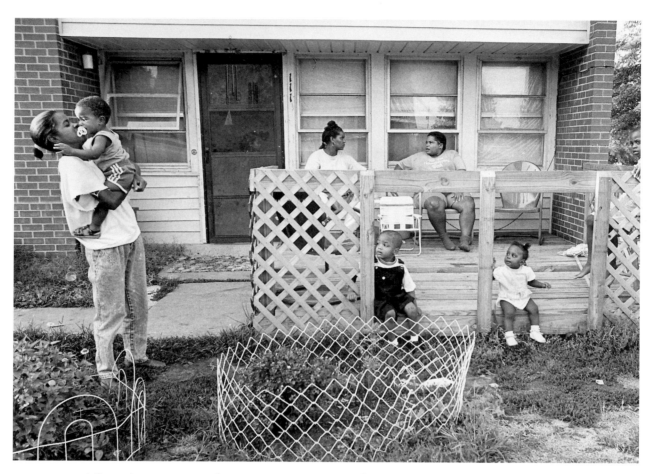

The Coleman sisters often congregate on Tina's front porch, which she built herself.
Tina (background, right) says, "We take care of one another."

A FAMILY OF SISTERS

The Coleman sisters are the backbone of their family. Each a single mother, Tina, Betty, Robin and Evelyn form a network of mutual support. They live in separate homes in Columbia, Mo., but the doors between them are always open. "Everybody's got a family if they want to stick together," Tina says.

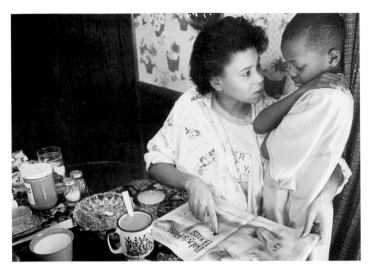

Evelyn teaches Tina's son, Daniyall, about childbirth.
Getting pregnant for Evelyn was an accident, and the baby's
father has little interest in parenthood.
But, she says, "We can deal with it."

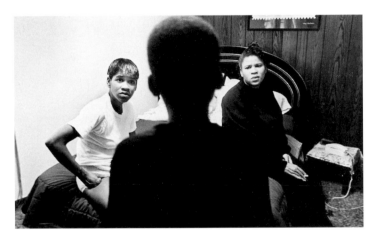

The women are the constants in the family, always there to
act as parent to each other's children. Robin (left) and
Evelyn question their nephew about playing in the rain.

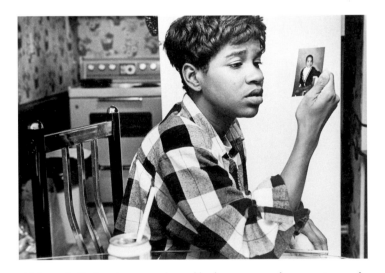

Although Robin keeps to herself, she stays within arm's reach
of her sisters. Before leaving for jail on a shoplifting
conviction, she packs a picture of her son, Jerrell, who will
stay with her sisters while she's away.

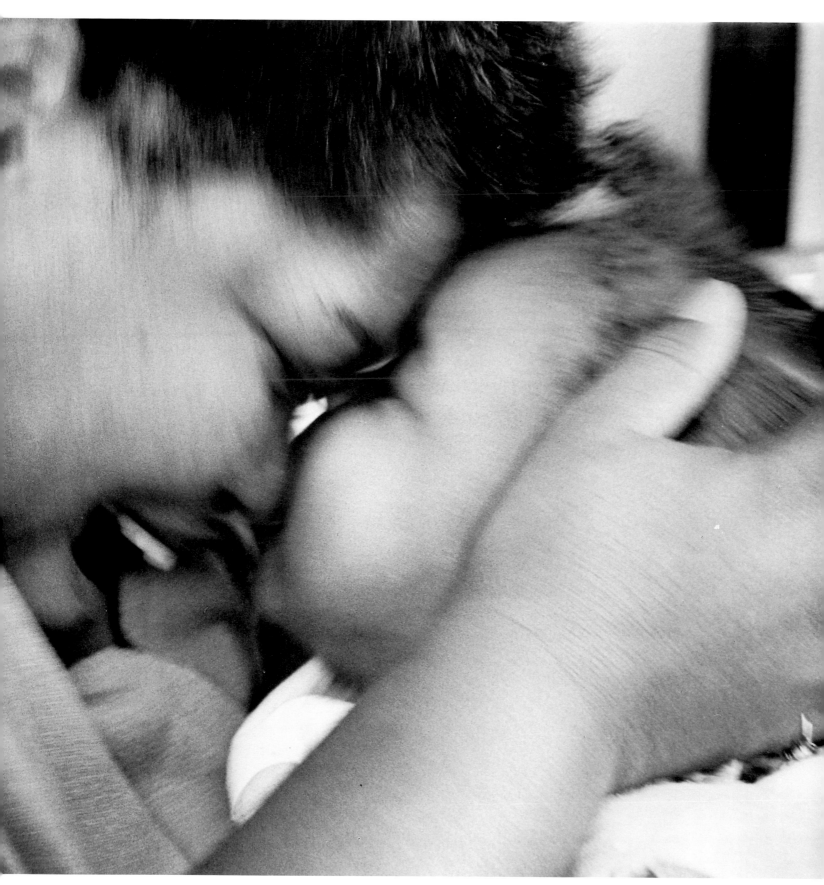

Tina, the oldest, has been the family babysitter since her parents separated when she was young.
Now she cares for Betty's daughter, Shana, while Betty works two jobs.

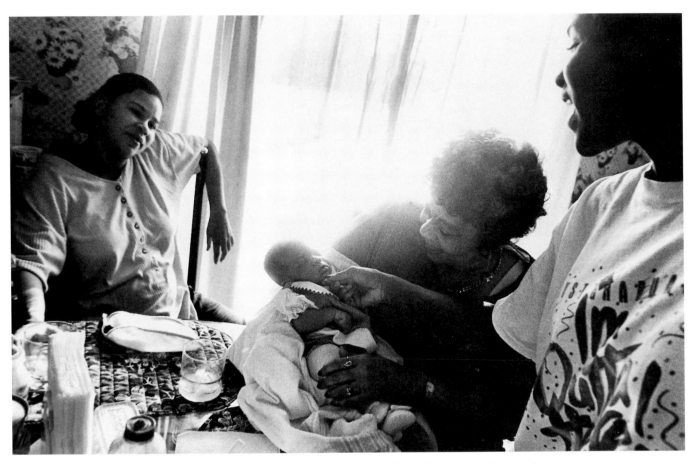

Robin and her aunt coo over baby Tanail as Evelyn, the new mother, looks on.
Evelyn says, "They still love me the same, but they pay more attention to her than me.
They are looking to see how well I take care of her."

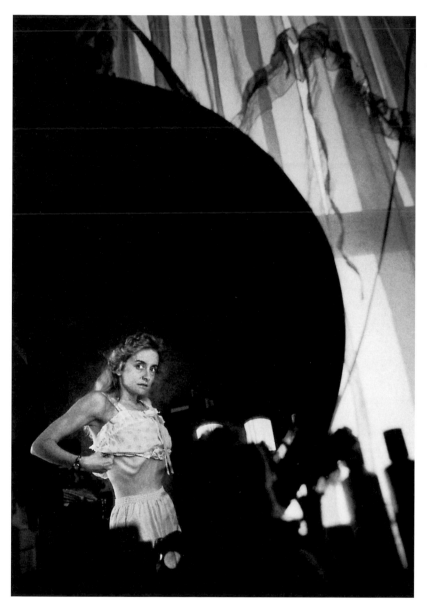

Susan scrutinizes her image in a mirror, displeased at what she considers excess weight.

SECRET, DEADLY DIET

Susan Sanborn of Kezar Falls, Maine, is on a diet — a deadly one. The 89-pound, 5-foot-4-inch woman suffers from the eating disorders anorexia nervosa and bulimia. Susan's obsession has damaged her body, robbing it of vital nutrients. Routinely hospitalized, her only source of a nourishing meal is forced into her intravenously. She has not sat with her family at dinner in two years. "Food," she says, "is the enemy."

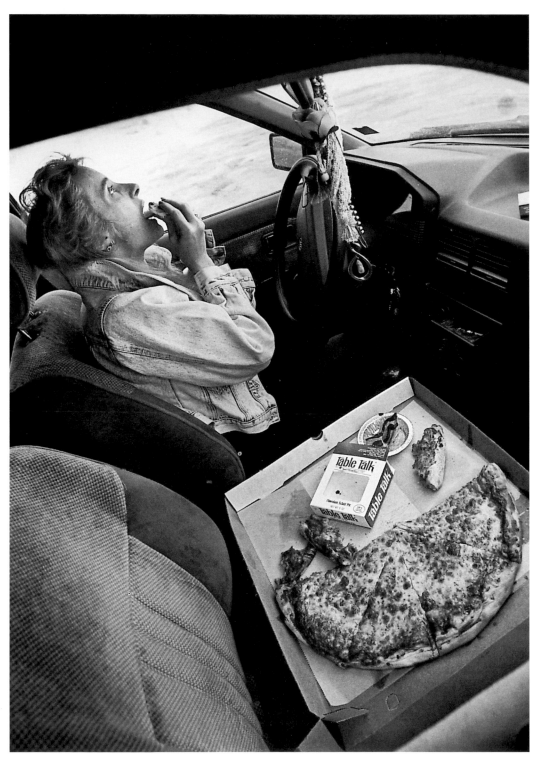

With hunger at its peak, Susan finds a remote location away from the eyes of her family
to indulge in food, eating ravenously.

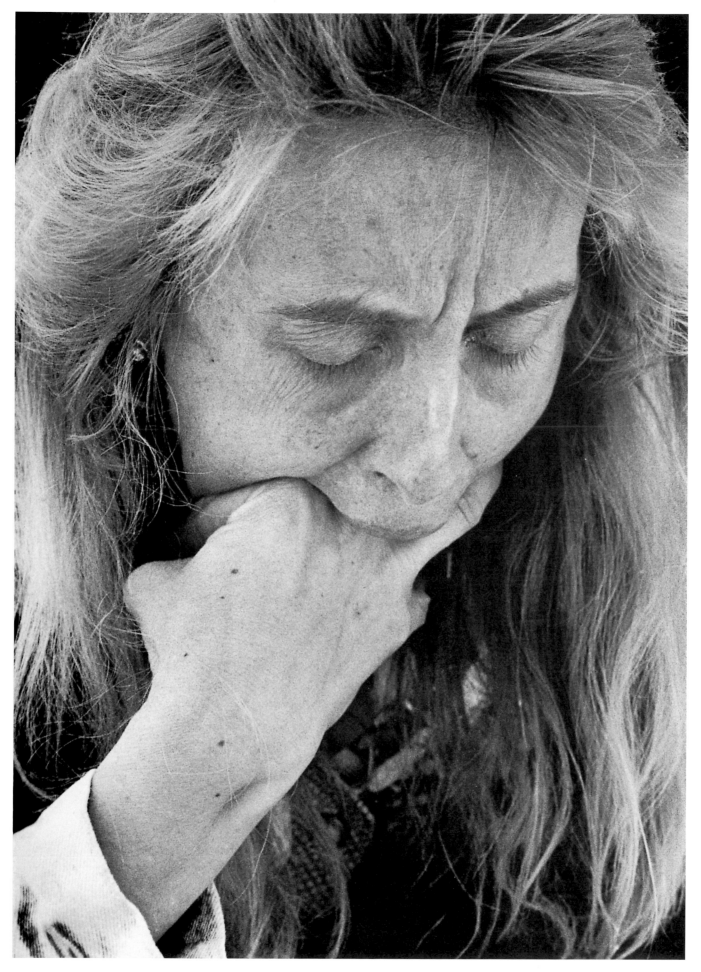

After eating, she forces herself to vomit.

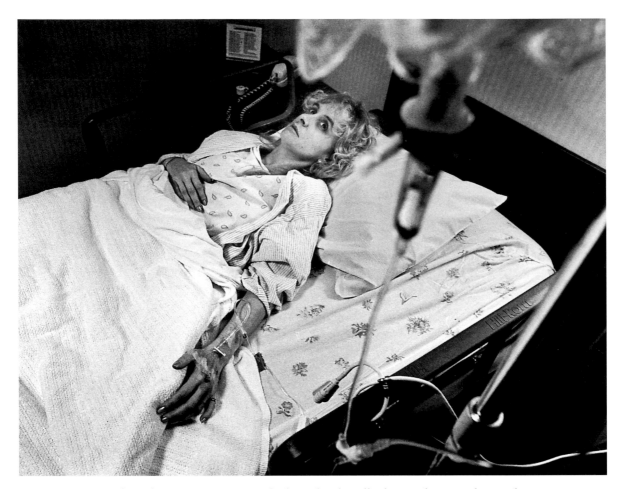

When the strain on Susan's body makes her ill, she is taken to a hospital.
She watches the intravenous feeding unhappily, knowing it is supplying her with calories.

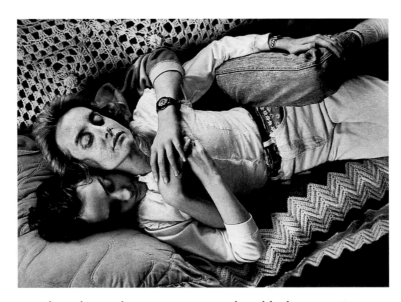

After a hospital stay, Susan is comforted by her son, Corey.

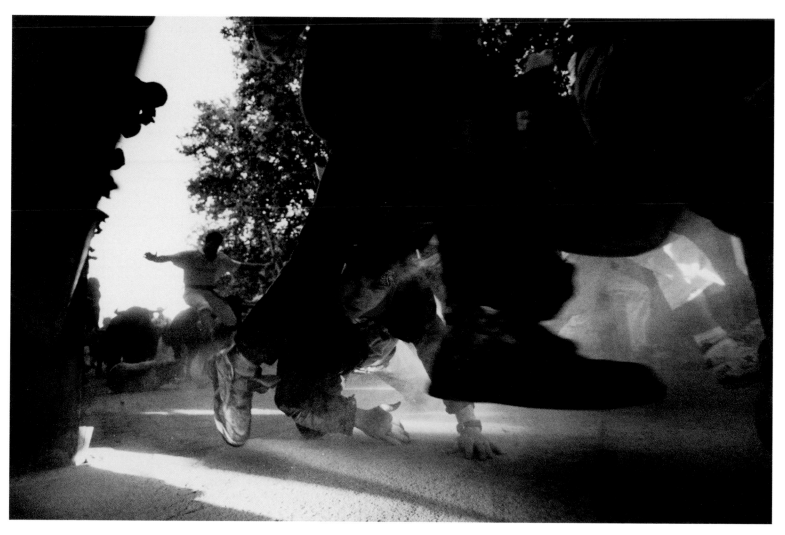

1ST PLACE
Jim Hollander, Reuters News Pictures
The running of the bulls in Pamplona, Spain.

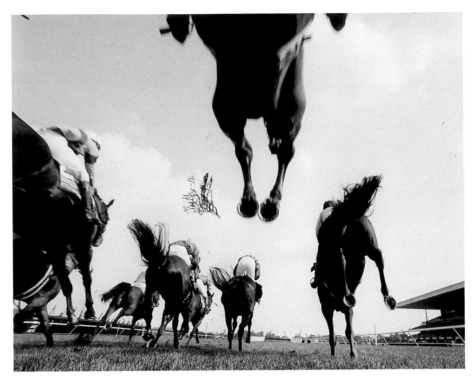

3RD PLACE
Alan Zale, freelance for The New York Times
Horses clear a jump at Breeders Cup Steeple Chase, Belmont Park.

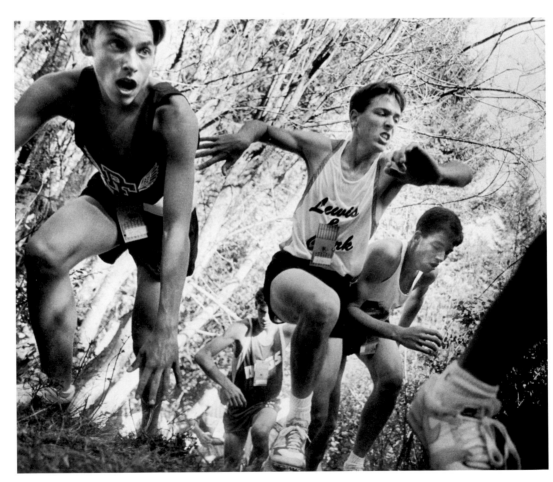

2ND PLACE
Blair Eliot Kooistra, Spokane Spokesman-Review
Cross-country runners struggle over the top of "Goat Hill," a gut-wrenching climb up a mountain, during the annual Coeur d'Alene Invitational high-school meet in Farragut State Park, Idaho.

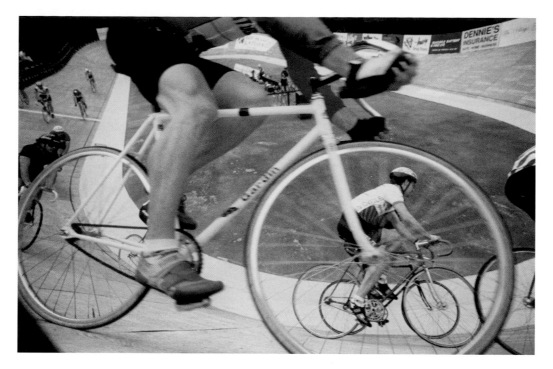

AWARD OF EXCELLENCE
Mathew McCarthy, freelance for The Hamilton (Ontario) Spectator
Cyclists negotiate a turn during a race on the world's steepest and shortest outdoor
Velodrome, in Fonthill, Ontario.

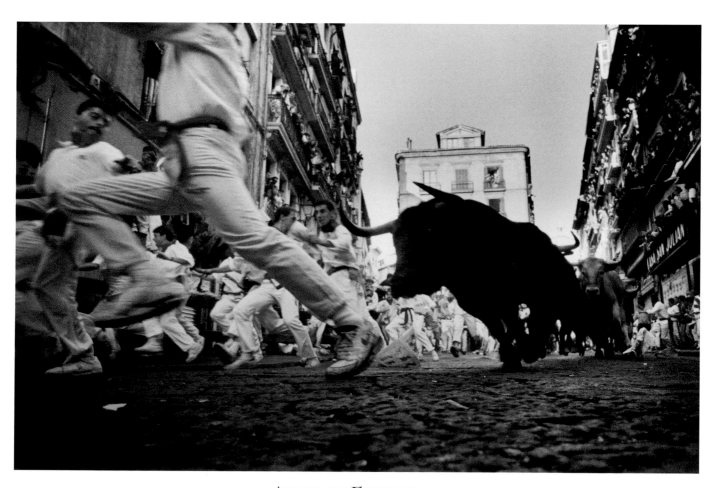

AWARD OF EXCELLENCE
Jim Hollander, Reuters News Pictures
Runners in full stride expertly lead a pack of fighting bulls around a sharp corner during the weeklong Fiesta de San
Fermin in Pamplona, Spain.

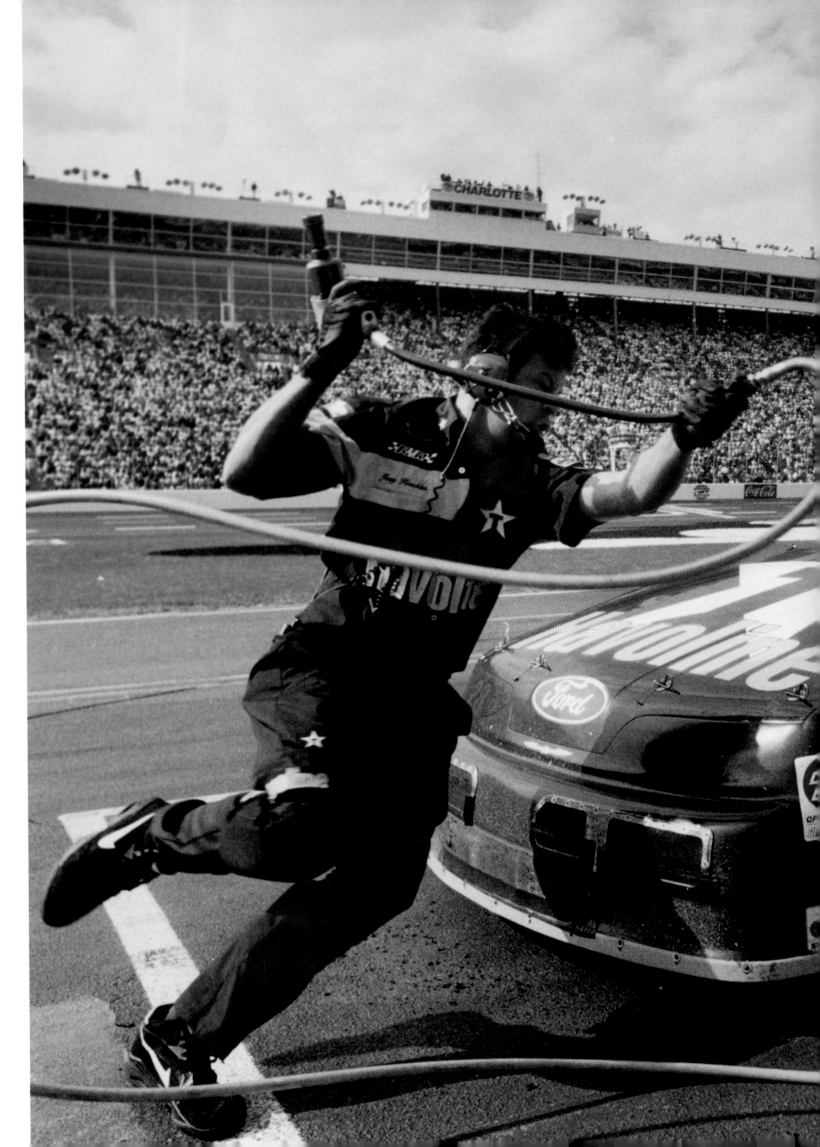

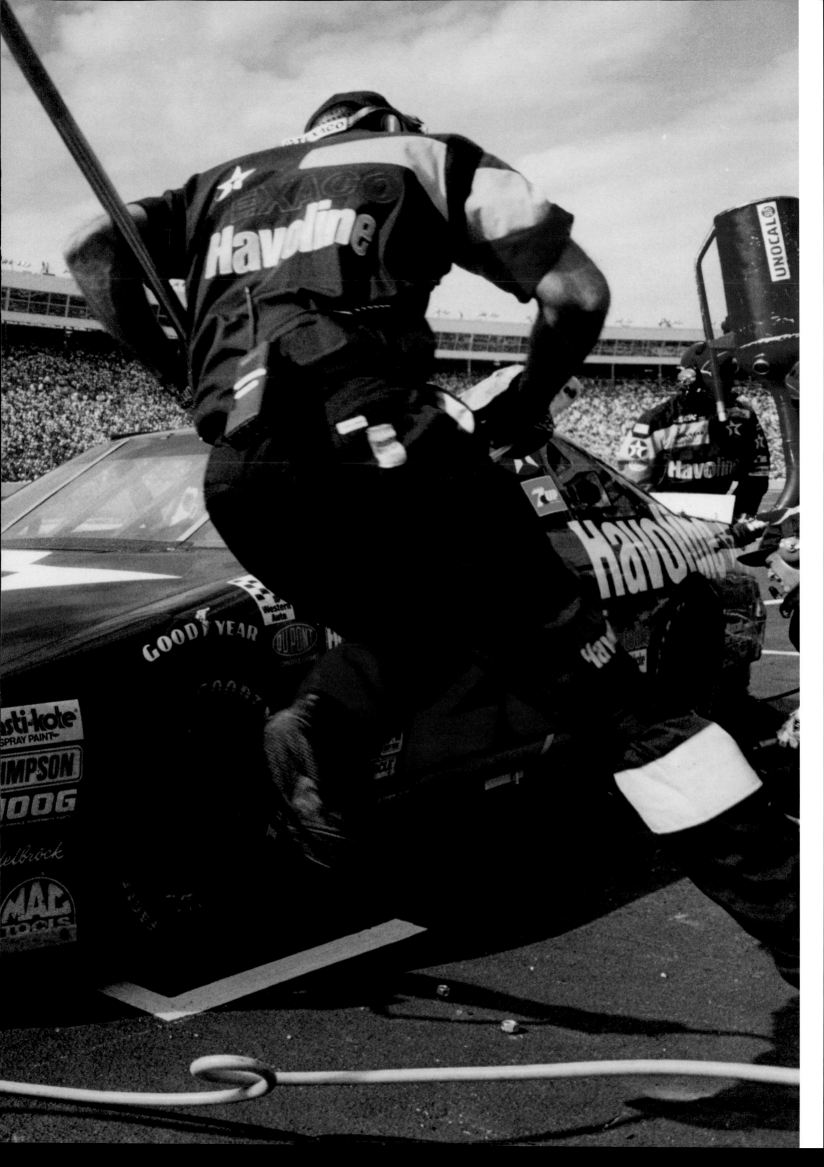

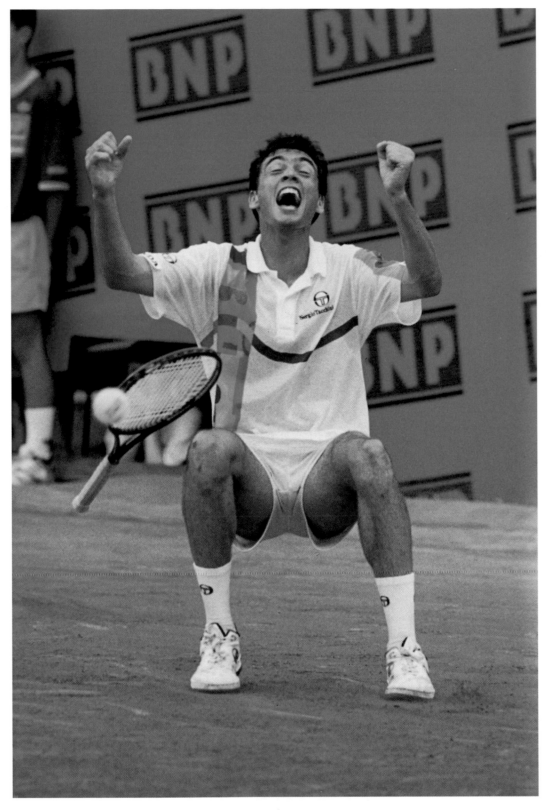

AWARD OF EXCELLENCE
Jean-Loup Gautreau, Agence France-Presse
Spanish tennis player Sergei Bruguera rejoices in his French Open victory.

The preceding page:

AWARD OF EXCELLENCE
Christopher A. Record, The Charlotte Observer
Earnie Irvan's pit crew goes to work during the Mello Yello 500
in Charlotte, N.C., helping Irvan win the race.

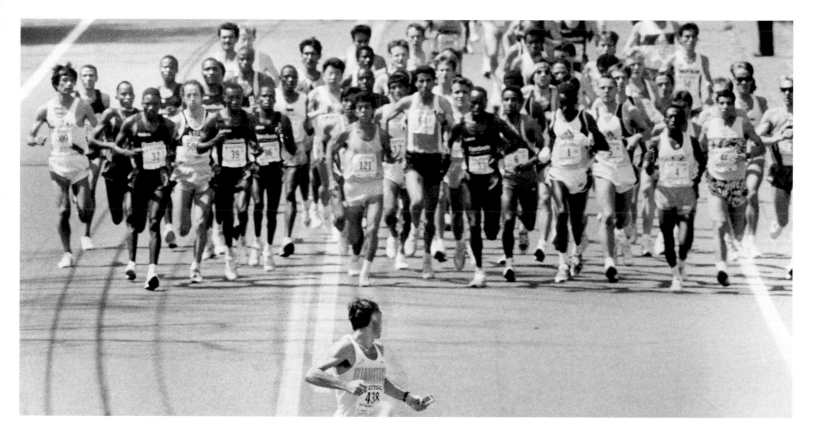

1st Place
Jim Collins, Worcester (Mass.) Telegram & Gazette
Early in the Boston Marathon, Partev Popalian of Hollywood, Calif., looks back as he takes the lead. He did not win the race, but placed first among California runners.

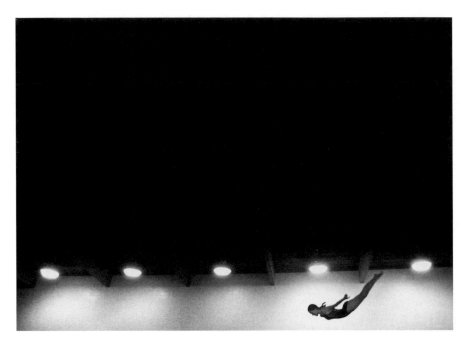

3RD PLACE
Brian Plonka, Biddeford (Maine) Journal Tribune
Thornton Academy springboard diver Susan Biddle practices her
form long after her teammates have gone home.

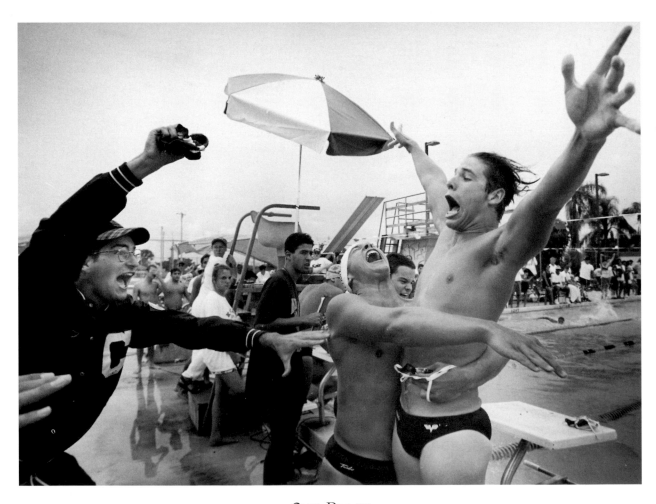

2ND PLACE
David Bergman, The Miami Herald
Members of the Columbus High School 400 freestyle relay team celebrate after finishing first at the annual
Dade County Youth Fair swim meet in Miami. The win clinched the Youth Fair title for the team.

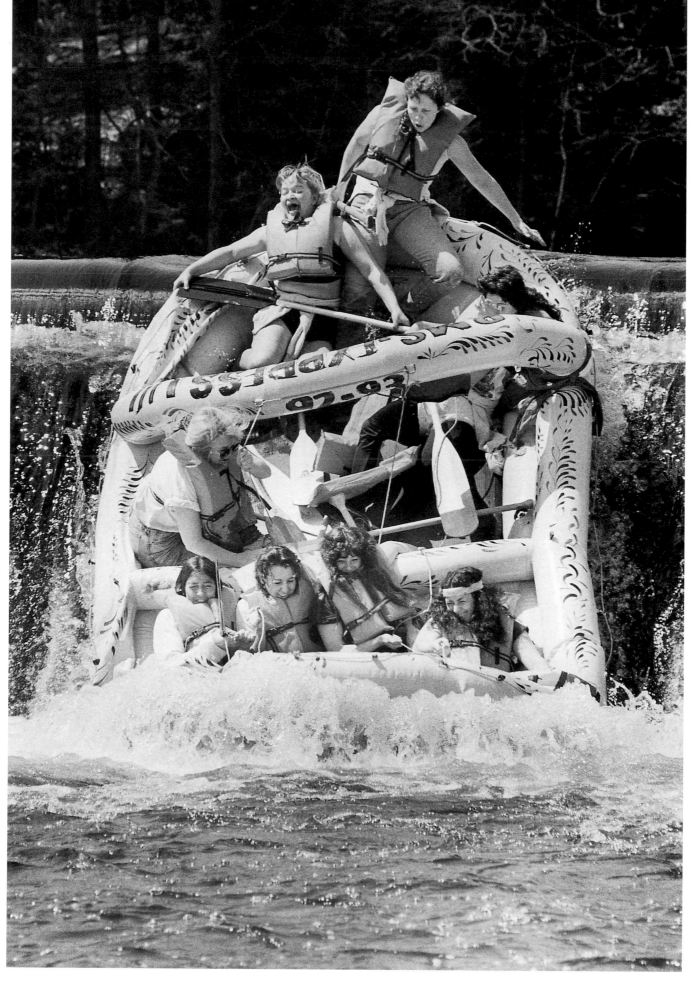

AWARD OF EXCELLENCE
Jim Collins, Worcester (Mass.) Telegram & Gazette
A group of women in a World War II-era life raft dubbed the PMS Express go over the 10-foot-high Old Sturbridge Village Dam in the annual Quinebaug River Race in Massachusetts.

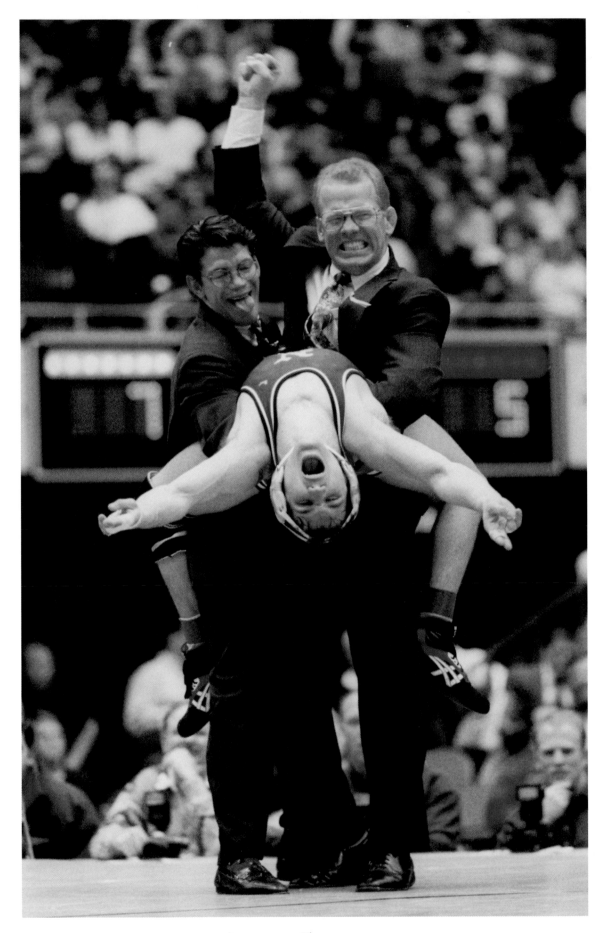

AWARD OF EXCELLENCE
Jeffery Foss Davis, freelance for The Associated Press
University of Nebraska wrestler Tony Purler bends over backward in celebration after winning the
national title in the 126-pound class at the NCAA wrestling tournament in Ames, Iowa. Head
coach Tim Neumann (right) and assistant coach Brad Penrith hold Purler.

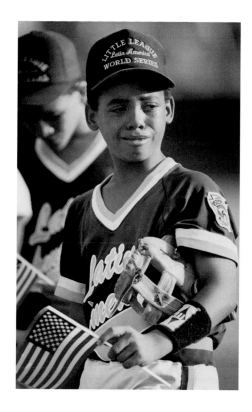

AWARD OF EXCELLENCE
Lloyd Fox, The Baltimore Sun
Ricardo Riggs of the Latin America Little League baseball team fights tears after losing the championship game in the Little League World Series in Williamsport, Pa.

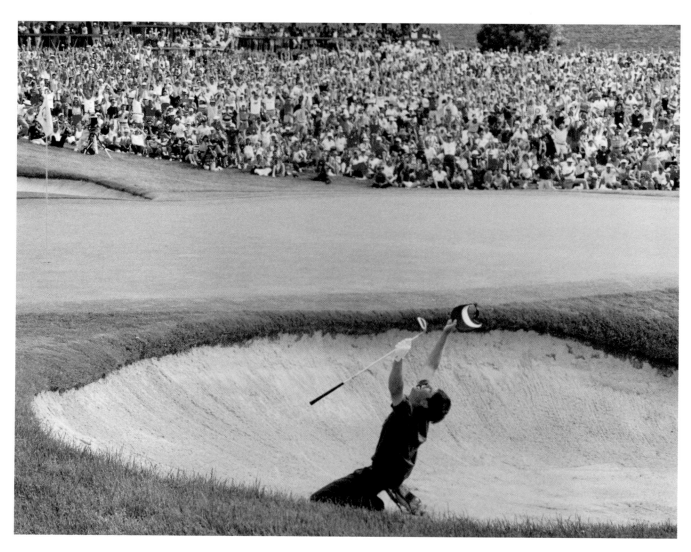

AWARD OF EXCELLENCE
Fred Squillante, The Columbus Dispatch
Paul Azinger rejoices after sinking a shot from a bunker on the last hole of the Memorial Tournament in Dublin, Ohio. The 20-foot shot brought Azinger from second place to win the tournament.

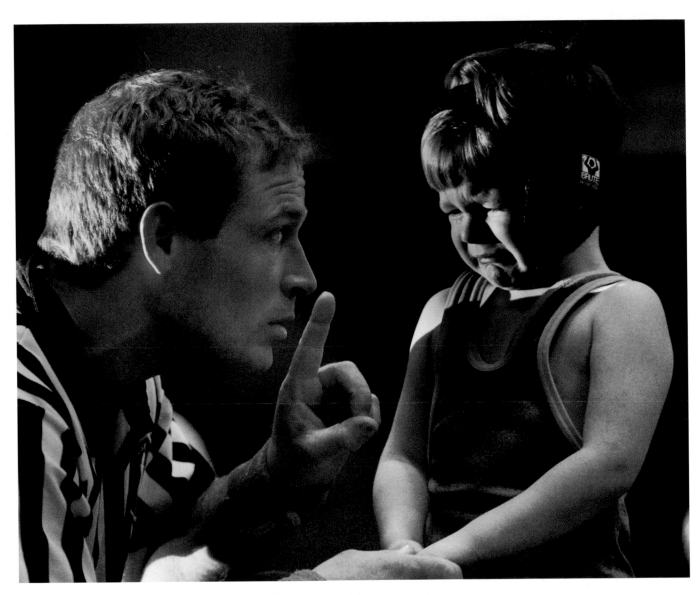

AWARD OF EXCELLENCE
Peter Ackerman, Asbury Park (N.J.) Press
Gregory Cranmer, 4, of the Pinelands Wildcats cries as referee Ed Tonnesen corrects his starting position during the
Just for Fun wrestling tournament at Pinelands Regional High School, N.J.

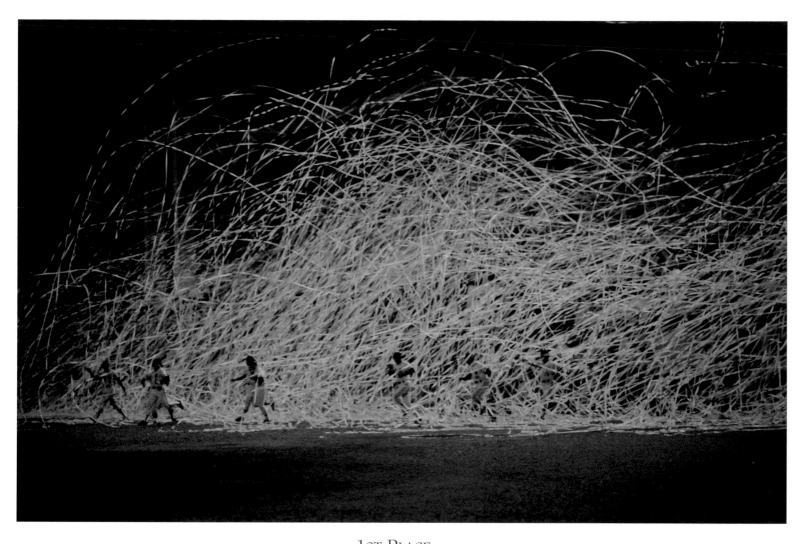

1ST PLACE
Jodi Cobb, National Geographic Magazine
After winning Taiwan's baseball championship, the Brother Elephants run from the dugout as fans hurl plastic streamers from the stands.

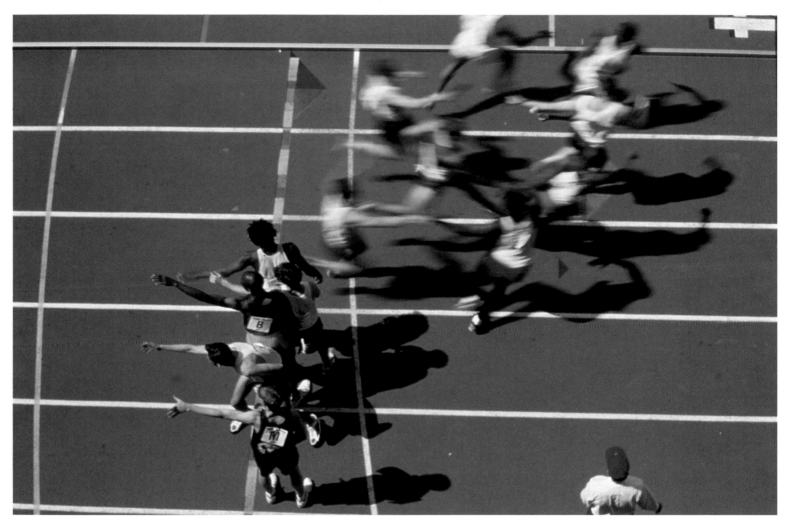

2ND PLACE
George Tiedemann, Sports Illustrated
Runners hand off batons during the Penn Relays.

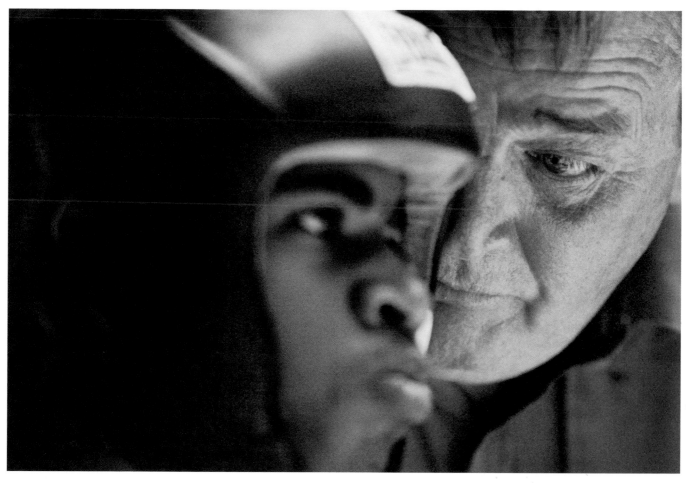

During a Golden Gloves tournament in Dallas, coach Jack Trussell watches Dominique Bilbo in the corner between rounds. Every year, hundreds of young men come together to test their mettle in the Golden Gloves boxing tournaments across America.

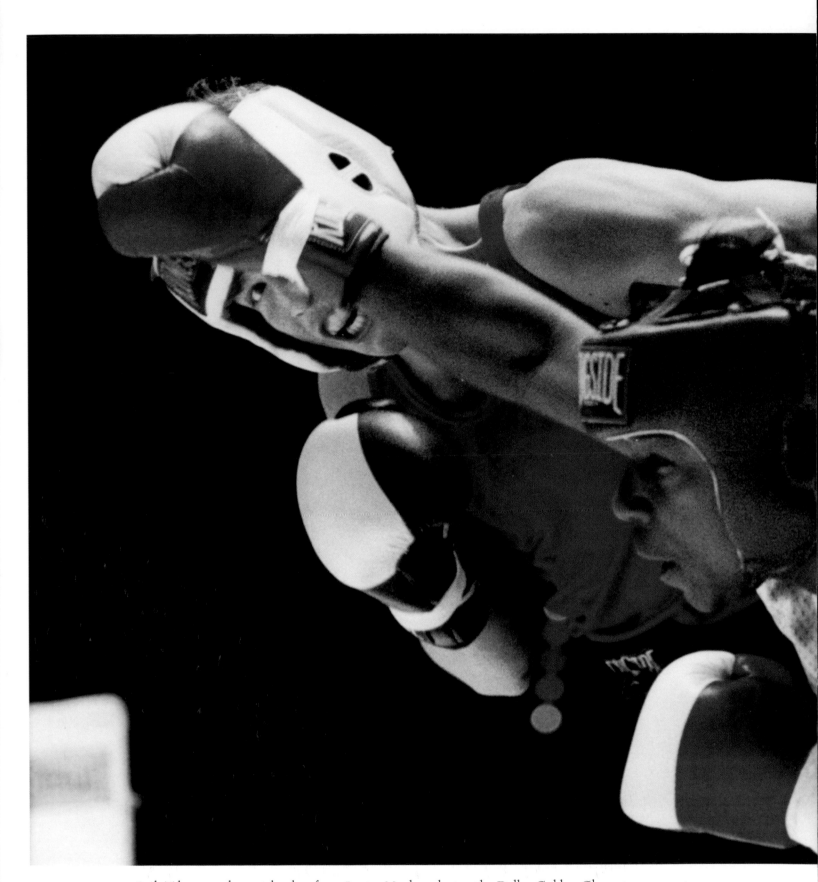

Jack Televar evades a right shot from Lester Murkow during the Dallas Golden Gloves tournament.

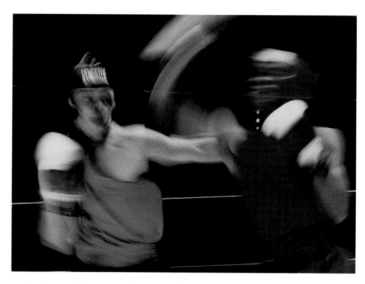

Lightweight Jose Chow (right) misses an uppercut against Ignacio Perez during their championship bout.

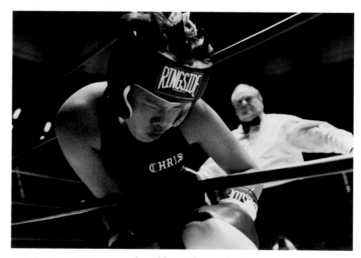

Enrique Diaz goes headfirst through the ropes after an onslaught by his flyweight opponent.

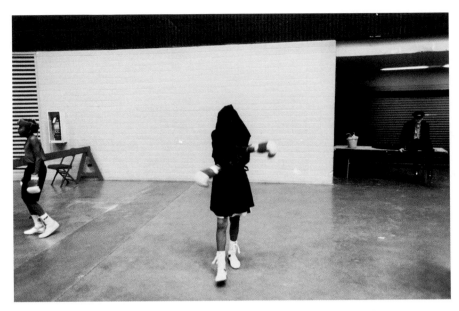

A hooded Richard Trevino warms up before his flyweight bout in
the Dallas Golden Gloves tournament.

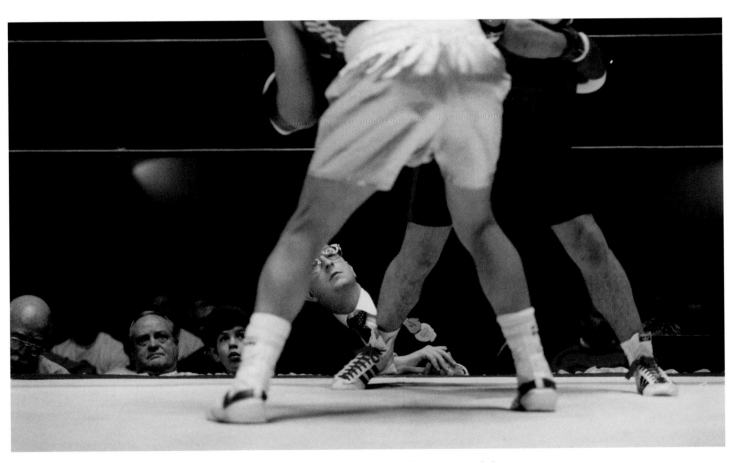

Ring judge David Harris tries to get a better view of the action.

Dwayne Sheldon is given the standing eight count. He returned to the fight but lost.

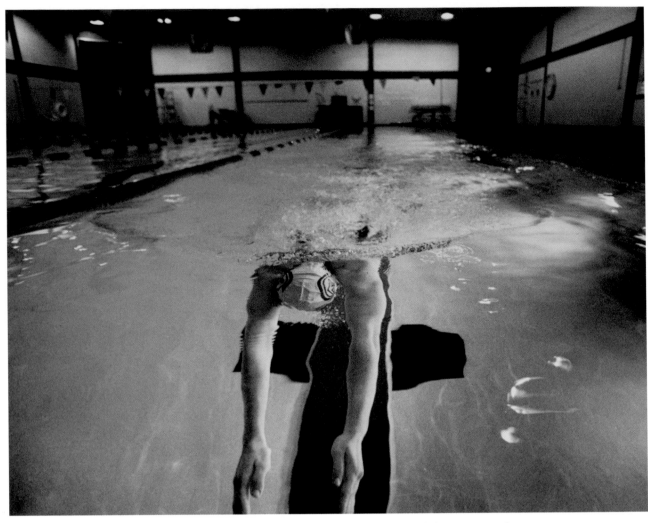

A swimmer for Richardson High School in Texas reaches for the wall during an early-morning practice.

Weber Strickland hoses himself down after the Farmers Branch Triathlon.

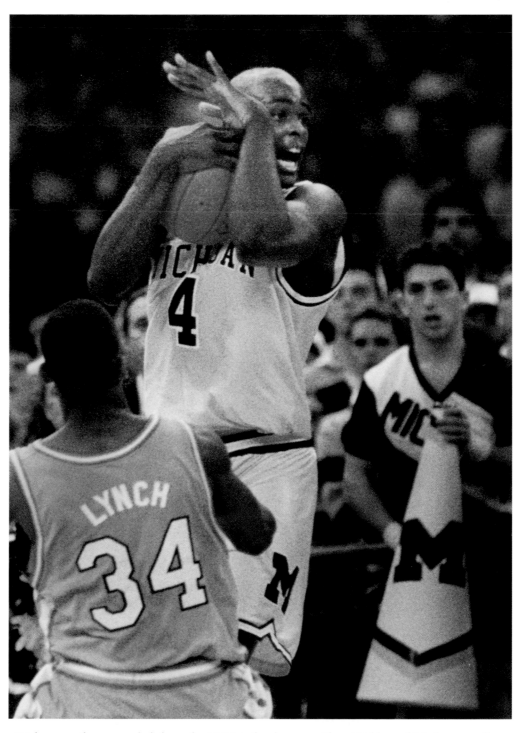

With just a few seconds left in the NCAA final game, Chris Webber of Michigan calls a timeout his team doesn't have. The mistake was costly: North Carolina won the title.

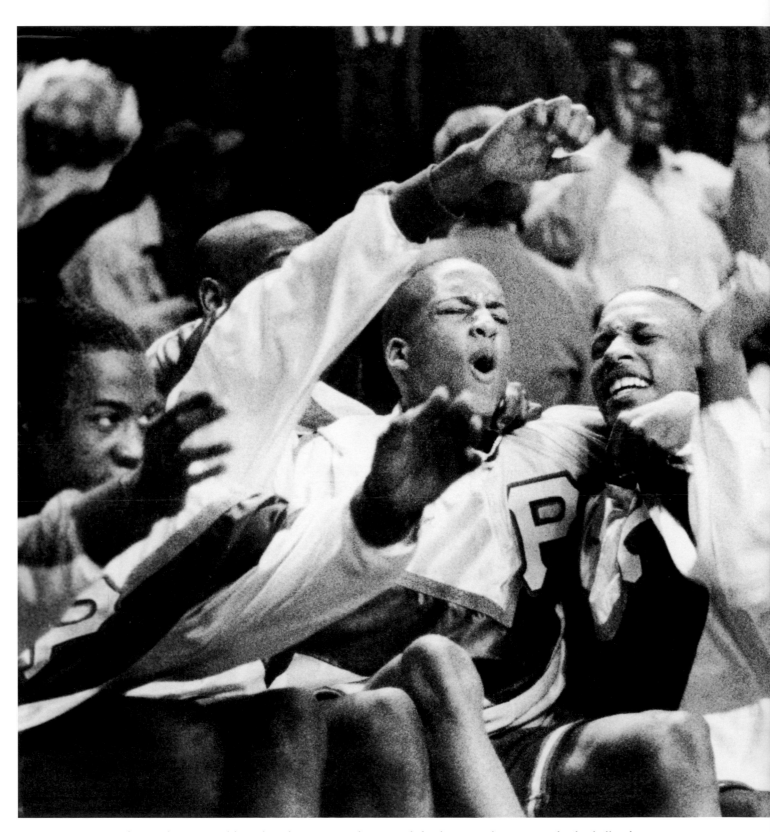

The Pershing Doughboys bench erupts as the team defends its Michigan state basketball title.

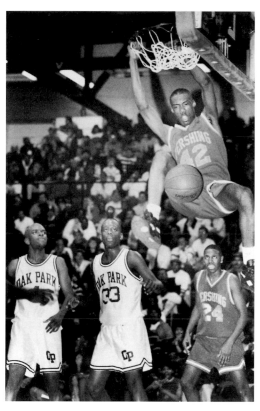

Carlos Williams responds with a jam as the
Doughboys polish off the game.

After a school rally, the Doughboys and their state championship medals draw admiring
stares from their girlfriends.

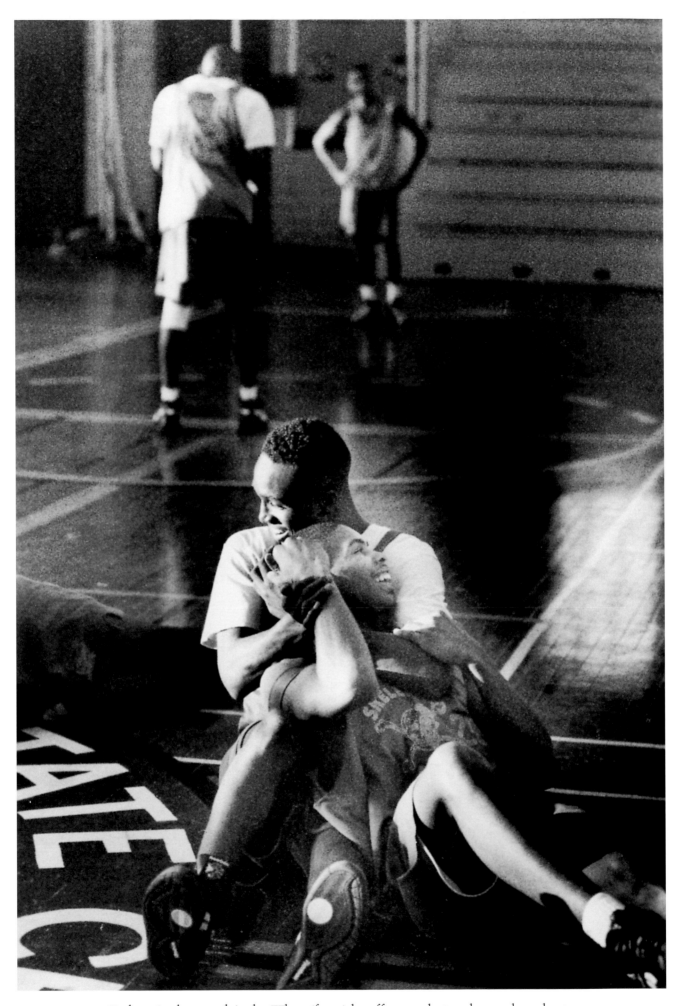

Rodney Anthony and Andra White (front) let off steam during the tough workouts.

In anticipation of the Michigan basketball playoffs, Coach Johnny Goston assembles his Pershing High School Doughboys in their banner-adorned gym.

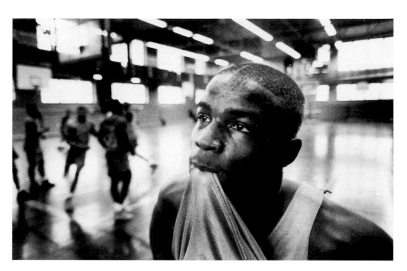

The week before the state finals, Julian Simpson must deal with grief after his brother is killed in a drive-by shooting.

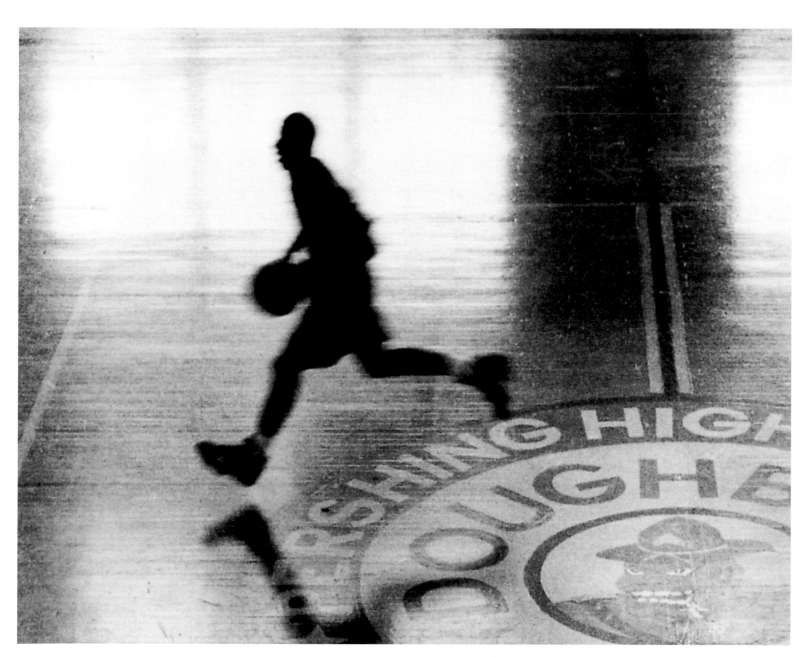

The Doughboys owe their success to hard work during practices.

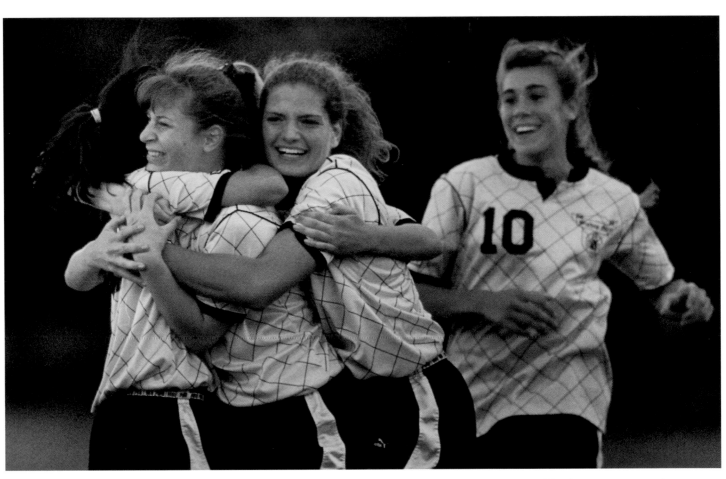

Tanya Cianfasani (second from left) of Bishop Foley High School in Michigan is hugged by her teammates after scoring the winning goal of the girls state soccer playoffs.

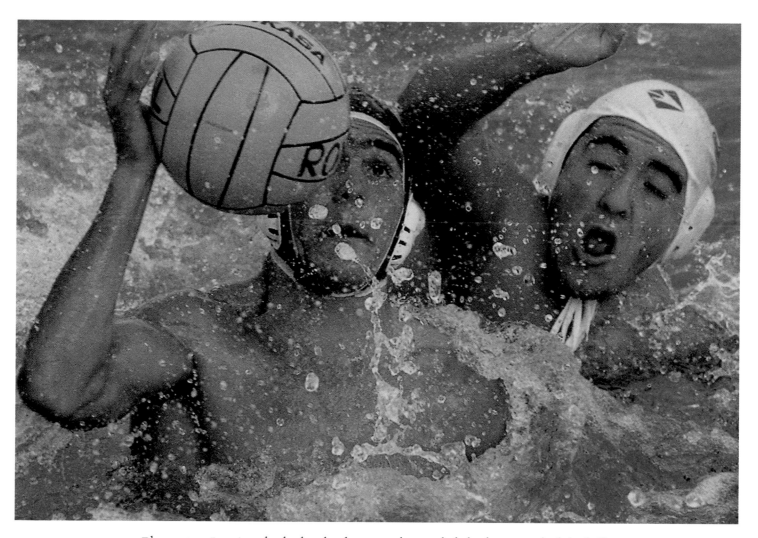

Players in a Los Angeles high-school water-polo match fight for control of the ball.

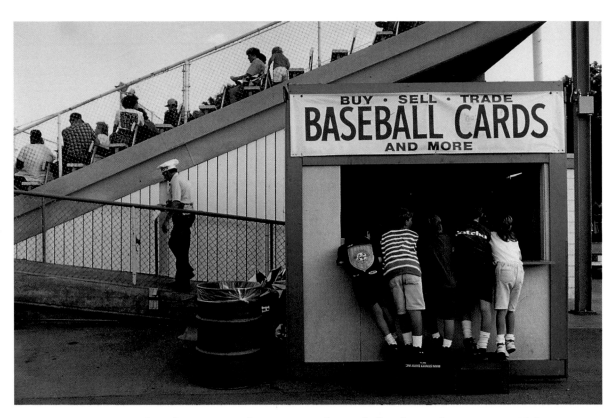

Youngsters shop for sports cards at a minor-league ballpark in Palm Springs, Calif.

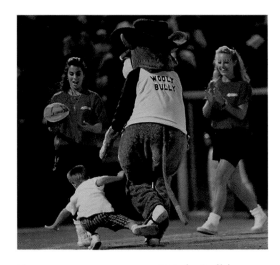

Between innings, mascot Wooly Bull bumps into a boy as they race around the bases.

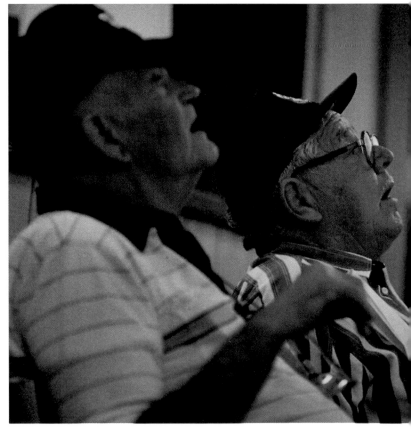

Old-timers watch the flight of the ball. They have been coming to the ballpark in San Bernardino, Calif., for more than 20 years.

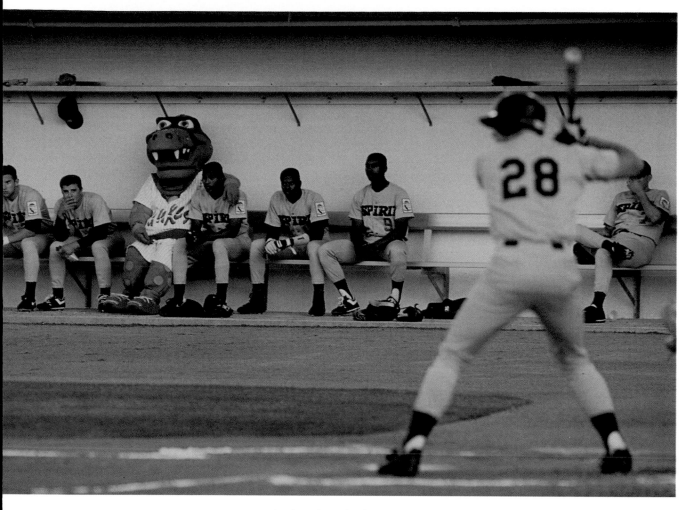

A team mascot sits on the bench with players in Rancho Cucamonga, Calif.

A boy waits with pen and ball in hand, hoping
for an autograph.

A weightlifter releases a bar behind her after realizing she cannot lift it overhead
during the U.S. Olympic Festival in San Antonio, Texas.

A diver competes in the 3-meter springboard event at the U.S. Olympic Festival.

1ST PLACE
Jay Koelzer, Rocky Mountain News
"He Loves Me Not!"
This photo was used with a story on sexual harassment in junior high and high school.

2ND PLACE
Kathy Anderson, The New Orleans Times-Picayune
"Cycle of Abuse"
This ran with a story on a study that found that women can be conditioned from childhood into accepting a cycle of abuse.

AWARD OF EXCELLENCE
Brad Graverson, The Daily Breeze
"Tabloid Trouble"
This illustrated a story on sensationalized journalism being
under fire from legal and professional factions.

AWARD OF EXCELLENCE
Jay Koelzer, Rocky Mountain News
"Wish I Were Beautiful"
A photo illustration about women who go through repeated cosmetic
surgeries because of their insecurities.

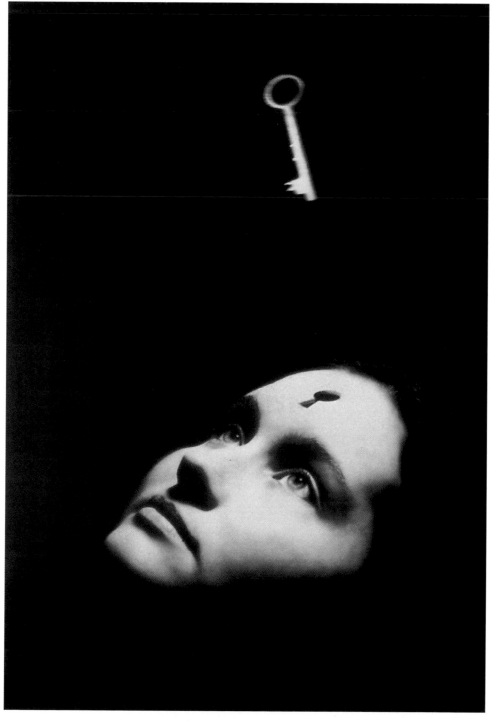

1ST PLACE
Matt Mahurin, Time Magazine
"Key (unlocking mind)"
This illustrated the cover story, "Is Freud Dead?"

2ND PLACE
J. Kyle Keener, The Philadelphia Inquirer Magazine
"Bearing the Yellow Death"
An illustration for a piece on Philadelphia's yellow fever epidemic of 1793.

3RD PLACE
Paula Lerner, Woodfin Camp for Newsweek
"Hyperactivity"

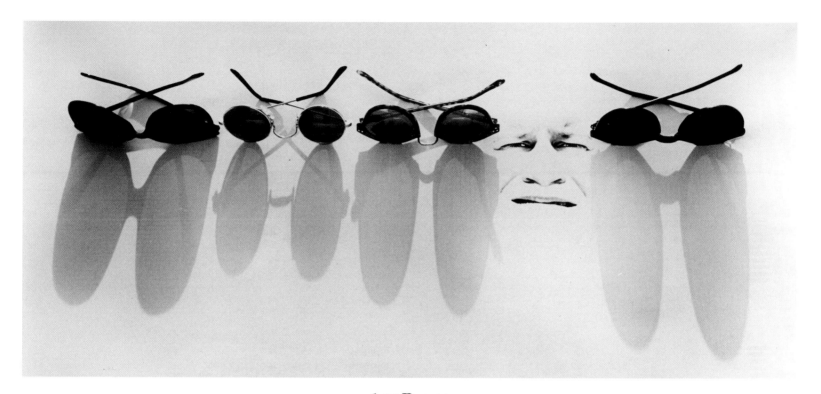

1ST PLACE
Jeff Horner, Walla Walla Union-Bulletin
"Shades" of Summer

2nd Place
Michael S. Wirtz, The Philadelphia Inquirer
"Shampoo – Nature's Ingredients" This photo illustration
accompanied a story about an organic shampoo.

AWARD OF EXCELLENCE
Jay Koelzer, Rocky Mountain News
"Catholic Food" ran with a story on memories of growing
up Catholic, to coincide with the Pope's visit to Denver.

AWARD OF EXCELLENCE
John Luke, Detroit Free Press
"Body Pierce" illustrated a fashion-trend piece.

3RD PLACE
Ellen Jaskol, Rocky Mountain News
"Pig On Point"
A pot-bellied pig, being photographed for a story on Halloween costumes for pets, became uncooperative.

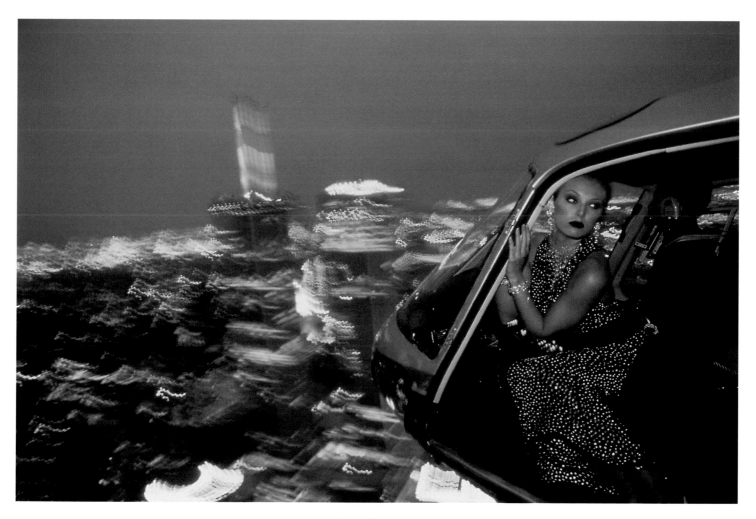

1ST PLACE
Joseph McNally, freelance
"Glamorous Evening"
Enjoying the nighttime view over Manhattan.

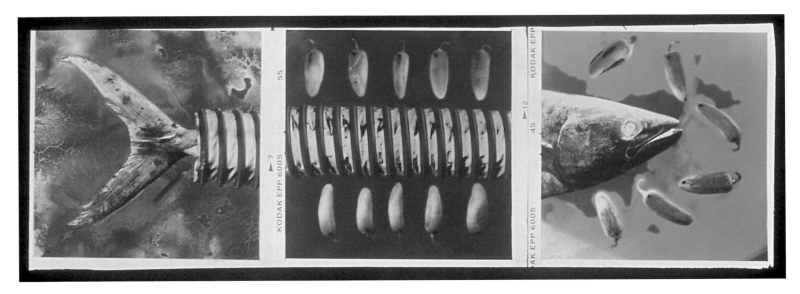

2ND PLACE
Stan Gaz, freelance for Newsweek
"Fish and Chilies"
Teaching an old fish new tricks: peppering up tuna.

3RD PLACE
Carmen Troesser, University of Missouri
"The Versatility & Variety of Melons"

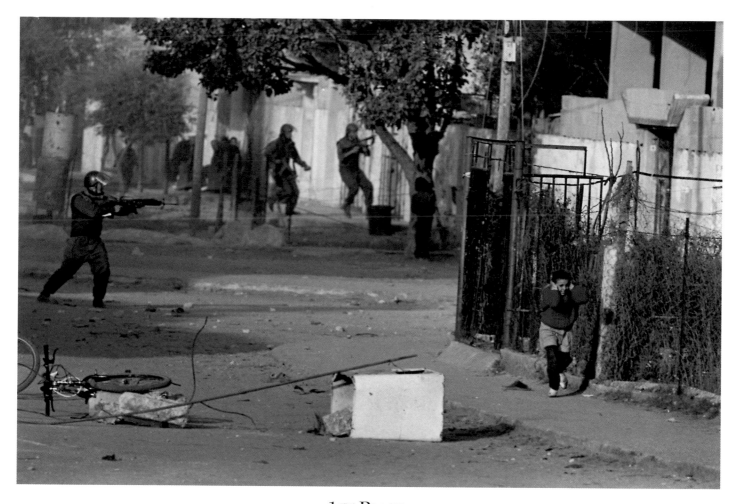

1st Place
Patrick Baz, Agence France-Presse
A young girl runs for safety during a clash between Palestinian demonstrators and Israeli border police in the Gaza Strip.

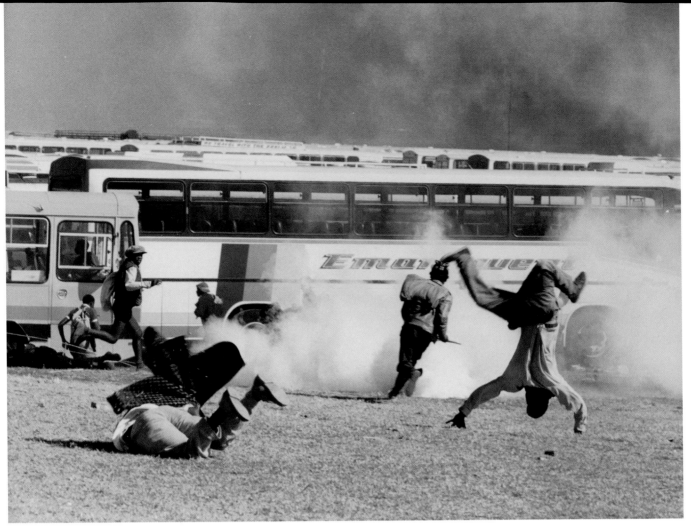

3rd Place
Greg Marinovich, The Associated Press

South African demonstrators scatter as police fire tear gas, rubber bullets and buckshot outside the Soweto soccer stadium where the funeral of activist Chris Hani was held.

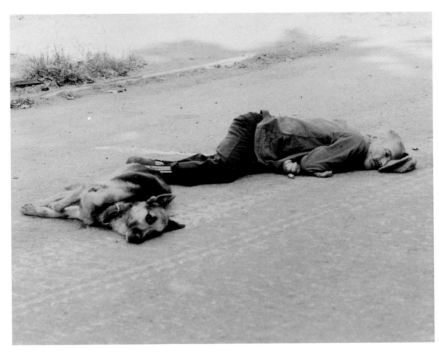

2nd Place
Andrei Soloviev, The Associated Press

A dog and its master, both killed during the Abkhazian assault on Sukhumi, become two more victims of the civil war in Georgia.

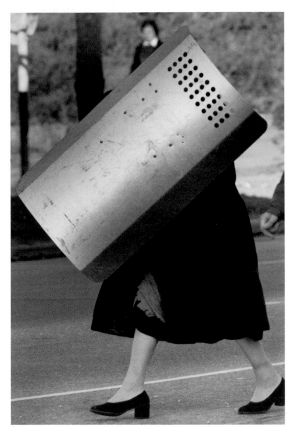

Award of Excellence
Philip S. Hossack, Winnipeg Free Press
A Moscow woman carries an abandoned riot shield
to pro-communist forces during fighting between
Yeltsin supporters and communist hard-liners.

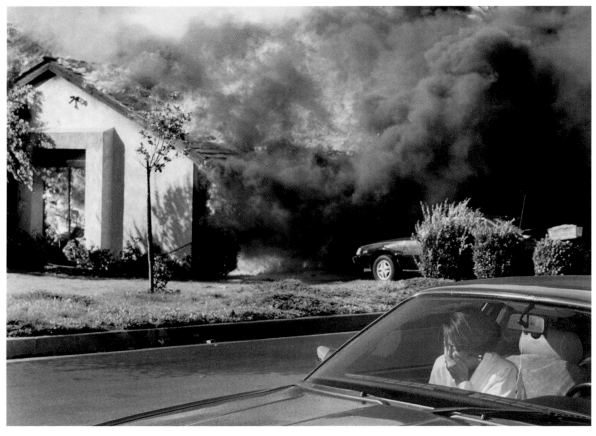

Award of Excellence
Mark J. Terrill, The Associated Press
A woman cries as her neighbor's house burns in Altadena, Calif.

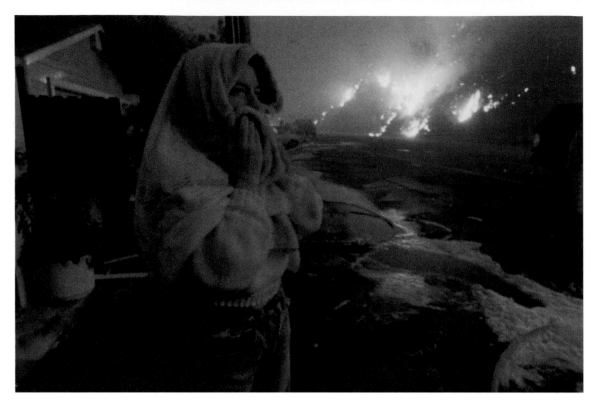

AWARD OF EXCELLENCE
Richard Hartog, Oakland (Calif.) Outlook
Susan Stanfield watches a firestorm sweep near her Malibu, Calif., home at midnight.

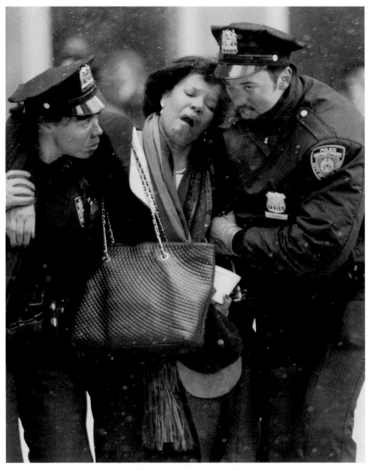

AWARD OF EXCELLENCE
Joseph Tabacca, freelance for The Associated Press
A woman gasps for breath as she is helped by New York City
police officers after a terrorist bombing at the World Trade Center.

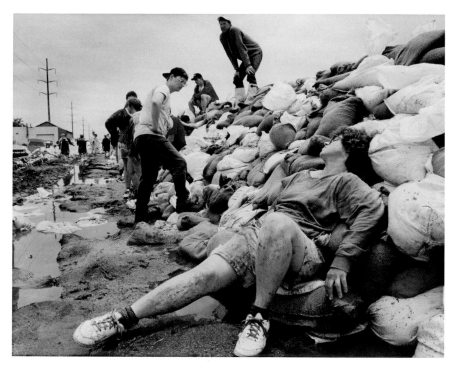

AWARD OF EXCELLENCE
Jeff Beiermann, freelance for The Associated Press
Pam Christian lies asleep from exhaustion after helping to build a sandbag
dike during flooding in Des Moines, Iowa.

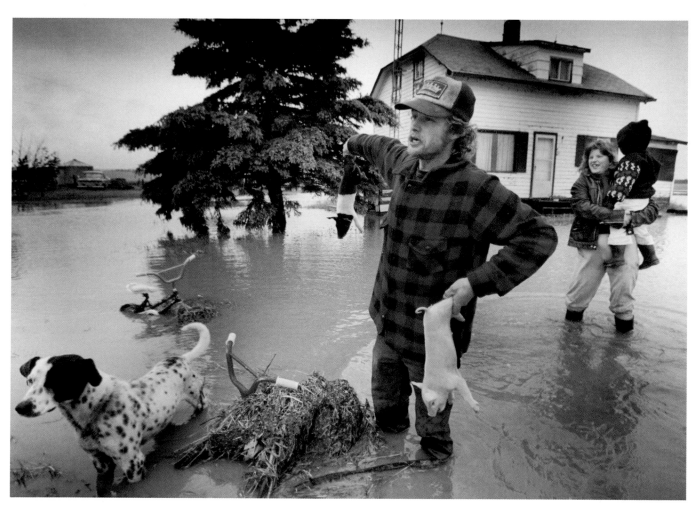

AWARD OF EXCELLENCE
Marc Gallant, Winnipeg Free Press
Farmer Norman Brown searches for day-old piglets during flooding.

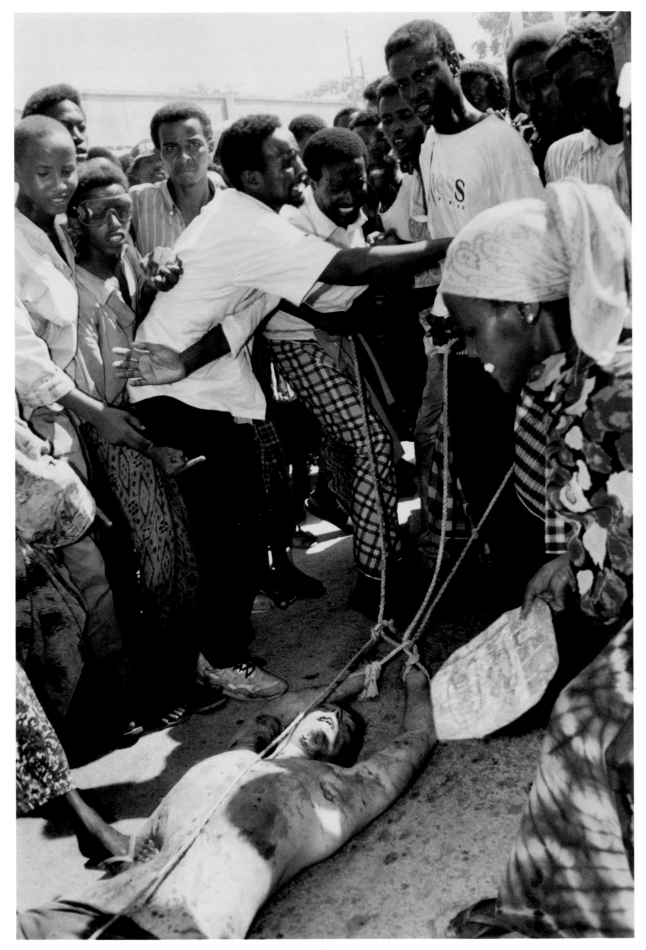

Award of Excellence
Paul Watson, The Toronto Star/The Associated Press
The corpse of a U.S. serviceman is dragged through the streets of war-torn Mogadishu.

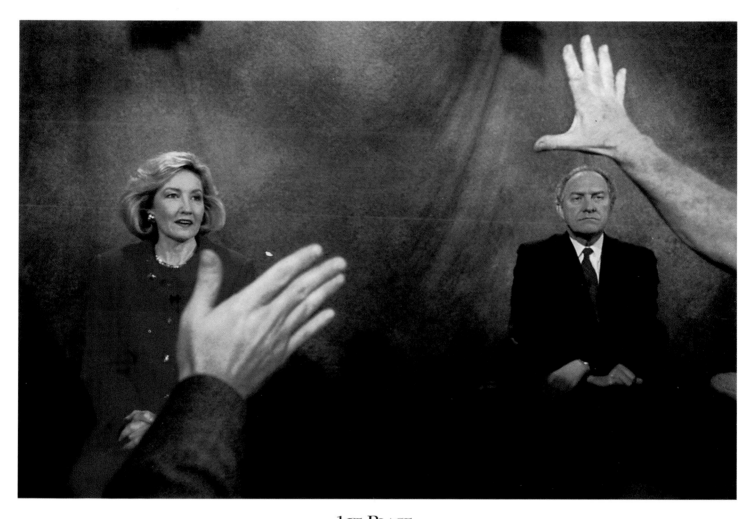

1st Place
Patrick Davison, The Dallas Morning News
Senatorial candidates Kay Bailey Hutchison and Bob Kreuger receive instructions from producers before a taped debate on KERA-TV in Dallas.

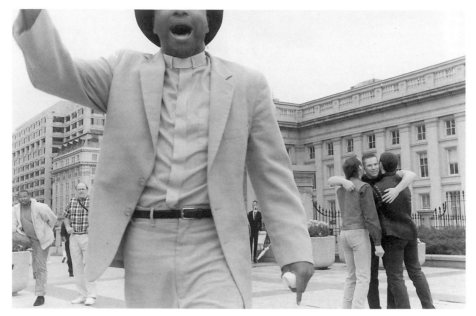

3RD PLACE
Gene Berman, University of Missouri
A reverend from Florida shouts "All fags go to hell," as three gay men embrace in the background, during the 1993 Gay Rights March in Washington, D.C.

2ND PLACE
Kathy Anderson, The New Orleans Times-Picayune
New Orleans police officers restrain the Rev. Avery Alexander, longtime civil-rights leader and state representative, during a scuffle at rededication ceremonies of the Liberty Monument. Many African-American leaders say the monument is a racist symbol.

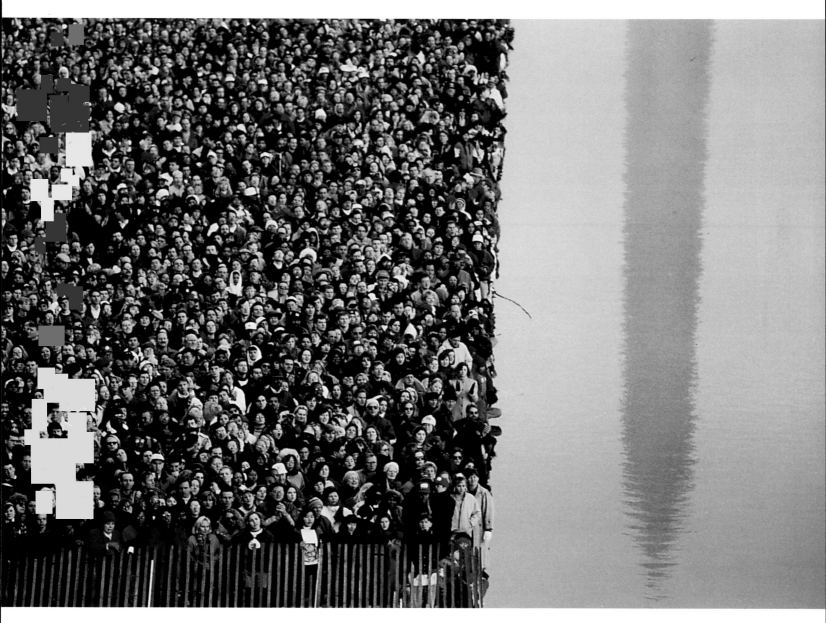

AWARD OF EXCELLENCE
Paul F. Gero, The Arizona Republic
A crowd of thousands gathers near the Lincoln Memorial in Washington, D.C., for a concert kicking off the Clinton Inauguration in January 1993. The Washington Monument is reflected in the pool at right.

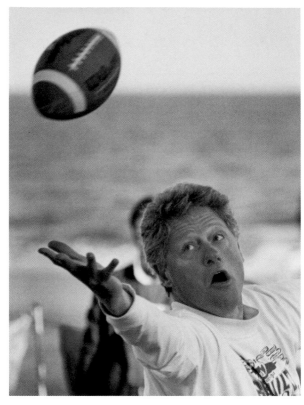

AWARD OF EXCELLENCE
Robert Giroux, Agence France-Presse
President Clinton finds the pigskin beyond his reach
during a touch football game at Hilton Head, S.C.

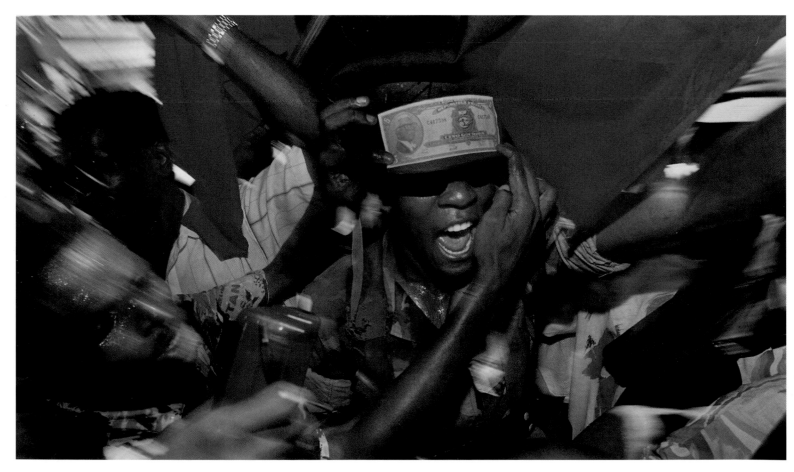

AWARD OF EXCELLENCE
Lannis Waters, The Palm Beach Post
A Haitian soldier joins a street demonstration in Port-au-Prince, opposing the scheduled return of ousted President Jean-Bertrand
Aristide in October 1993. The former leader did not return.

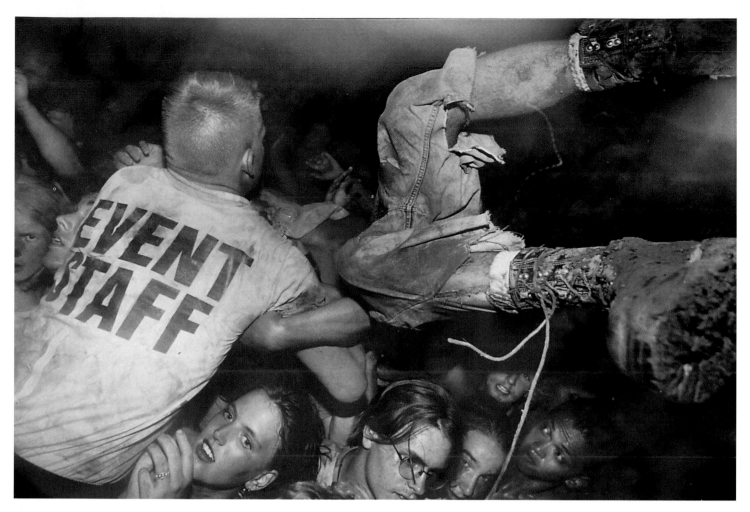

Award of Excellence
Joe Crocetta, The (Hagerstown, Md.) Herald-Mail Co.
A stagefront security guard helps a concertgoer out of the "moshing pit" at Lollapalooza '93 in Charles Town, W.Va.

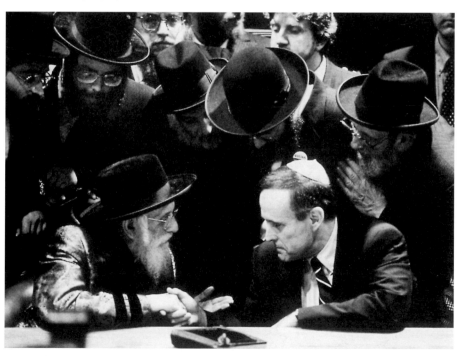

Award of Excellence
Andrea Mohin, The New York Times
New York City Mayor Rudolph W. Guiliani (right) consults Grand Rabbi Solomon
Halberstam while campaigning in Brooklyn at Bobover Hasidic Headquarters.

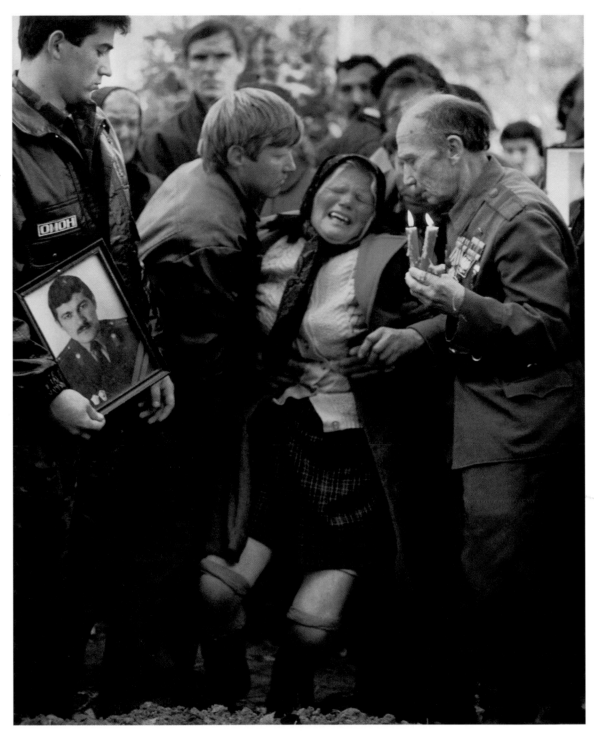

Award of Excellence
Lucian Perkins, The Washington Post
Lt. Alexander Marvin's mother collapses at his graveside during his burial. Marvin was a member of Russia's elite force, the Omon, and was killed when his unit retook the Parliament building during the October 1993 Moscow standoff between Yeltsin supporters and pro-communist hard-liners.

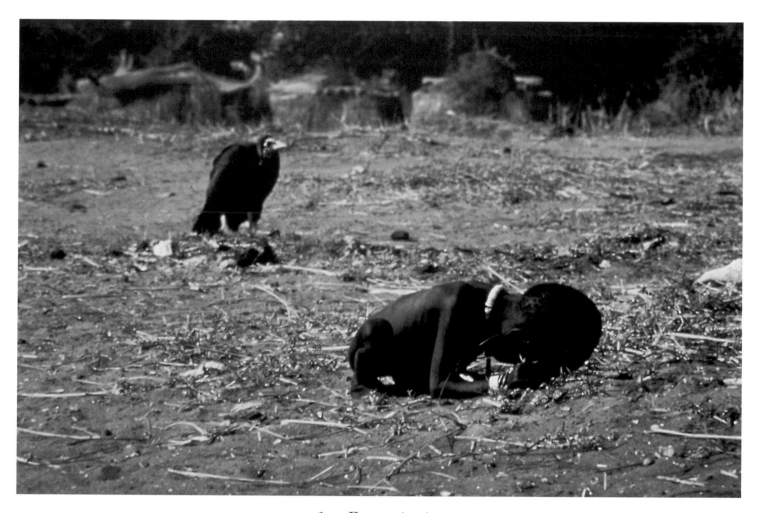

1ST PLACE (TIE)
Kevin Carter, Sygma
A vulture lurks nearby as a starving Sudanese child collapses on the trail to a feeding center.

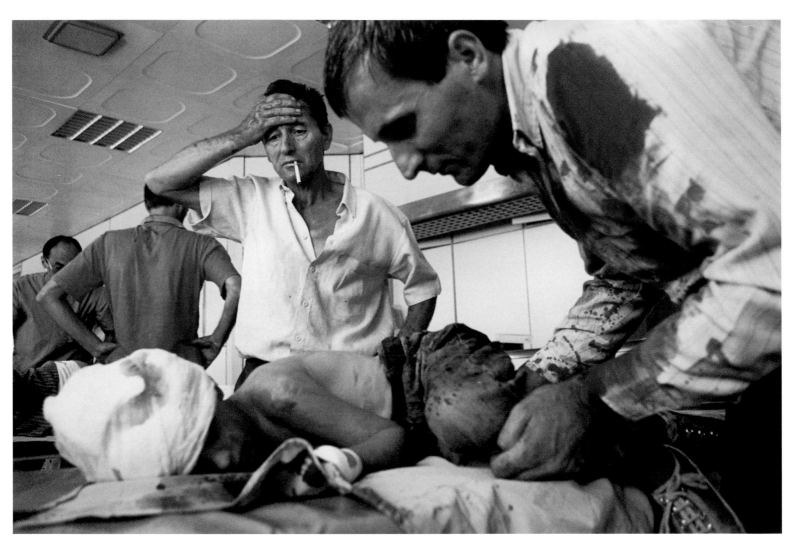

1st Place (tie)
Debbi Morello, freelance
A father comforts his wounded son as a distressed relative looks on in Mostar, Bosnia-Herzegovina.

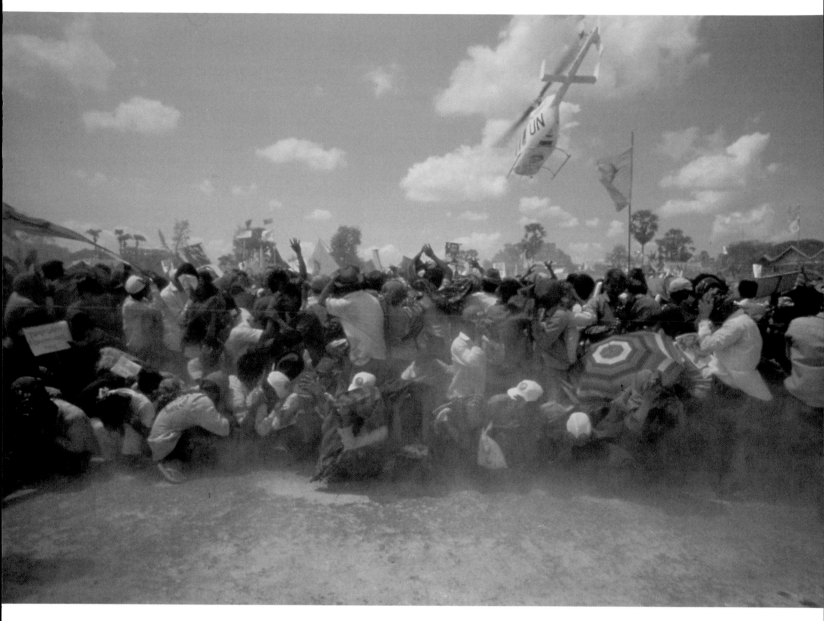

2ND PLACE
Tim Page, Life/Reportage Photos
United Nations helicopters hover overhead to supervise during a Cambodian election.

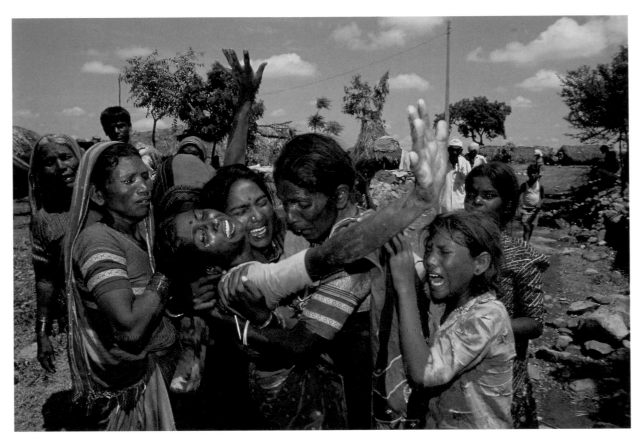

AWARD OF EXCELLENCE
Swapan Parekh, Black Star

After a predawn earthquake in Latur, India, several survivors grieve together. Over 15,000 people perished in the Sept. 30, 1993, temblor, and as one person said, "There is no one to console anymore. Most are dead."

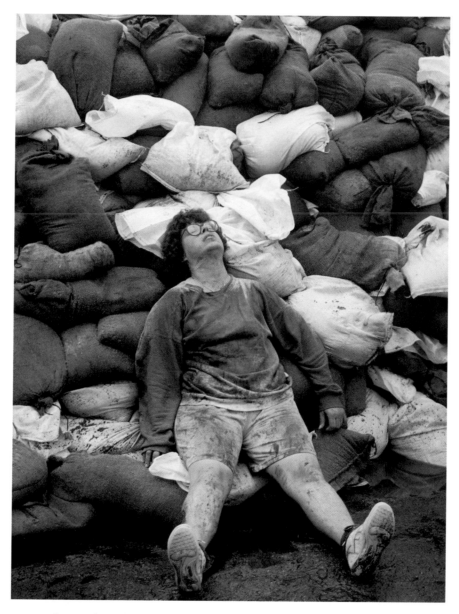

An exhausted Pam Christian collapses on a wall of sandbags after helping patch a levee to save some downtown businesses in Des Moines, Iowa.

THE GREAT FLOOD OF '93

During the summer of 1993, torrential rains pounded the Midwest, sending floodwaters over swollen levees and swamping communities along the Mississippi River. After more than three months of flooding, the toll was 50 dead, 70,000 homeless and over 20 million acres of farmland ruined. At a price tag of over $12 billion, the flood ranks as the second most costly natural disaster in U.S. history, behind Hurricane Andrew.

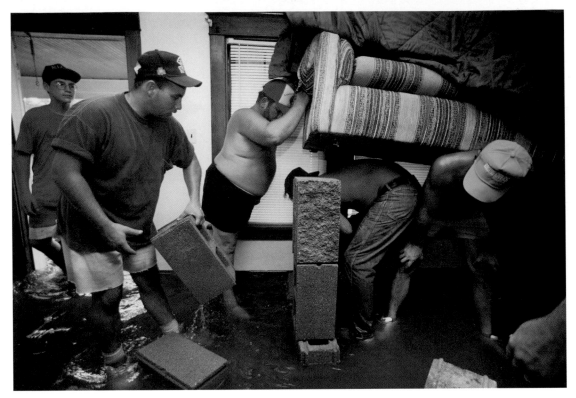

Jeff Hughes offers his back to hold up a couch while neighbors in Grafton, Ill., help the Gallegos family raise the furniture above the rising Mississippi River.

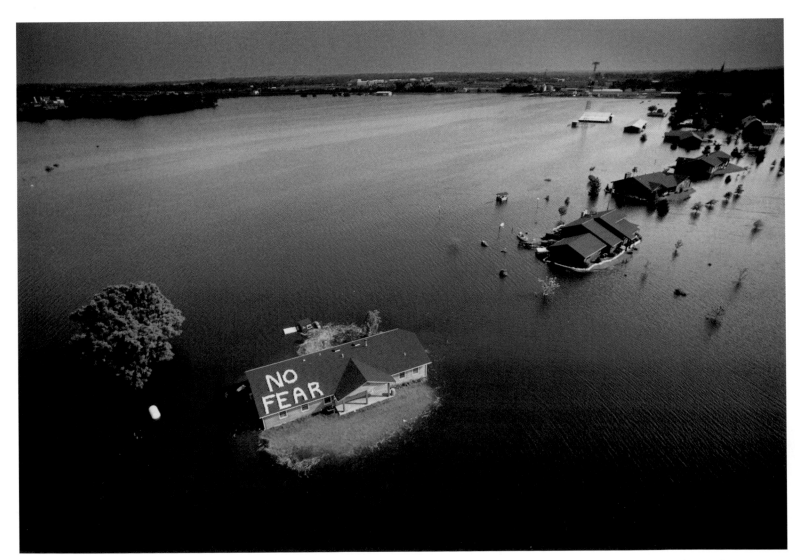

Despite a perilous position, a house in St. Charles, Mo., carries a hopeful message written in sandbags on the roof.

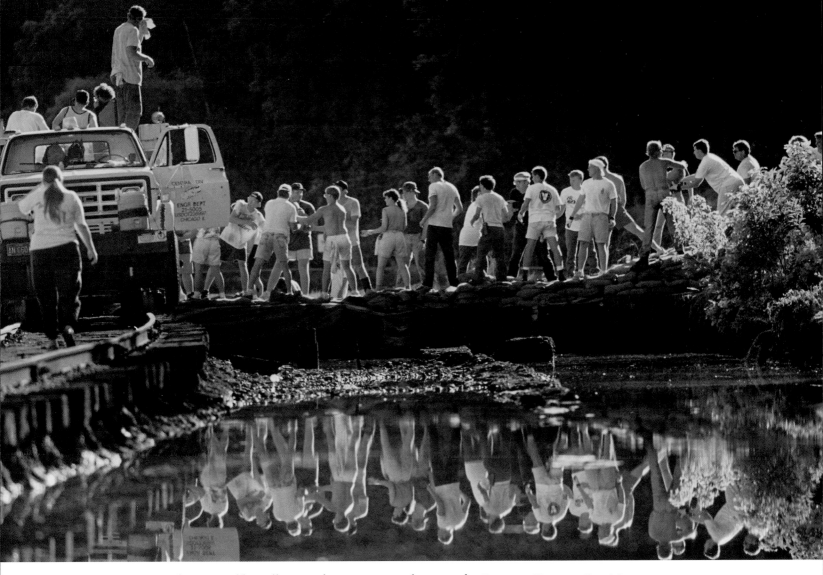

Volunteers add sandbag reinforcements to a levee on the Raccoon River in Des Moines.
More than 1.5 million sandbags were used in the area.

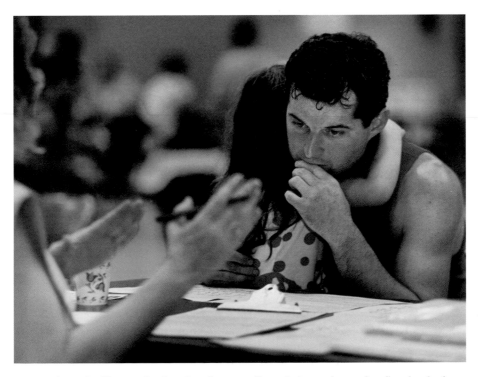

Fred Medcalf consoles his daughter, Kellie, while applying for flood-relief
money in St. Louis.

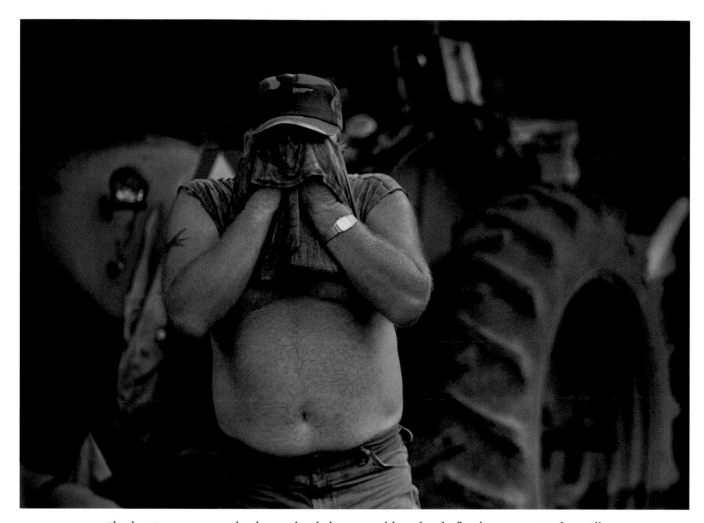

Charlie Simpson wipes his brow after helping neighbors battle floodwaters in Grafton, Ill.

The 1st place winner
in this category is part
of the Newspaper
Photographer of the
Year portfolio,
beginning on page 11.

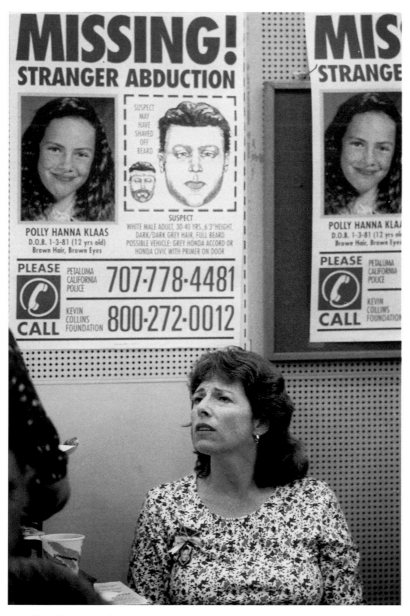

Polly Klaas' mother, Eve Nichol, waits at the search headquarters, hoping for her daughter's safe return.

PRAYERS FOR POLLY

On Oct. 1, 1993, 12-year-old Polly Klaas was kidnapped from a bedroom in her mother's home in Petaluma, Calif. Over the next two months, a nationwide search was launched for the girl. Polly's mother and hundreds of volunteers tried to stay optimistic as the days passed without a clue. But in December, a few days after an arrest was made in the case, Polly's body was discovered.

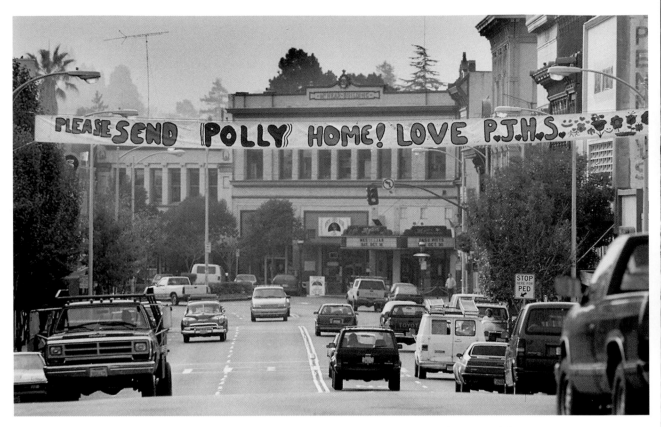

Polly's classmates hang a banner over downtown Petaluma, Calif.

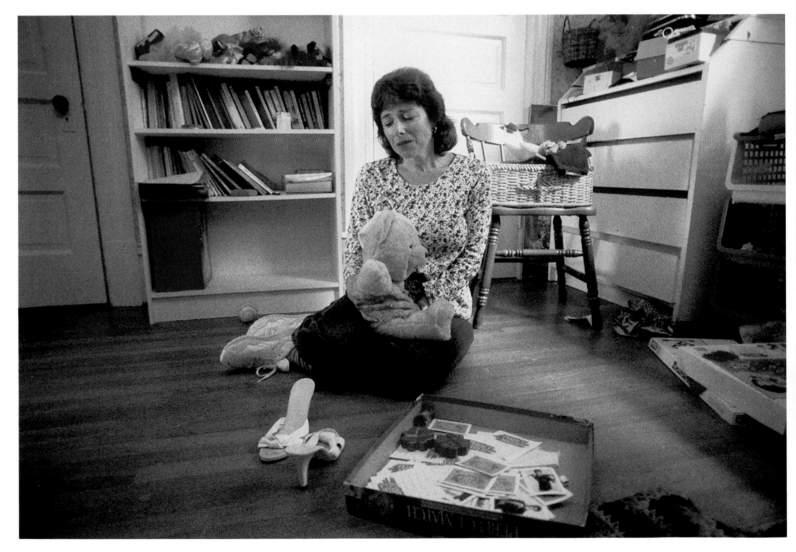

Inside her daughter's bedroom, Eve tries to remain optimistic.

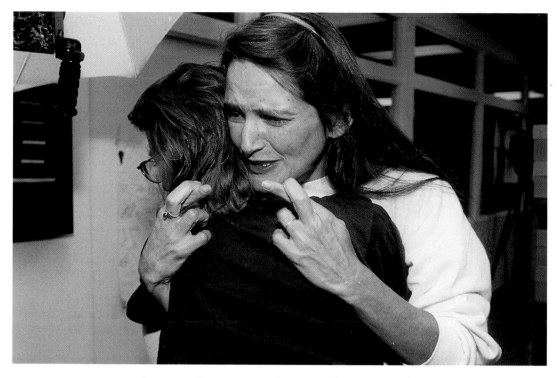

As word comes of an arrest in the case, volunteers are hopeful.

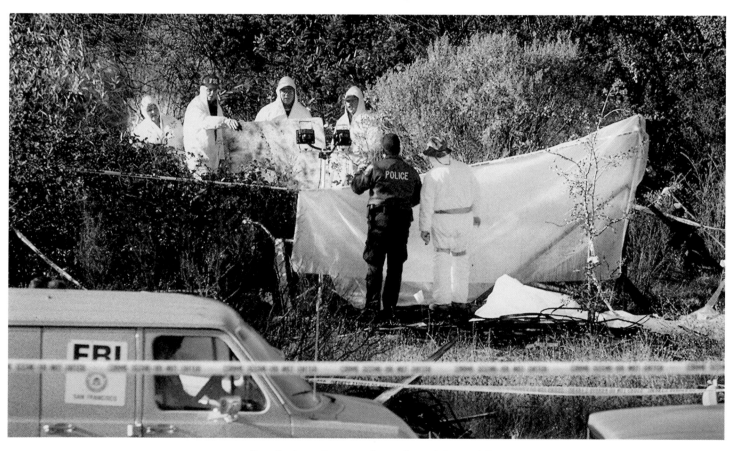

Polly's body is discovered in Cloverdale, Calif.

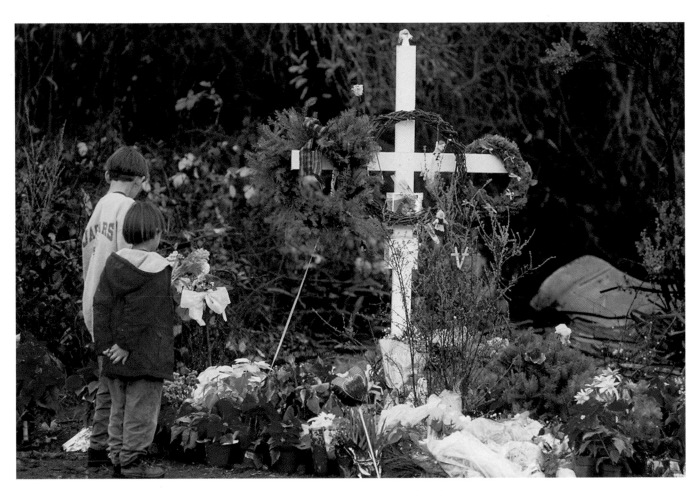

A white cross is placed at the site where Polly's body was found.

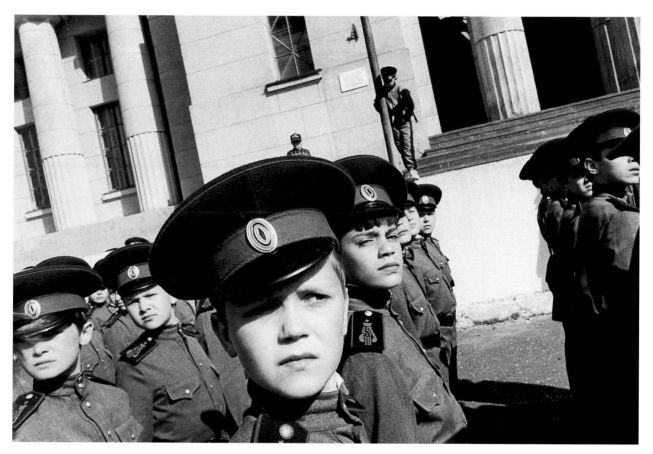

Young Cossacks practice military marching drills at "Kadetsky Korpus,"
a cadet training academy in Novocherkassk, Russia.

COSSACK THUNDER

Today's Cossacks take pride in their history of serving the Czars during Russia's imperial expansion. In their paramilitary society, they protected Russia's borders and suppressed any opposition to Russian orthodoxy. They also were free to terrorize with brutal pogroms. After years of peaceful coexistence with other ethnic groups — imposed upon them by communist rule — the Cossacks are striking out. They have started an academy for boys to rekindle Cossack identity and teach military strategy. Adults once again wear the traditional uniforms, and crave recognition as the force to keep Russia's soul alive.

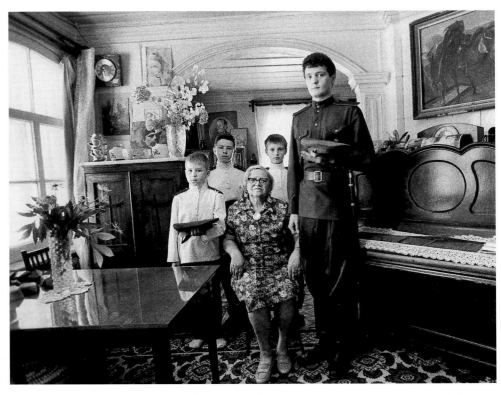

Ludmilla Larina, 67, sits at home with her four grandsons, all students of the Kadetsky Korpus. The oldest, Konstantin, fought in Abkhazia. Under communist rule, it would have been a crime for the boys to own or wear a Cossack uniform.

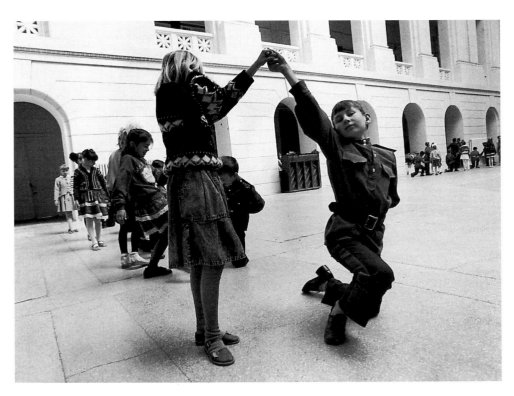

With the help of local residents, cadets learn formal dancing at the academy.

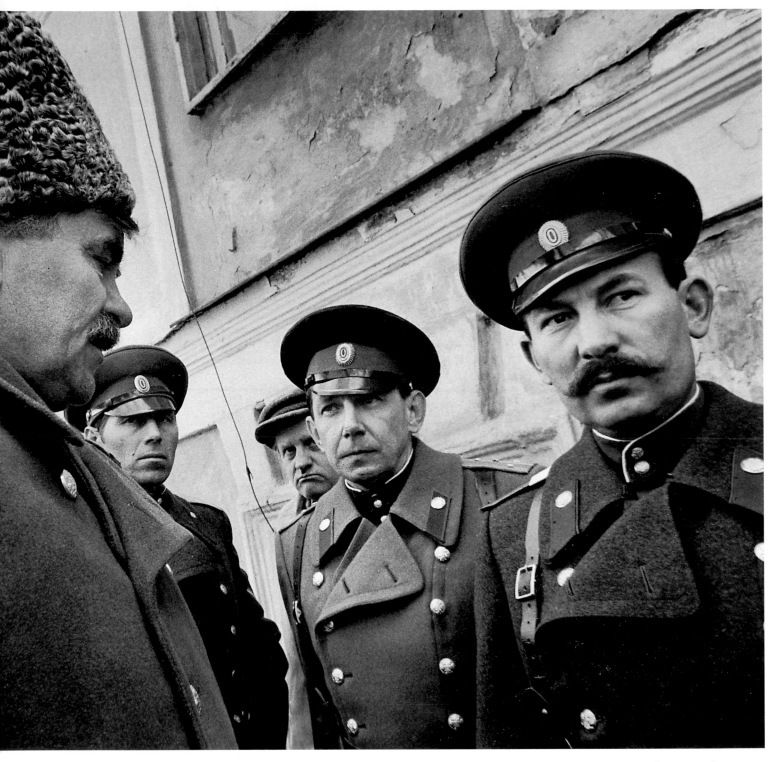

Cossack Chief Vasili Kaledin addresses his men outside Cossack headquarters in Rostov-on-Don, Russia. The Cossacks were evicted from the building two weeks earlier by the local government after a murder had occurred inside. The men stood vigil every day waiting for word that they could re-enter.

Cossack Chief Alexander Udin holds an informal, outdoor meeting with his men in Rostov-on-Don, Russia. Udin is critical of other Cossack chiefs for accepting non-ethnic members into their groups.

Cossacks crowd into a cathedral in Novocherkassk, Russia, for a service in honor of Gen. Count Matvey Platov, a hero of the Napoleonic war. After eulogies, a symbolic coffin is lowered into the crypt from which Platov's body was exhumed by the Soviets.
This is part of a two-day celebration honoring the Cossack movement.

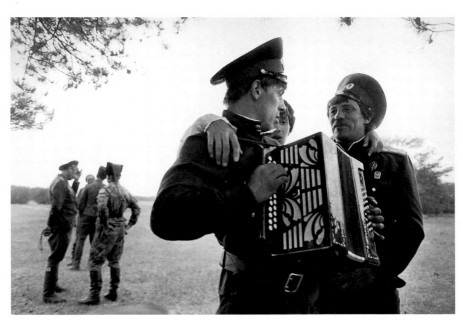

Cossacks gather in the village of Veshinskaya, Russia, the home of novelist
Mikhail Sholokhov, for a weekend festival celebrating his 88th birthday.
Author of *And Quiet Flows the Don*,
Sholokhov won the Nobel Prize for Literature in 1965.

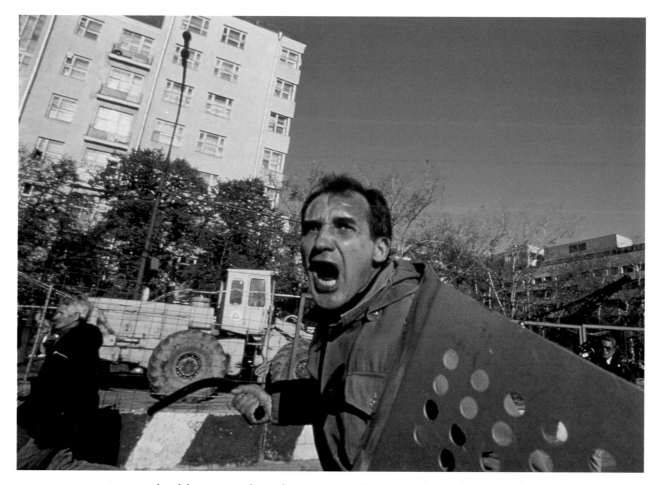

An angry hard-liner runs through Moscow on his way to the Parliament building.

RED OCTOBER

A power struggle between Russian President Boris Yeltsin and those opposed to the pace of his political and economic reforms came to a head in the fall of 1993. After Yeltsin disbanded Parliament in late September, former Vice President Alexander Rutskoi and other hard-liners barricaded themselves in the Parliament building. For nearly two weeks the standoff was peaceful, but on Oct. 3, communists and neo-fascists supporting Rutskoi rioted in Moscow. Yelstin quelled the rebellion by calling in troops to take back the building, forcing Rutskoi and his followers to surrender. It was the worst fighting in the city since the 1917 Bolshevik Revolution.

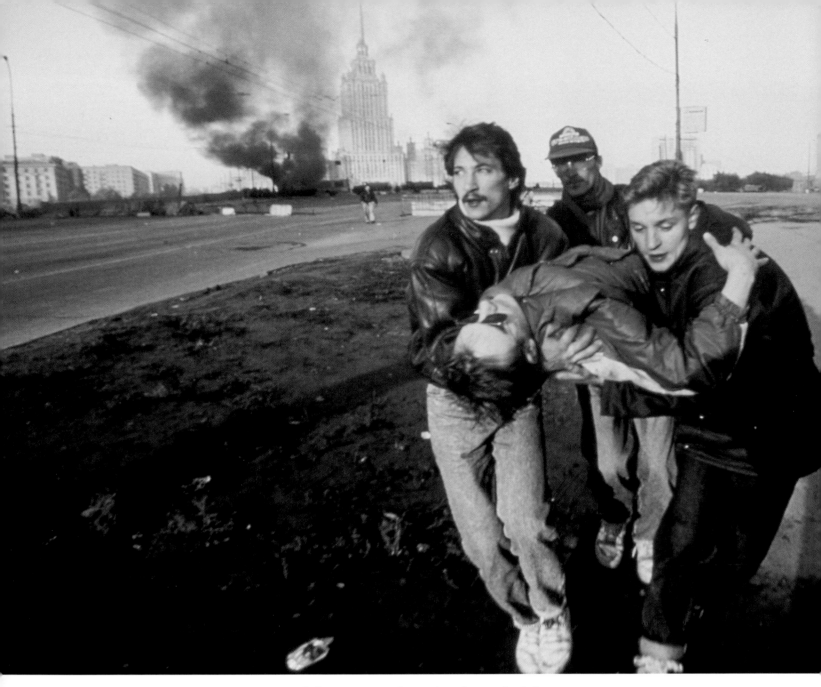

A wounded man is carried to safety during the fighting.

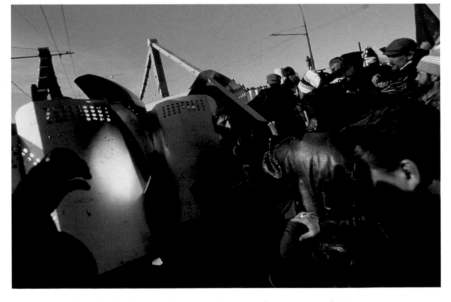

A mob clashes with riot police on the streets of Moscow.

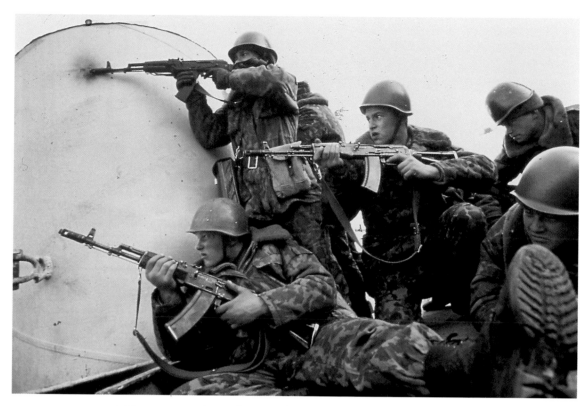

Soldiers aim at the Parliament building from behind a water tank
on a rooftop before penetrating the building.

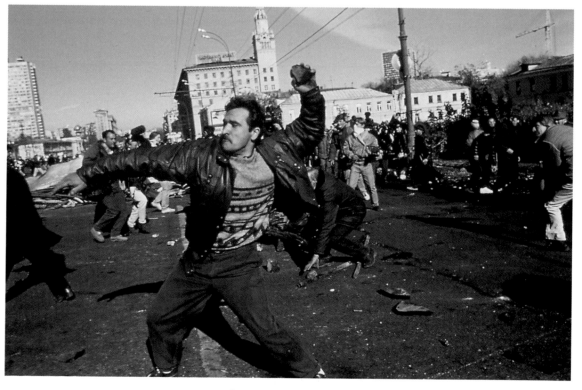

An angry mob temporarily controls the street.

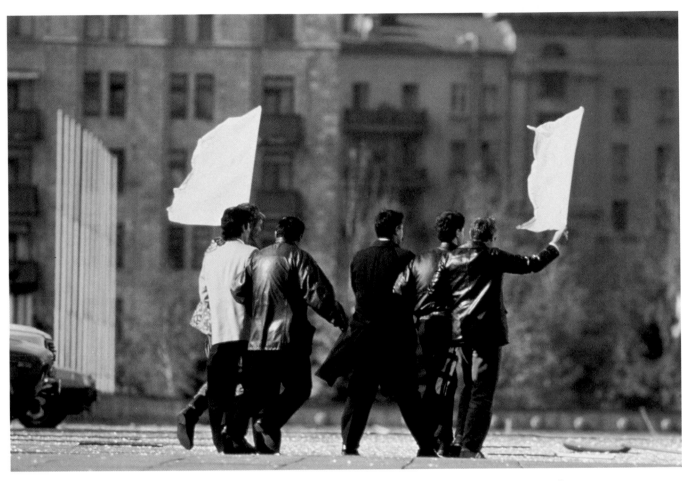

Those who surrendered were guaranteed safe escort out of the building by the assault unit.

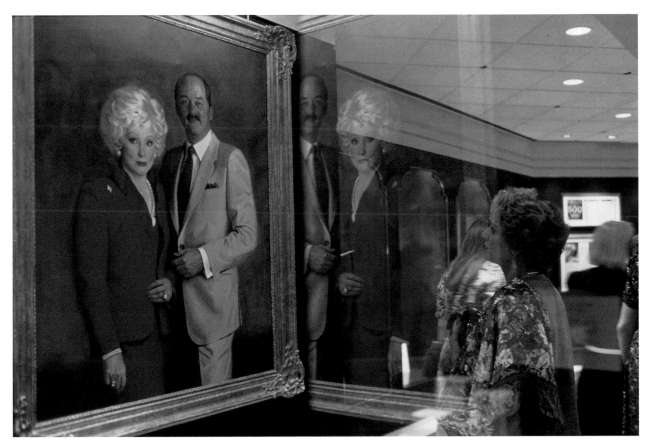

A Mary Kay museum in Dallas displays a painting of Chairman Emeritus Mary Kay Ash and her son, cofounder and Chairman Richard Rogers.

PINK CADILLACS, WHITE ROCKS

Mary Kay Ash knows what the people who work hard to sell her cosmetics want: more than money, more than diamonds, more even than pink Cadillacs, they want recognition – a stroke from above for a job well done. And Ash is just the person to give it to them. Every year, Ash hosts Seminar, a three-day convention in Dallas that applauds the accomplishments of the women and men who sell Mary Kay cosmetics and inspires them to strive even harder. The inspiration seems to work: the company's sales have topped $613 million. More than 6,500 consultants now drive complimentary pink Cadillacs, and countless others sport diamond rings, bracelets and pins attesting to their sales prowess.

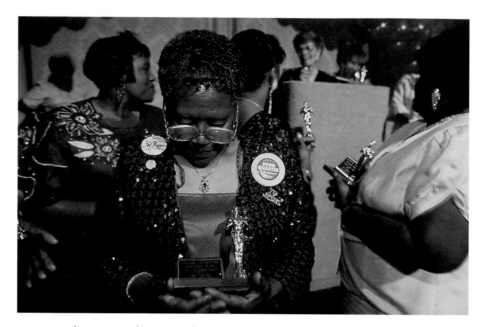

Jessie Jackson considers a trophy she received at Seminar, an annual three-day
rally held in Dallas for Mary Kay consultants.

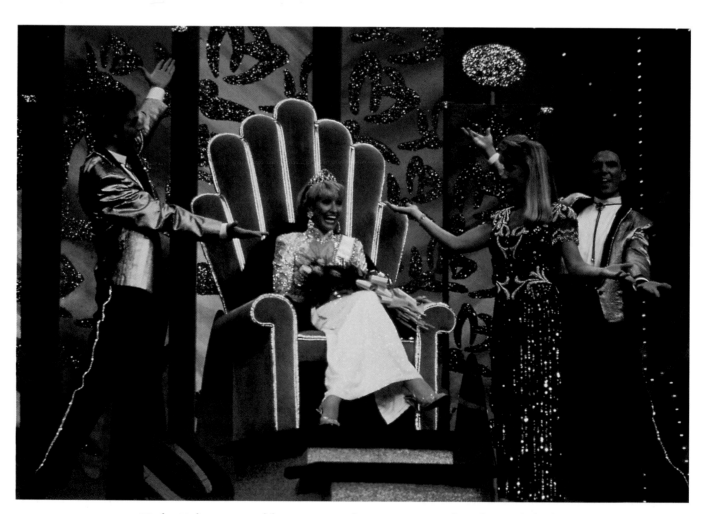

Kathy Helou is one of four Queens of Seminar crowned at the yearly bash.
The honor is bestowed on women who have excelled in the business.

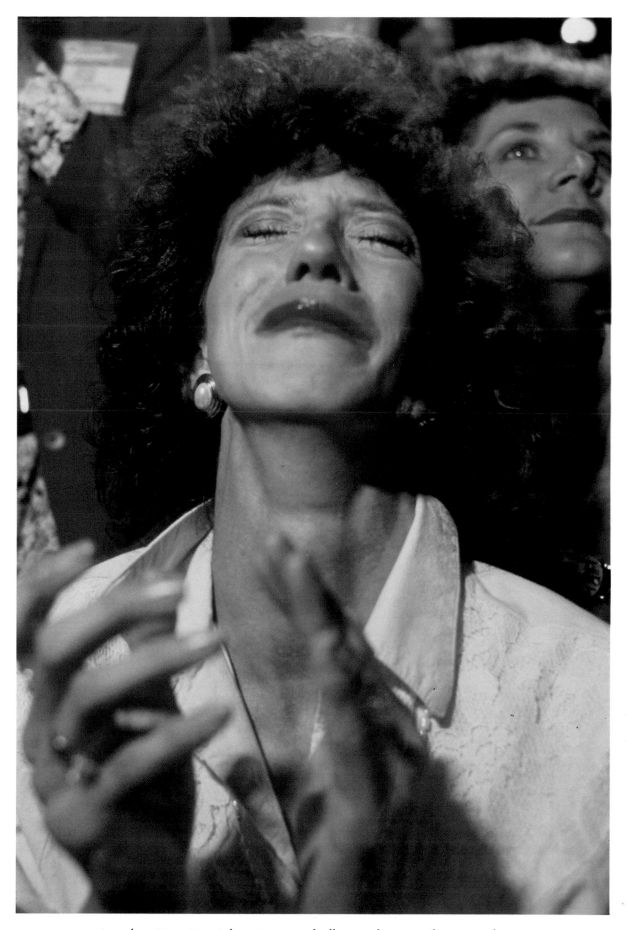

A peek at Mary Kay Ash at Seminar thrills consultants to the point of tears.

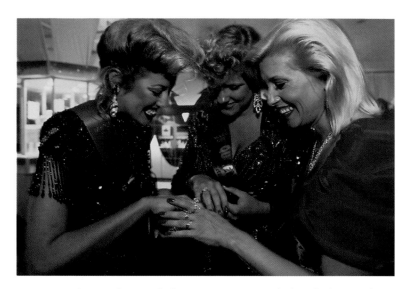

Women whose sales reach $32,000 are rewarded with diamonds.

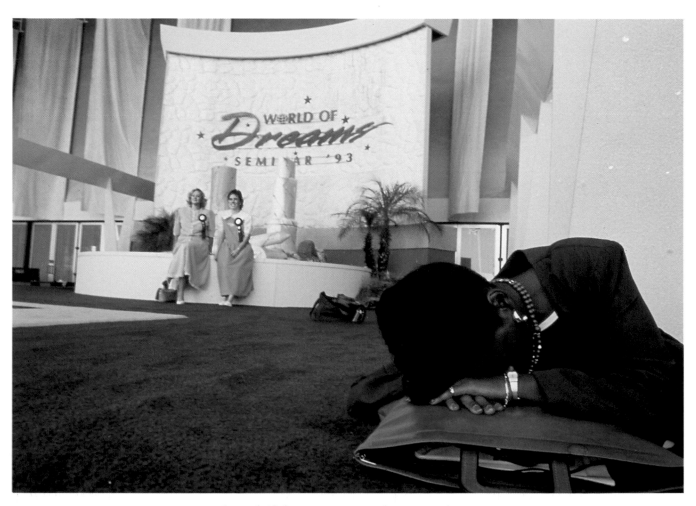

At the end of the convention, exhaustion takes over.

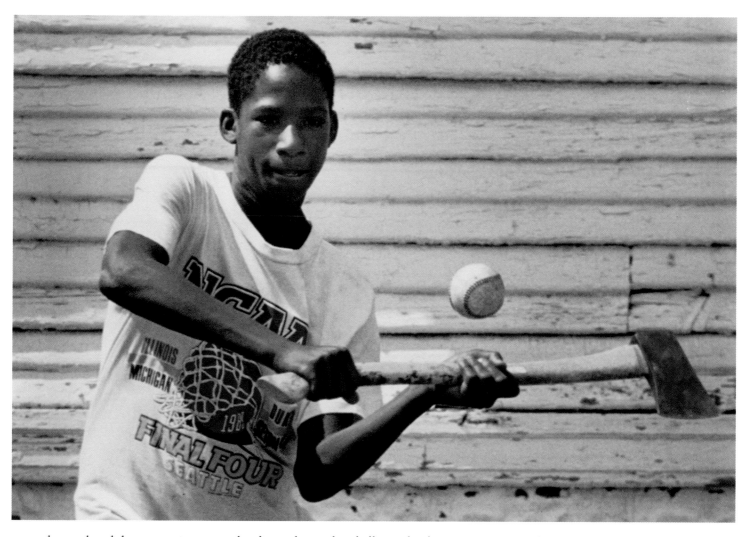

Lacking a bat didn't stop Cortez Traylor from playing baseball near his home in Detroit. The 12-year-old made due with a long-handled axe until a friend with a real bat joined the game.

Farewell: After a bitter, 2-1/2 year custody battle, Baby Jessica is taken from her adoptive parents and returned to her biological parents.

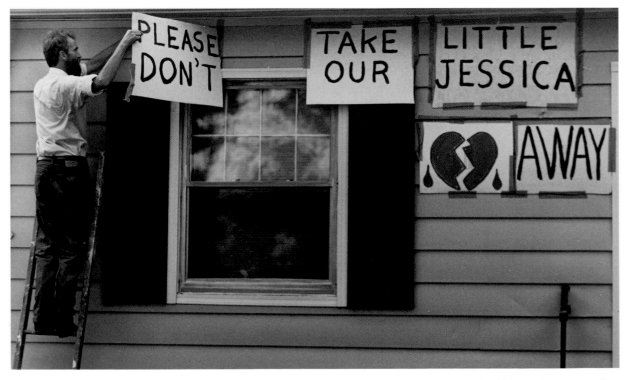

Jan DeBoer removes signs he put on his home in Ann Arbor, Mich., as a last-ditch effort to keep custody of Baby Jessica.

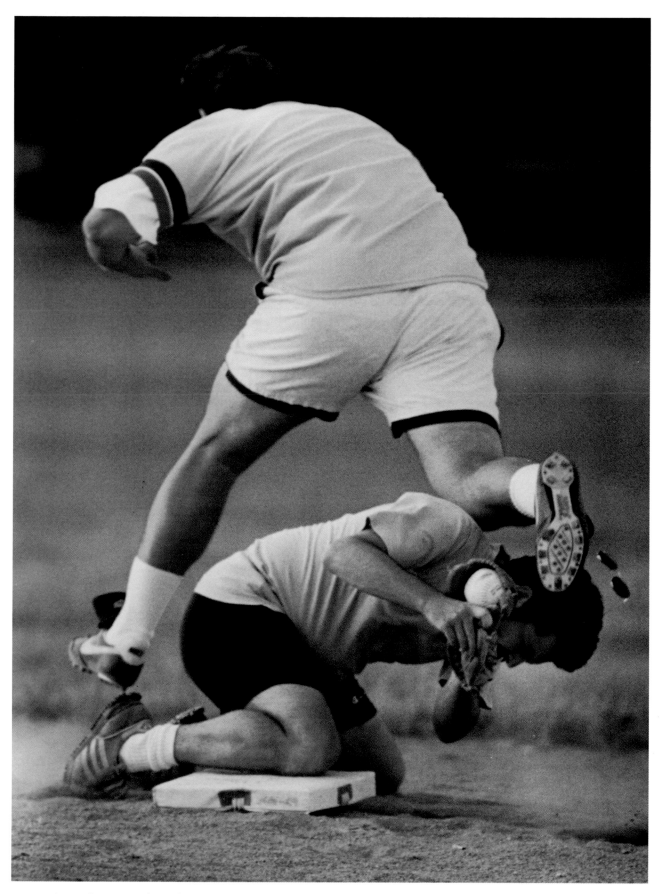

Mark Riashi is tagged out despite running over second baseman Andrew Wise during a company softball game between attorneys and clerks from the Federal Defenders Office and the law offices of Dickenson-Wright in Detroit.

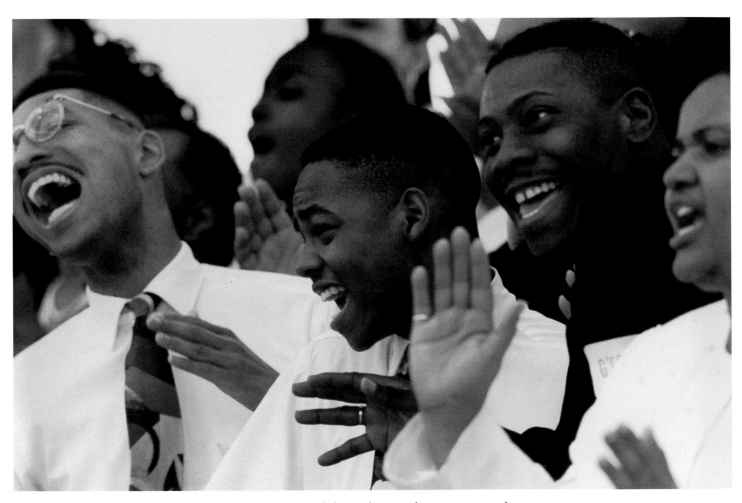

The Young Artists for Christ Workshop Choir performs at a gospel concert in Detroit.

NEWSPAPER ONE WEEK'S WORK

Brian Davies • Second Place • Marysville (Calif.) Appeal-Democrat

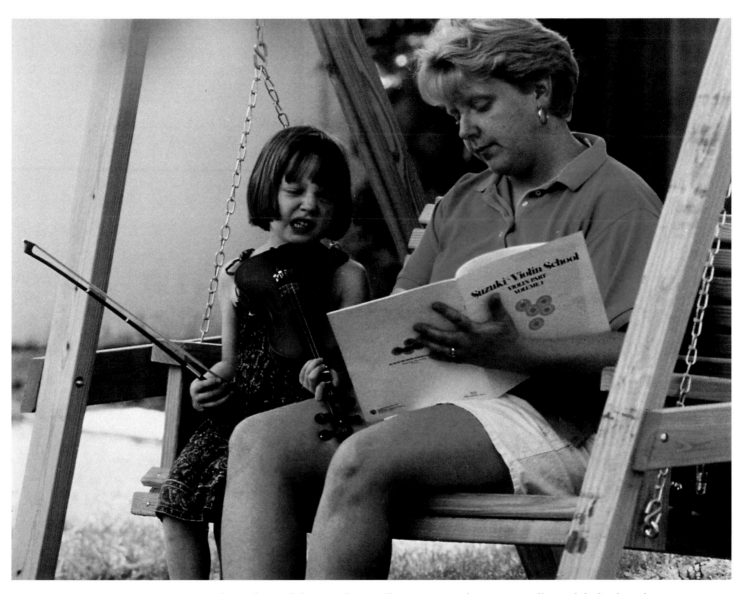

Hattie Bains practices the violin with her mother, Kellie Bains, in their Marysville, Calif., backyard.

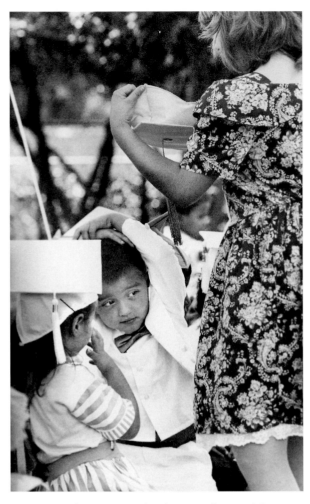

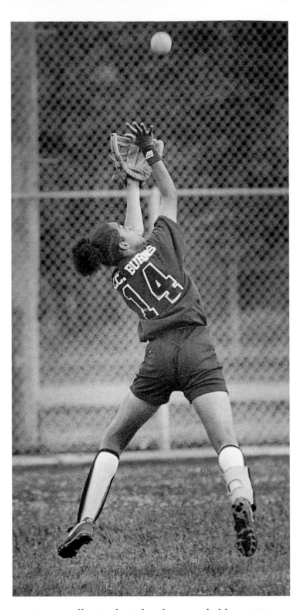

At a Head Start preschool in Gridley, Calif., not every five-year-old can be persuaded to wear a cap for the graduation ceremony.

Marysville High School centerfielder C.C. Burns makes an over-the-shoulder catch during a high-school playoff game in Lodi, Calif.

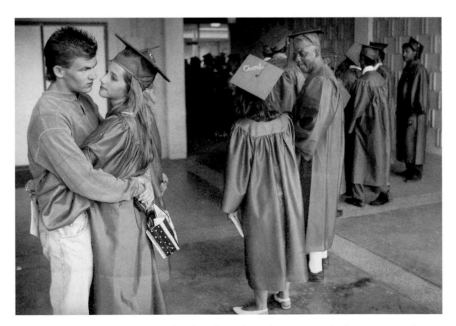

Paula Villarreal embraces her boyfriend, Mike Ganus, before joining her Yuba College classmates for their 1993 commencement exercises.

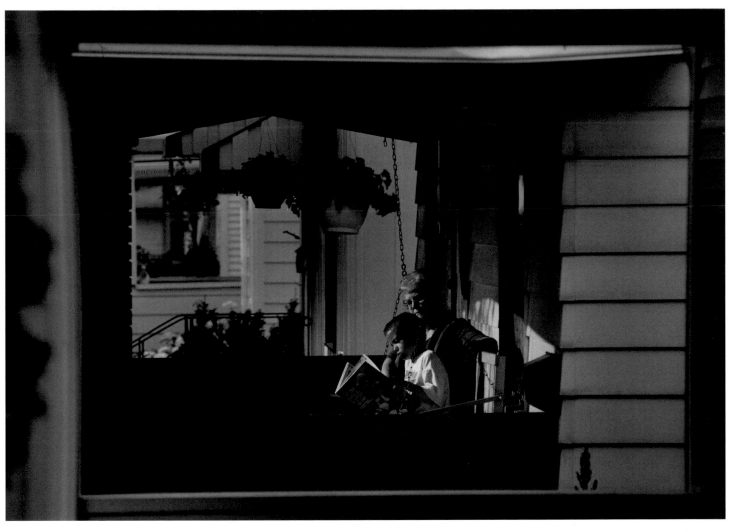

Ilja Miller and his grandmother, Sally Miller, spend a quiet evening on the porch of their East Toledo, Ohio, home. Ilja's father, Dennis, died of complications from AIDS.

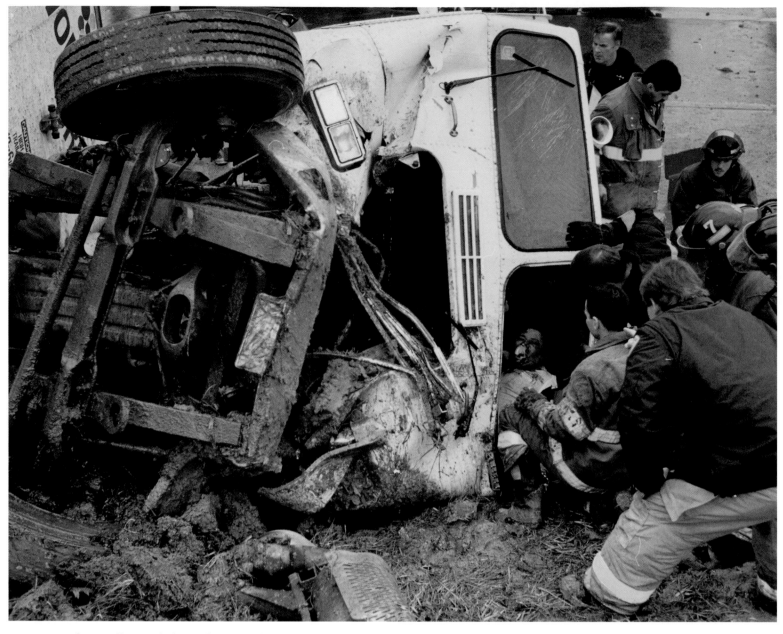

Rescue workers pull a truck driver from wreckage after a rollover on Interstate 280 in Toledo, Ohio. The driver was not seriously injured.

Larry Seitz carries a miniature horse at his farm in Swanton, Ohio.

Fred Morey and Andy Prather, roommates at the Grass Lake, Mich., Group Home, wave to passersby as they wait for the newspaper to be delivered.

WINNERS OF THE 51ST ANNUAL PICTURES OF THE YEAR COMPETITION

Judged February 15 through 24 at the University of Missouri-Columbia. Sponsored by the National Press Photographers Association, The University of Missouri School of Journalism, with grants from: Canon U.S.A. Inc., and Professional Imaging, Eastman Kodak Co.

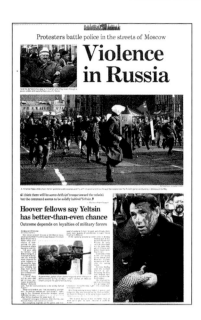

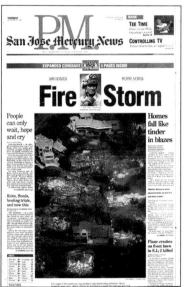

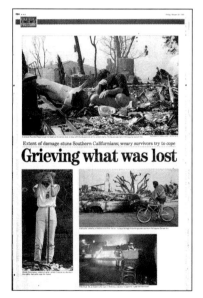

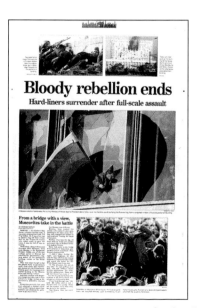

San Jose Mercury News
Overall Excellence in Editing Award/Newspapers

The Judges

Kate Glassner Brainerd/KGB Partnership (Denver, CO), J. B. Colson/University of Texas, Celeste Ericsson/The Seattle Times, Ricardo Ferro/St. Petersburg Times, Carol Guzy/The Washington Post, Colin Jacobson/The Independent Magazine, Kim Komenich/San Francisco Examiner, Nancy Lee/The New York Times, Maria Mann/Agence France-Presse, Randy Miller/Detroit Newspapers

Newspaper Photographer of the Year

LUCIAN PERKINS,
 1st Place, The Washington Post
PATRICK DAVISON,
 2nd Place, The Dallas Morning News
STAN GROSSFELD,
 3rd Place, The Boston Globe

Magazine Photographer of the Year

ANTHONY SUAU,
 1st Place, Freelance/Time Magazine
JAMES NACHTWEY,
 2nd Place, Magnum

Canon Photo Essayist Award

LARRY TOWELL,
 1st Place, Magnum , "El Salvador"
MALCOLM LINTON,
 Special Recognition, Black Star, "Georgia at War"
ANTHONY SUAU,
 Special Recognition, Freelance, "Romania's gentler moments"
SHEPARD SHERBELL,
 Special Recognition, SABA Press Photos, "The Soviets"

Kodak Crystal Eagle Award

MICHAEL S. WILLIAMSON,
 The Washington Post, "Homelessness in America"

Overall Excellence in Editing Award for Newspapers

San Jose Mercury News

Newspaper Spot News

PATRICK BAZ,
 1st Place, Agence France-Presse, "Girl flees gunfire"
ANDREI SOLOVIEV,
 2nd Place, The Associated Press, "Georgia civil war – The people"
GREG MARINOVICH,
 3rd Place, The Associated Press, "South African riots"
PAUL WATSON,
 Award of Excellence, The Toronto Star/The Associated Press,
 "A Grisly image: U.S. soldier killed"
JOSEPH TABACCA,
 Award of Excellence, Freelance/The Associated Press, "Breathless"
MARC GALLANT,
 Award of Excellence, Winnipeg Free Press, "Survivors"
PHILIP S. HOSSACK,
 Award of Excellence, Winnipeg Free Press, "Ladies aid"
JEFF BEIERMANN,
 Award of Excellence, Freelance/The Associated Press,
 "Sandbagger's exhaustion"
MARK J. TERRILL,
 Award of Excellence, The Associated Press, "Anguished"

San Jose Mercury News
1st place Picture Editing/News
Story/Single Page

Detroit Free Press
2nd place Picture Editing/News
Story/Single Page

Los Angeles Times/Orange County
1st place Picture Editing/Feature
Story/Single Page

Los Angeles Times/Orange County
2nd place Picture Editing/Feature
Story/Single Page

Orange County Register
1st place Picture Editing/News
Story/Newspaper/Multiple Page

Orange County Register
1st place Picture Editing/News
Story/Newspaper/Multiple Page

RICHARD HARTOG,
 Award of Excellence, The Outlook, "Paradise lost"
LUCIAN PERKINS,
 Award of Excellence, The Washington Post, "Nowhere to run"
JOHN MOORE,
 Award of Excellence, The Associated Press, "Boys afraid"

Newspaper General News

PATRICK DAVISON,
 1st Place, The Dallas Morning News, "Senate debate"
KATHY ANDERSON,
 2nd Place, The Times Picayune, "Battling history"
GENE BERMAN,
 3rd Place, University of Missouri, "All fags go to hell"
MICHAEL STRAVATO,
 Award of Excellence, The Associated Press, "Salvador, Brazil"
LUCIAN PERKINS,
 Award of Excellence, The Washington Post, "I'll be back"
LUCIAN PERKINS,
 Award of Excellence, The Washington Post, "A Mother's agony"
JOHN H. WHITE,
 Award of Excellence, Chicago Sun-Times, "Before the blessing"
JOE CROCETTA,
 Award of Excellence, The Herald-Mail Company
 (Hagerstown, MD), "Moshing"
OLGA SHALYGIN,
 Award of Excellence, The Associated Press,
 "Russia: Taking a hard line"
LANNIS WATERS,
 Award of Excellence, The Palm Beach Post, "Democracy's death"
ANDREA MOHIN,
 Award of Excellence, The New York Times, "Mayor's counsel"
PAUL F. GERO,
 Award of Excellence, The Arizona Republic, "Inaugural
 reflections"
ALEXANDER SHOGIN,
 Award of Excellence, The Associated Press,
 "Russia: Taking a hard line"
ROBERT GIROUX,
 Award of Excellence, Agence France-Presse, "Just out of reach"

Newspaper Feature Picture

CAROLYN COLE,
 1st Place, The Sacramento Bee, "Grounded . . ."
A. ZEMLIANICHENKO,
 2nd Place, The Associated Press, "Azerbaijan ethnic
 dispute—The people"
ALLAN DETRICH,
 3rd Place, The Toledo Blade, "Passing the time"
LARRY ROBERTS,
 Award of Excellence, Agence France-Presse, "Off to Gaza"
CRAIG STRONG,
 Award of Excellence, Freelance, "Doggone it!"
STEPHEN JAFFE,
 Award of Excellence, Freelance/Reuters "1st day
 for 1st Daughter"
LELEN BOURGOIGNIE,
 Award of Excellence, University of Miami, "Bruxelles, Belgium"
BRIAN BAER,
 Award of Excellence, St. Petersburg Times, "Coffin for son"
PATRICK BAZ,
 Award of Excellence, Agence France-Presse, "Hats off for
 Hassidim"
ERIC FEFERBERG,
 Award of Excellence, Agence France-Presse, "New reality"

Newspaper Sports Action

JIM HOLLANDER,
 1st Place, Reuters, "Panic at daybreak"
BLAIR KOOISTRA,
 2nd Place, The Spokesman Review, "Climbing Goat Hill"
ALAN ZALE,
 3rd Place, Freelance/The New York Times, "Steeple chase"
JEAN-LOUP GAUTREAU,
 Award of Excellence, Agence France-Presse, "Tennis exaltation"
ROLLIN BANDEROB,
 Award of Excellence, Record Searchlight (Redding, GA),
 "Splash down"
JANET WORNE,
 Award of Excellence, Lexington Herald-Leader (KY), "High hopes"
MATHEW MCCARTHY,
 Award of Excellence, Freelance, "Velodrome"
SCOTT STRAZZANTE,
 Award of Excellence, Daily Southtown (Chicago),
 "Squeeze play"
JIM HOLLANDER,
 Award of Excellence, Reuters, "Just for the lark of it"
CHRISTOPHER A. RECORD,
 Award of Excellence, The Charlotte Observer, "Full throttle"

Newspaper Sports Feature

JIM COLLINS,
 1st Place, Telegram & Gazette (Worcester, MA), "The Look back"
DAVID BERGMAN,
 2nd Place, The Miami Herald, "Swimmers' jubilation"
BRIAN PLONKA,
 3rd Place, Journal Tribune (Biddeford, ME)
 "For an audience of none"
JIM COLLINS,
 Award of Excellence, Telegram & Gazette (Worcester, MA),
 "Over the edge"
GEORGE WILHELM,
 Award of Excellence, Los Angeles Times, "Card stand"
PETER ACKERMAN,
 Award of Excellence, Asbury Park Press (NJ), "Stern ref"
ROBERT COHEN,
 Award of Excellence, The Commercial Appeal, "All eyes"
BETH A. KEISER,
 Award of Excellence, The Miami Herald, "A Judge's view"
THOMAS MICHAEL ALLEMAN,
 Award of Excellence, San Pedro News-Pilot, "Shaving swimmers"
CRAIG FRITZ,
 Award of Excellence, Western Kentucky University,
 "Superbowl celebration"
LLOYD FOX,
 Award of Excellence, The Baltimore Sun, "Defeat"
FRED SQUILLANTE,
 Award of Excellence, The Columbus Dispatch, "The Winning
 shot"
TODD ANDERSON,
 Award of Excellence, The Journal-Gazette (Fort Wayne, IN)
 "Nordic race"
JEFFERY F. DAVIS,
 Award of Excellence, Freelance/The Associated Press,
 "The Thrill of victory"

Newspaper Portrait/Personality

JOHN R. STANMEYER,
 1st Place, Tampa Tribune, "A Dinka tribe woman, Sudan"
JOEY MCLEISTER,
 2nd Place, Minneapolis Star Tribune, "Maria"

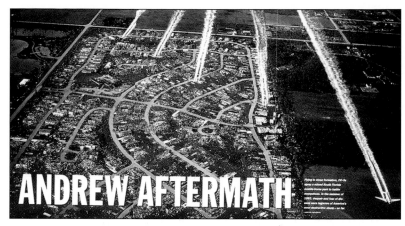

National Geographic Magazine
1st Place Picture Editing/News Story/Magazine/Multiple Page

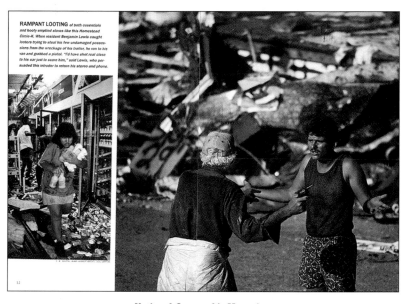

National Geographic Magazine
1st Place Picture Editing/News Story/Magazine/Multiple Page

Time Magazine
2nd Place Picture Editing/News Story/Magazine/Multiple Page

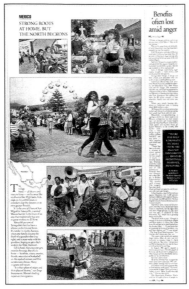

Detroit Free Press
1st Place Picture Editing/Feature
Story/Newspaper/Multiple Page

Detroit Free Press
1st Place Picture Editing/Feature
Story/Newspaper/Multiple Page

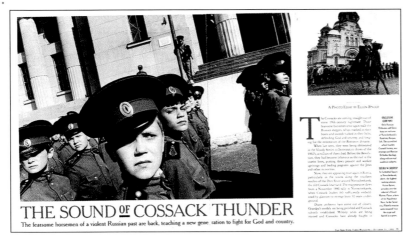

The New York Times Magazine
1st place Picture Editing/Feature Story/Magazine/Multiple Page

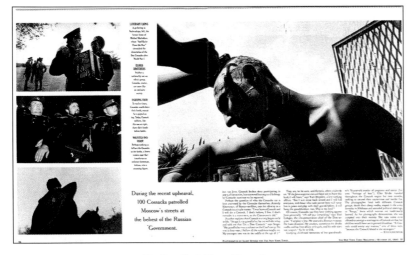

The New York Times Magazine
1st place Picture Editing/Feature Story/Magazine/Multiple Page

CANDACE B. BARBOT,
 3rd Place, The Miami Herald, "Twin love"
CHRISTOPHER A. RECORD,
 Award of Excellence, The Charlotte Observer, "Beggar"
MICHELE MCDONALD,
 Award of Excellence, The Boston Globe, "Young adult"
FRED ZWICKY,
 Award of Excellence, Journal-Star (Peoria, IL),
 "Did you know that one fly can breed a million young?"

Newspaper Pictorial

CARL D. WALSH,
 1st Place, Journal Tribune (Biddeford, ME), "Snow (e)scape"
MATTHEW CRAIG,
 2nd Place, Augusta Chronicle, "Radial keratotomy"
LARRY MAYER,
 3rd Place, The Billings Gazette, "Nebraska farmland"
LARRY MAYER,
 Award of Excellence, The Billings Gazette, "Missouri River
 sandbar"
RICHARD D. SCHMIDT,
 Award of Excellence, The Sacramento Bee, "Pegasus lives!"
CHRISTOPHER ANDERSON,
 Award of Excellence, The Spokesman Review, "Rainbow rider"
CHRISTOPHER T. ASSAF,
 Award of Excellence, Costa Mesa Daily Pilot, "Late nite changes"
SHERMAN ZENT,
 Award of Excellence, The Palm Beach Post, "Bird shadows"

Newspaper Product Illustration

JEFF HORNER,
 1st Place, Walla Walla Union-Bulletin, "Shades of summer"
MICHAEL S. WIRTZ,
 2nd Place, The Philadelphia Inquirer, "Shampoo – Nature's
 ingredients"
ELLEN JASKOL,
 3rd Place, Rocky Mountain News, "Pig on point"
JAY KOELZER,
 Award of Excellence, Rocky Mountain News, "Catholic food"
ROGER W. WINSTEAD,
 Award of Excellence, The News & Observer, "Clothes to die for"
JOHN LUKE,
 Award of Excellence, Detroit Free Press, "Body pierce"
ALEX GARCIA,
 Award of Excellence, Long Beach Press-Telegram, "A Hip cap
 for a cool cat"

Newspaper Issue Illustration

JAY KOELZER,
 1st Place, Rocky Mountain News, "Loves me not!"
KATHY ANDERSON,
 2nd Place, The Times Picayune, "Cycle of abuse"
PETER CASOLINO,
 3rd Place, New Haven Register, "Targeting your inner emotions"
JAY KOELZER,
 Award of Excellence, Rocky Mountain News, "Wish I
 were beautiful"
TOM BURTON,
 Award of Excellence, The Orlando Sentinel, "Channel surfing"
ERIC LUSE,
 Award of Excellence, San Francisco Chronicle, "AIDS toll"
BRAD GRAVERSON,
 Award of Excellence, The Daily Breeze, "Tabloid trouble"

Newspaper News Picture Story

LUCIAN PERKINS,
 1st Place, The Washington Post, "Raid on a Gypsy camp"

BILL GREENE,
 2nd Place, The Boston Globe, "The Great Flood of '93"
BRANT WARD,
 3rd Place, San Francisco Chronicle, "Prayers for Polly"
NANINE HARTZENBUSCH,
 Award of Excellence, Newsday, "Grieving for George"
GARO LACHINIAN,
 Award of Excellence, The Baltimore Sun, "Urban war zone:
 Portrait of Baltimore's most violent neighborhood"
TAMARA VONINSKI,
 Award of Excellence, Virginian-Pilot/Ledger-Star, "Mary Sue
Terry"
BRIAN BAER,
 Award of Excellence, St. Petersburg Times, "Fire on the bay"

Newspaper Feature Picture Story

JAMIE FRANCIS,
 1st Place, The State (Columbia, SC), "A World apart"
MARY BETH MEEHAN,
 2nd Place, University of Missouri, Freelance, "A Family
 of sisters"
BRIAN PLONKA,
 3rd Place, Journal Tribune (Biddeford, ME), "Secret deadly diet"
LORI WASELCHUK,
 Award of Excellence, The Advocate (Baton Rouge, LA),
 "Teach for America: Running on empty"
FREDERIC LARSON,
 Award of Excellence, San Francisco Chronicle,
 "A Curse on the Gypsies"
ALLAN DETRICH,
 Award of Excellence, The Toledo Blade, "Orphaned by AIDS"
GEORGE WILHELM,
 Award of Excellence, Los Angeles Times, "Visiting the Minors"
ALGERINA PERNA,
 Award of Excellence, The Baltimore Sun, "Beyond the threshold"
MERI SIMON,
 Award of Excellence, Contra Costa Times (Walnut Creek, CA),
 "Sons of death"
CINDY YAMANAKA,
 Award of Excellence, The Dallas Morning News,
 "Violence against women"
CAROLYN COLE,
 Award of Excellence, The Sacramento Bee, "City blues"
KARI RENE HALL,
 Award of Excellence, Los Angeles Times, "Liberty"
TIMOTHY H. REESE,
 Award of Excellence, Syracuse Newspapers, "Joe Fahey for Mayor"
ANGELA PETERSON,
 Award of Excellence, The Orlando Sentinel, "The Miracle
 of Philip"
JAY JANNER,
 Award of Excellence, Corpus Christi Caller-Times, "The Face
 of AIDS"

Newspaper Sports Portfolio

PATRICK DAVISON,
 1st Place, The Dallas Morning News
JOSEPH DeVERA,
 2nd Place, The Detroit News
GEORGE WILHELM,
 3rd Place, Los Angeles Times
GERARD MICHAEL LODRIGUSS,
 Award of Excellence, The Philadelphia Inquirer
RONALD CORTES,
 Award of Excellence, The Philadelphia Inquirer

The Boston Globe
1st Place Picture Editing/Series

The Boston Globe
1st Place Picture Editing/Series

Concord Monitor (NH)
1st Place, Best Use of
Photographs/Newspapers under 25,000

Concord Monitor (NH)
1st Place, Best Use of
Photographs/Newspapers under 25,000

The Daily Republic (Fairfield, CA)
2nd Place, Best Use of
Photographs/Newspapers under 25,000

The Daily Republic (Fairfield, CA)
2nd Place, Best Use of
Photographs/Newspapers under 25,000

The Phoenix Gazette
1st Place, Best Use of Photographs/
Newspapers 25,000 to 150,000

The Phoenix Gazette
1st Place, Best Use of Photographs/
Newspapers 25,000 to 150,000

The Gazette Telegraph (Colorado Springs)
2nd Place, Best Use of Photographs/
Newspapers 25,000 to 150,000

The Gazette Telegraph (Colorado Springs)
2nd Place, Best Use of Photographs/
Newspapers 25,000 to 150,000

San Jose Mercury News
1st Place, Best Use of Photographs/
Newspapers more than 150,000

San Jose Mercury News
1st Place, Best Use of Photographs/
Newspapers more than 150,000

Newspaper One Week's Work

ALAN LESSIG,
 1st Place, The Detroit News
BRIAN DAVIES,
 2nd Place, Appeal-Democrat (Marysville, CA)
ALLAN DETRICH,
 3rd Place, The Toledo Blade

Magazine News Picture

KEVIN CARTER,
 1st Place (Tie), Sygma, "A Vulture lurks"
DEBBI MORELLO,
 1st Place (Tie), Freelance, "A Father's pain"
TIM PAGE,
 2nd Place, Life/Reportage Photos, "Cambodian election"
SWAPAN PAREKH,
 Award of Excellence, Black Star, "Earthquake in Latur, India"
JON JONES,
 Award of Excellence, Time Magazine/Sygma, "Croats raid house"
TOMAS MUSCIONICO,
 Award of Excellence, Contact Press Images, "Food line"

Magazine Feature Picture

ANTHONY SUAU,
 1st Place, Time Magazine, "Ready for the attack"
JODI COBB,
 2nd Place, National Geographic Magazine,
 "The Happiest day of her life"
RICK RICKMAN,
 3rd Place, National Geographic Magazine, "Bonzai"
ERICA LANSNER,
 Award of Excellence, Black Star, "The New China"

Magazine Sports Picture

JODI COBB,
 1st Place, National Geographic Magazine, "Streaming to victory"
GEORGE TIEDEMANN,
 2nd Place, Sports Illustrated, "Handoff"

Magazine Portrait/Personality

MALCOLM LINTON,
 1st Place, Black Star, "Georgia at War"
ELLEN BINDER,
 2nd Place, The New York Times, "Exclusive company"
JOEL SARTORE,
 3rd Place, National Geographic Magazine,
 "Elder statesman of the groves"
LARRY DOWNING,
 Award of Excellence, Newsweek, "Ginsburg"
CHRISTOPHER FITZGERALD,
 Award of Excellence, Freelance/American Legion Magazine,
 "A Story in his eyes"
ALEXANDRA AVAKIAN,
 Award of Excellence, Contact Press Images, "Yasser Arafat"
CHRIS RAINIER,
 Award of Excellence, JB Pictures, "Initiation rites"
NINA BERMAN,
 Award of Excellence, SIPA Press, "Portrait of rape's
 enduring shame"
AL SCHABEN,
 Award of Excellence, J D & A Agency, "Mother Teresa at prayer"

Magazine Pictorial

FRANS LANTING,
 1st Place, Life, "The African night"

CHRIS RAINIER,
 2nd Place, JB Pictures, "Gathering firewood"
STEVE MCCURRY,
 3rd Place, National Geographic Magazine, "Rubble of war"
NORMA JEAN GARGASZ,
 Award of Excellence, Freelance, "Marin County, California"
ROGER H. RESSMEYER,
 Award of Excellence, National Geographic Magazine,
 "Highway to heaven"
LARS GELFAN,
 Award of Excellence, Freelance, "Ha Long rowers"
AARON KAMELHAAR,
 Award of Excellence, Freelance, "Neighbors"
JOSE AZEL,
 Award of Excellence, Aurora & Quanta Production,
 "Back to the future"

Magazine Science/Natural History

ROGER H. RESSMEYER,
 1st Place, National Geographic Magazine, "Starfire's lasers"
RICHARD HERRMANN,
 2nd Place, International Wildlife Magazine, "Getting ahead"
CAMERON DAVIDSON,
 3rd Place, National Geographic Magazine, "Sailboat"
MICHIO HOSHINO,
 Award of Excellence, National Wildlife Magazine,
 "Life in the slow lane"
DAVID DOUBILET,
 Award of Excellence, National Geographic Magazine,
 "Sea anemone"

Magazine Product Illustration

JOSEPH MCNALLY,
 1st Place, Freelance, "Glamorous evening"
STAN GAZ,
 2nd Place, Freelance/Newsweek, "Fish and chilies"
CARMEN TROESSER,
 3rd Place, University of Missouri, "The Versatility
 & variety of melons"

Magazine Issue Illustration

MATT MAHURIN,
 1st Place, Time Magazine, "Key (unlocking mind)"
J. KYLE KEENER,
 2nd Place, The Philadelphia Inquirer Magazine, "Bearing the
 Yellow Death"
PAULA LERNER,
 3rd Place, Woodfin Camp/Newsweek, "Hyperactivity"
J. KYLE KEENER,
 Award of Excellence, The Philadelphia Inquirer Magazine,
 "Whispers from the walls"

Magazine Picture Story

ELLEN BINDER,
 1st Place, The New York Times Magazine, "The Sound of
 Cossack thunder"
CHRISTOPHER MORRIS,
 2nd Place, Time Magazine, "Red October"
NINA BERMAN,
 3rd Place, SIPA Press/Fortune Magazine, "The World
 of Dreams convention"
ED KASHI,
 Award of Excellence, JB Pictures, "The Living City of the Dead"
MICHAEL S. YAMASHITA,
 Award of Excellence, National Geographic Magazine,
 "The Mekong – A haunted river's season of peace"

The Seattle Times
2nd Place, Best Use of Photographs/
Newspapers more than 150,000

The Seattle Times
2nd Place, Best Use of Photographs/
Newspapers more than 150,000

National Geographic Magazine
1st Place, Best Use of
Photographs/ Magazine

Life Magazine
2nd Place, Best Use of
Photographs/ Magazine

Sue Morrow
San Jose Mercury News/The Boston Globe
1st Place, Newspaper Picture Editing
Award/Individual Portfolio

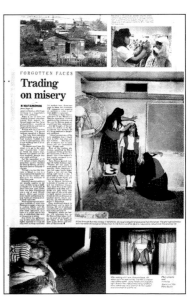

Sue Morrow
San Jose Mercury News/The Boston Globe
1st Place, Newspaper Picture Editing
Award/Individual Portfolio

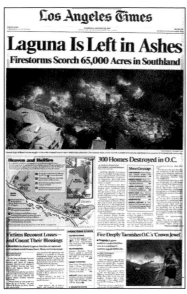

Colin Crawford
Los Angeles Times/Orange County
2nd Place, Newspaper Editing
Award/Individual Portfolio

Colin Crawford
Los Angeles Times/Orange County
2nd Place, Newspaper Editing
Award/Individual Portfolio

Los Angeles Times
1st Place, Newspaper Editing
Award/Team Portfolio

Los Angeles Times
1st Place, Newspaper Editing
Award/Team Portfolio

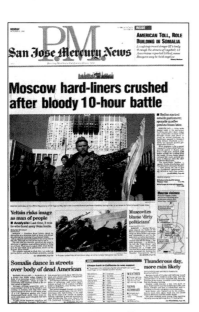

San Jose Mercury News
2nd Place, Newspaper Editing
Award/Team Portfolio

San Jose Mercury News
2nd Place, Newspaper Editing
Award/Team Portfolio

ANTHONY SUAU,
Award of Excellence, Time Magazine, "The Fall of Sukhumi"
LUC DELAHAYE,
Award of Excellence, SIPA Press/Newsweek, "The emergency ward of the Kosevo Hospital, Sarajevo"

Magazine Sports Portfolio

Judges elected to give no awards in this category

Single Page News Story/Newspaper

MURRAY KOODISH,
1st Place, San Jose Mercury News, "Three Concord boys escape tragedy on raging river"
CHRIS MAGERL,
2nd Place, Detroit Free Press, "Seven kids die alone"
COLIN CRAWFORD,
3rd Place, Los Angeles Times, "Laguna: Insurance coverage assessed"
MURRAY KOODISH,
Award of Excellence, San Jose Mercury News, "President in Sunnyvale: We want to be like you"
MURRAY KOODISH,
Award of Excellence, San Jose Mercury News, "U.S. to add troops as Somalia threat rises"
SCOTT DEMUESY,
Award of Excellence, San Jose Mercury News, "Violence in Russia"

Single Page Feature Story/Newspaper

COLIN CRAWFORD,
1st Place, Los Angeles Times/Orange County, "Visions of mercy"
COLIN CRAWFORD,
2nd Place, Los Angeles Times/Orange County, "Abzakh: Aid for Abkhazians"
MURRAY KOODISH,
3rd Place, San Jose Mercury News, "Born too soon"
COLIN CRAWFORD,
Award of Excellence, Los Angeles Times/Orange County, "Battle to heal"

Multiple Page News Story/Newspaper

JAY BRYANT, MICHELE CARDON, CHRIS CARLSON, JOE GENTRY, RON LONDEN,
1st Place, Orange County Register, "Fighting Back"
GERI MIGIELICZ, MURRAY KOODISH, SCOTT DEMUESY, GARY REYES, LINDA BARON,
2nd Place, San Jose Mercury News, "Southland ablaze"
STAFF,
3rd Place, Des Moines Register, "Floods cripple Des Moines; entire city without water"
GARY MILLER, PATRICK OLSEN,
Award of Excellence, San Bernardino Sun, "Ring of fire"

Multiple Page News Story/Magazine

LARRY NIGHSWANDER,
1st Place, National Geographic Magazine, "Andrew aftermath"
ROBERT STEVENS,
2nd Place, Time Magazine, "Red October"
ELIE ROGERS,
3rd Place, National Geographic Magazine, "Europe faces an immigration tide"
BERT FOX,
Award of Excellence, The Philadelphia Inquirer Magazine, "Unrest in peace"
BERT FOX,
Award of Excellence, The Philadelphia Inquirer Magazine, "Pursuing peace"

Multiple Page Feature Story/Newspaper

MIKE SMITH, MARCIA PROUSE,
 1st Place, Detroit Free Press, "Immigration: Hate and hope"
DENIS FINLEY,
 2nd Place, The Virginian-Pilot, "Reflection on
 a failed campaign"
THEA BREITE,
 3rd Place, The Providence Journal, "Coming of age"
GREG PETERS,
 Award of Excellence, The Columbus Dispatch,
 "Swimming with dolphins"
SCOTT DEMUESY,
 Award of Excellence, San Jose Mercury News, "Play ball"
THEA BREITE,
 Award of Excellence, The Providence Journal, "The West End:
 Rites of Passage"

Multiple Page Feature Story/Magazine

KATHY RYAN,
 1st Place, The New York Times Magazine, "The Sound of
 Cossack thunder"
LARRY NIGHSWANDER,
 2nd Place, National Geographic Magazine,
 "In the heart of Appalachia"
LARRY NIGHSWANDER,
 3rd Place, National Geographic Magazine, "California's
 North Face"
JOHN ECHAVE,
 Award of Excellence, National Geographic Magazine,
 "Afghanistan's uneasy peace"
ELIE ROGERS,
 Award of Excellence, National Geographic Magazine, "Cairo:
 Clamorous heart of Egypt"
ROBERT STEVENS,
 Award of Excellence, Time Magazine, "Slaughter in slow motion"
BERT FOX,
 Award of Excellence, The Philadelphia Inquirer Magazine,
 "American dreamers"
LARRY NIGHSWANDER,
 Award of Excellence, National Geographic Magazine, "The
 Superior way of life"

Newspaper Series

SUE MORROW,
 1st Place, The Boston Globe, "On the beat"
MIKE SMITH, MARCIA PROUSE,
 2nd Place, Detroit Free Press, "Jerusalem:
 The people, the struggle"
MIKE HEALY,
 3rd Place, Minneapolis Star Tribune, "Efforts to revive
 Cambodia founder"
CARL DAVAZ, GEORGE MILLENER, PAUL CARTER, CHRIS PIETSCH,
ANDY NELSON, JOE WILKINS II,
 Award of Excellence, The Register-Guard, "Redemption"

Newspaper Special Section

Judges elected to give no awards in this category

Best Use of Photographs/Newspapers:
Circulation of under 25,000

1st Place, Concord Monitor (NH)
2nd Place, The Daily Republic (Fairfield, CA)
3rd Place, The Journal Tribune (Biddeford, ME)
Award of Excellence, The Herald (Jasper, IN)

The New York Times Magazine
1st Place, Newspaper-produced
Magazine Picture Editing Award

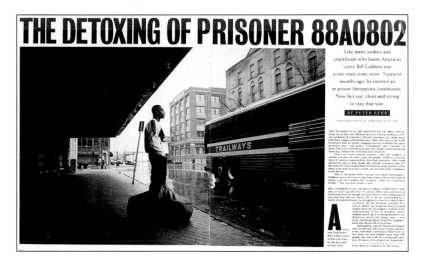

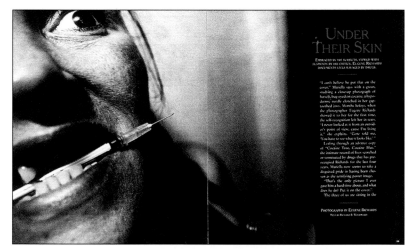

The New York Times Magazine
1st Place, Newspaper-produced Magazine Picture Editing Award

The Philadelphia Inquirer
2nd Place, Newspaper-produced Magazine Picture Editing Award

Peter Howe
Outtakes/Audubon
1st Place, Picture Editing
Award/Magazine

Best Use of Photographs/Newspapers: Circulation of 25,000 to 150,000

1st Place, The Phoenix Gazette
2nd Place, The Gazette Telegraph (Colorado Springs, CO)
3rd Place, Tallahassee Democrat
Award of Excellence, Anchorage Daily News
Award of Excellence, The Sun (Bremerton, WA)

Best Use of Photographs/Newspapers: Circulation of more than 150,000

1st Place, San Jose Mercury News
2nd Place, The Seattle Times
3rd Place, The Des Moines Register

Best Use of Photographs/Magazine

1st Place, National Geographic Magazine
2nd Place, Life Magazine
3rd Place, Newsweek
Award of Excellence, Outtakes
Award of Excellence, The Philadelphia Inquirer Magazine
Award of Excellence, Audubon Magazine

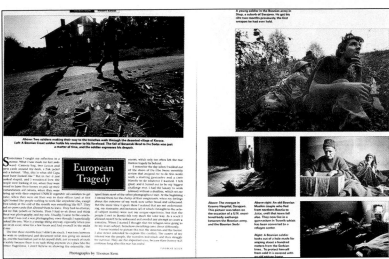

Peter Howe, Outtakes/Audubon
1st Place, Picture Editing Award/Magazine

Newspaper Picture Editing Award/Individual Portfolio

SUE MORROW,
1st Place, The Boston Globe and San Jose Mercury News
COLIN CRAWFORD,
2nd Place, Los Angeles Times/Orange County
MURRAY KOODISH,
3rd Place, San Jose Mercury News
THOMAS MCGUIRE,
Award of Excellence, The Hartford Courant
FRED NELSON,
Award of Excellence, The Seattle Times
CHRIS MAGERL,
Award of Excellence, Detroit Free Press

Newspaper Picture Editing Award/Team Portfolio

1st Place, Los Angeles Times
2nd Place, San Jose Mercury News
3rd Place, The Orange County Register
Award of Excellence, Detroit Free Press
Award of Excellence, The Seattle Times

Newspaper-produced Magazine Picture Editing Award

KATHY RYAN,
1st Place, The New York Times Magazine
BERT FOX,
2nd Place, The Philadelphia Inquirer
GARY SETTLE, ROBIN AVNI,
3rd Place, The Seattle Times

Magazine Picture Editing Award

PETER HOWE,
1st Place, Outtakes/Audubon
LARRY NIGHSWANDER,
2nd Place, National Geographic Magazine
DAVID FRIEND,
3rd Place, Life Magazine
STEVE FINE,
Award of Excellence, Sports Illustrated

Larry Nighswander, National Geographic
2nd Place, Picture Editing Award/Magazine

Index

Last Look

3RD PLACE, NEWSPAPER SPORTS PORTFOLIO
George Wilhelm, Los Angeles Times
A baby sleeps in the pressbox announcer's booth as a game progresses into the evening in Riverside, Calif.

Acknowledgments

This project could not have been accomplished without
the support and technical assistance of the following people:
Bill Kuykendall and Lisa Barnes; The University of
Missouri, Columbia, Mo.
Tom McIntyre, Jon Michaels and Mary Anne Kuhn;
Bowne of Phoenix, Inc., Phoenix, Ariz.
Dave Klene, Jostens Printing, Topeka, Kan.

The Editors wish to thank Phoenix Newspapers Inc. for
its ongoing support of the employees who participated in this
volunteer project for the past six years.